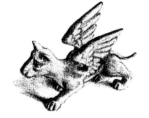
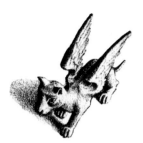
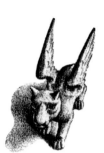

Bruno Ernst
The Magic Mirror
of M. C. Escher

Bruno Ernst The Magic Mirro

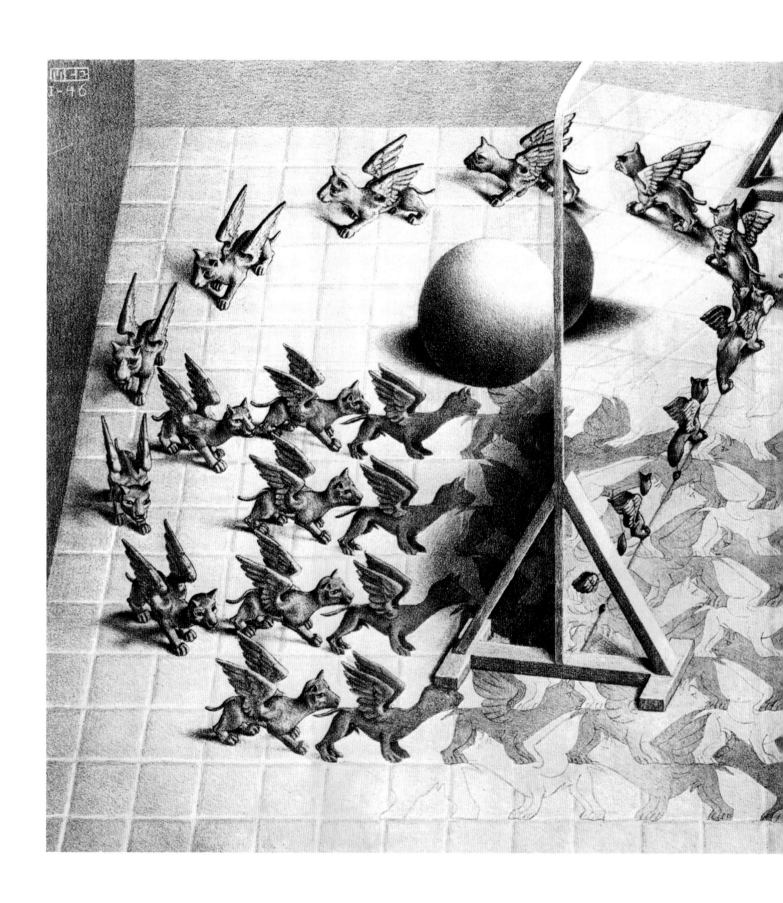

of M.C. Escher

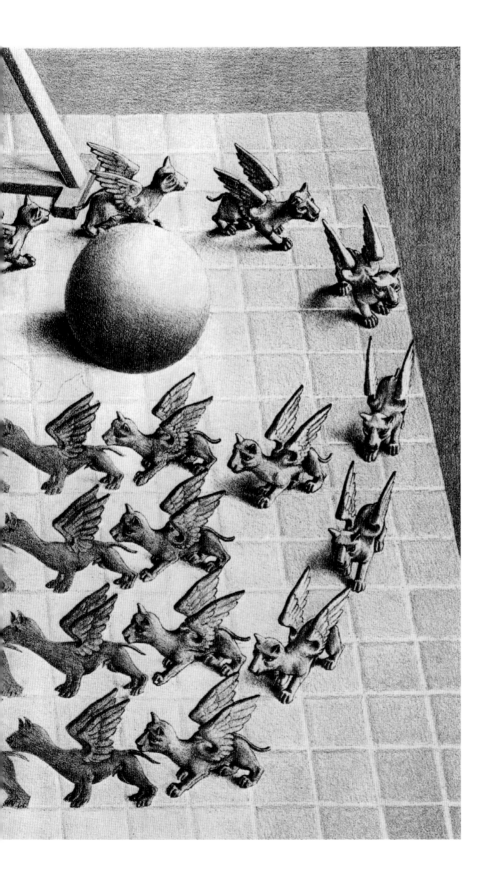

TASCHEN

© 1978 Bruno Ernst
© 2015 for this edition:
TASCHEN GmbH
Hohenzollernring 53, D-50672 Köln
www.taschen.com

We are grateful to Cordon Art B.V., Baarn, Holland, for permission to
reproduce the pictures and sketches by Escher in this book.

Many diagrams and explanatory drawings were first published in
Pythagoras, a journal for mathematics students, and we are grateful
to Wolters–Noordhoff B.V., Groningen, Holland, for permission to
reproduce these. We are also indebted to the Bank of the Netherlands,
Amsterdam, for their permission to reproduce the banknotes designed
by Escher.

English translation by John E. Brigham
Cover Design: Sense/Net Art Direction, Andy Disl and
Birgit Eichwede, Cologne, www.sense-net.net

Printed in South Korea
ISBN 978–3–8228–3703–0

Contents

The magic mirror – a document

This book was written more than 25 years ago and has been translated into ten languages without any change to the text or the images. Yet much has happened in those 25 years to cause the text to be revised. Escher's extensive correspondence and other writings have become available; congresses about Escher have been held (including Rome 1985, Granada 1990); and a number of books have been published about Escher's life and work, together with books that delve deeply into the complexities of his work (e.g. Bruno Ernst, *Adventures with Impossible Objects* and *Optical Illusions*). A number of artists were inspired by Escher's graphic oeuvre and are responsible for a genre that can be termed Escherian.

Is there not a call then for additions and amendments to *The Magic Mirror of M. C. Escher?* No, this cannot be, for it would mar the factual value of this book which is the outcome of a large number of interviews with Escher. I wrote it in 1970 and 1971, and every part of the text was corrected, added to, and where necessary altered by Escher himself. It precisely reflected his own view of his work. This is apparent from the history of how the book came into being.

The book's genesis

Escher's print *High and Low* hung in the lecture room of the pedagogic institution where I lectured on mathematics. I was constantly fascinated by it: two reproductions of the same view of a town seen from two totally different perspectives, yet forming a harmonious unity with each other. What was the creator of this print communicating? How did he achieve it and what means did he employ?

In 1955, I was at Baarn (in Holland) to help a friend (Ir. A. Bosman) with the editing of a popular mathematics book, for which he had collected a lot of material. Escher came into conversation coincidentally and he told me: "He is a neighbour; he is ideal (for the purpose) and you can contact him quite easily and ask him the questions yourself." It was a little while before I dared to do so, because I not only regarded Escher as a great artist, but also as a wizard. I wrote a letter to him in the summer of 1956 with questions about the print *High and Low*. By return I received the following answer: "... there is much to say about the design and motivation of this lithograph. I do not have sufficient time to do so in writing. If you are able to visit me I will be able to tell you all manner of things by referring to ear-

lier and subsequent prints." This was an unforgettable visit. By the end of the afternoon, I had become acquainted with virtually every print Escher had made since 1940 and I came to understand much about Escher's imagination, while being constantly astonished. Later I was to return many times, since this introduction had been rather hasty. I had even criticized the print that he had just completed: *Print Gallery*. Several days after my visit he returned to the subject and made it clear that the changes I had proposed were impossible. Looking back I consider my criticism as outrageous. Imagine it, Escher was about 60 years old and had earned his acclaim as a graphic artist and creator of many exceptional and highly acclaimed prints. I was a 30 years old mathematics teacher. Yet Escher took the criticism of a young man who knew barely anything about his work completely seriously, as though I were a close colleague who had known him for thirty years.

In a letter to his son Arthur, he wrote of this visit: "I want to tell you about a 'brother' with whom I have made acquaintance. This brother," (I was at the time a member of a religious order that was mainly engaged in education), "who I only know as Erich, is a mathematics teacher ... A strange character, who just wrote to me all of a sudden to tell me that my prints fascinated him, and the boys he teaches, and that he longed to come to see me in Baarn. This he has done meanwhile. He viewed my jokes with perspective and above all my 'inversion' print *Convex and Concave* (which I believe I sent you, didn't I?), as well as my regular division of planes, with great interest. In connection with the *Convex and Concave* print he gave me a means to invert easily all manner of objects and landscapes that we view. It is so astounding that I will attempt to explain it to you." These were Escher's own words. You can see that there was no reference to my impertinence in passing criticism on his work.

My visit was the beginning of a long lasting friendship. Through the numerous visits and talks that followed, I was slowly guided into the world of Escher's imagination, about which I came to write so many articles over the years. I was very flattered by his reactions, such as "... I don't believe there is anything so authoritative written anywhere about this print (or others)." This was about an analysis of *Print Gallery*, which I had criticized in my first book and which Escher, and later I myself, regarded as his best work.

Early in 1970, Escher was talking about letters from admirers, who sometimes came up with the strangest interpretations of his prints. I had the spontaneous idea of dealing systematically with his work, print by print, so that people would have no uncertainty after his death about his intentions. Escher considered this a good plan and we agreed that I should visit him each week. This lasted for almost two years. On 24 May 1970, he wrote to his sons: "This will be the fourth Sunday afternoon, from four to half past six, that he has come to see me to collect material for a book about my work ... It is also enjoyable to see how he attempts so clearly to turn my intuitive way of working into words which I have neither used or known."

During these visits, it was not only the prints and the correlation between them that was discussed, but also the many roughs, alternatives, and early sketches. After each visit I wrote a little about what we had discussed and sent this to Escher, who then immediately wrote back with his comments, sometimes accompanied by encouraging remarks, such as: "Time and again, as I read a fragment once more, I think: what a fine book this is going to be." Or in a later comment: "In general, if I consider the entire work, it seems to me to be an amazingly fascinating book for the reader who is fed up with the drivel of art history."

Sometimes he was very taken with the particular expression in words of what he intended to convey in a print. When I had sent him the piece about his woodcut Spirals and was with him the following Sunday, he went to the drawer where he kept his prints, took out a print of Spirals, and signed it with an inscription to me. While doing so, he remarked: "I have only printed a small number and there is little demand, but your commentary hits the nail on the head. Will you accept this copy from me by way of thanks?"

While we were working on the book, Escher's health deteriorated significantly and I knew that my visits tired him greatly. One Saturday I telephoned to let him know what time I would come the next day. After a short chat, he said to me: "Wait a moment, while I lie down, because I am so tired." I suggested that it would be best to postpone our discussions for a week but he would not hear of it. The book must go on and I will feel better in the morning, was his comment.

Given the manner in which we worked, it was more Escher's book than mine. Of course I was not acting as a ghost writer but it was certainly an authorized translation of his imagination. In 1971, it was ready, and although both a Dutch and an American publisher wanted it, Escher was unable, through all manner of circumstances, to see his book published. This in spite of his looking forward to it as he wrote in a letter to his sons: "It delights me more and more, the appearance of this book."

The aura

The power of attraction of Escher's prints has grown since his death, together with the popularity of his books and the countless reproductions which are sold every year.

Escher never sought exclusivity. His prints were intended to be disseminated: as many people as possible must share in the enthusiasm and amazement which led to their creation. This is why he never restricted the editions of his prints. Provided there was a demand, he let new editions of his lithographs be printed, and printed new editions of his woodcuts himself. When the demand arose for much larger editions of his prints to be produced by normal commercial printing processes, he gave his permission.

Escher had no pupils; it had never arisen. What might they have learned in any case? At best, the technique of making woodcuts and drawing on lithographic stone. Passing on his ideas did not interest him and would have disturbed him in his constant quest. Besides, his aim was to convey his imagination through his prints. Although no 'Escher school' exists, many artists throughout the world (there are more than fifty that are recognized) have been inspired by his work. In the first instance, this is through the spirit which shines out of his creations. A typical example of this aura, which is not limited to a single print or group of prints, is given by an incident back in 1954. The famous physicist and cosmologist Professor Roger Penrose recounts: "My own involvement in impossible figures dates back to 1954, when I attended the international Congress of Mathematicians in Amsterdam ... A lecturer of my acquaintance suggested that I would be interested in an exhibition of work by the Dutch artist M.C. Escher ... I was totally fascinated, never having come across Escher's work before. On returning to England, I decided to try my hand at something impossible myself. Finally I came up with the impossible triangle which, in my view, embodied the impossibility I was trying to express, in its purest form. Although, in his exhibition, Escher had had many strange and wonderful things, there was nothing that we would now call an impossible object quite in that sense."

So far as his influence on other artists was concerned, this mainly stemmed from particular objects which Escher had carved out, with the regular division of planes and above all the impossible figures, although Escher only made three of these! This resulted in the view that Escher's work was being distorted and restricted. The public at large had similar preferences, judging from the demand for reproductions of his prints.

The influence on artists did not lead to any continuation of Escher's ideas. This was not really possible, for his journey of exploration was unique; a repetition would be meaningless and I cannot imagine any advancement.

Escher's work is multifaceted in terms of content but behind that plethora lurks a strong unity. After half a lifetime of illustration and reproduction of what especially attracted him to Mediterranean towns, villages, and landscapes, he concentrated after 1940 almost exclusively on the fundamentals and the essentials of his métier: illustration. Questions were posed such as: what is illustration; what potential does a surface provide if we wish to fill it with corresponding figures joined together? Isn't it astonishing that we can illustrate two or more three-dimensional representations on precisely the same piece of two-dimensional paper, without them forming an inextricable image? ... and so on.

An idea had to be completely thought out, sometimes over many months, before he would present it to the public. A surprising aspect, to which little consideration has been given, is that he never repeated himself. Look at the roughs of a number of his prints which are reproduced in this book: he could have made an interesting print of virtually every sketch for *Waterfall*, *Convex and Concave*, and *High and Low*. This would be entirely legitimate for an artist and many have established their oeuvre in this way.

But his aim was not the making of a number of fine and interesting prints. In this respect too he was unique: he strove after *the* print which most fully illustrated his idea. Occasionally we see several prints on the same theme, but it is always a matter of an improvement or variation, whereby he considered his idea would be more succinctly conveyed.

In the *Magic Mirror*, you will find not only to a biographical background, but an account of the genesis of Escher's work, resulting from a distillation of the many discussions I had with him, and which he regarded as a faithful description and another manifestation of his intentions.

Bruno Ernst, 1998
(Translation: Stephen Challacombe)

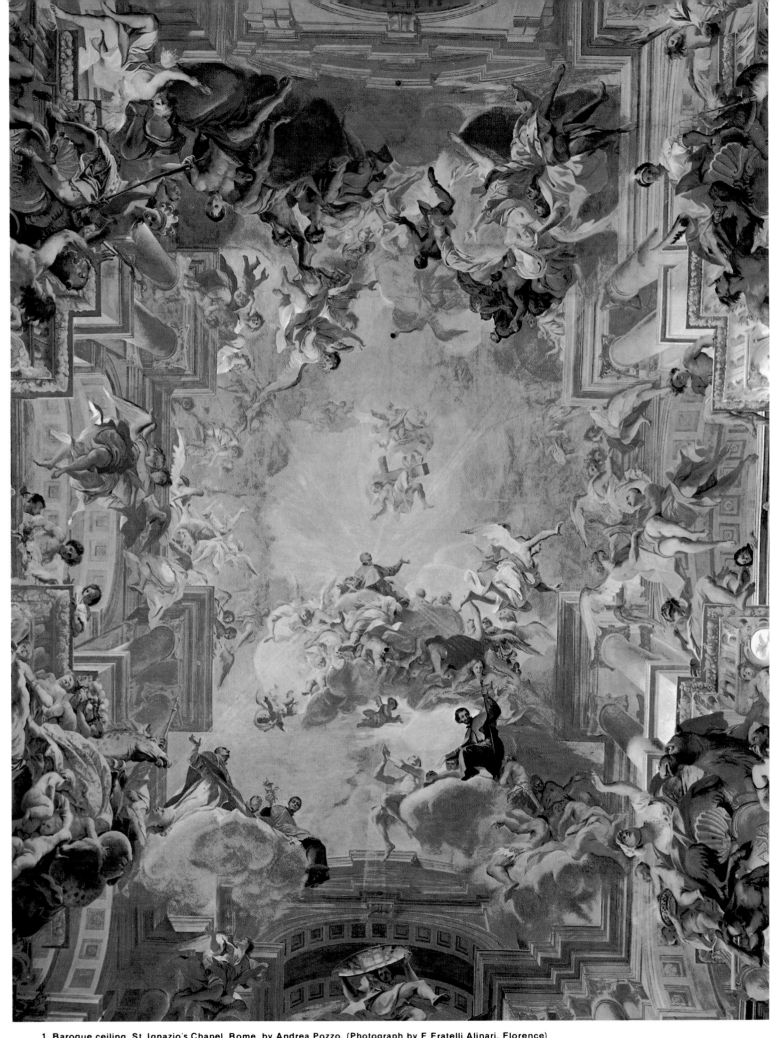

1. Baroque ceiling, St. Ignazio's Chapel, Rome, by Andrea Pozzo. (Photograph by F Fratelli Alinari, Florence)

Part One: Drawing is deception

1 The Magic Mirror

*"As the emperor gazed into the mirror his visage
became first a blood red blob and then a death's
head with slime dripping from it. The emperor
turned away from it in alarm. 'Your Majesty,'
said Shenkua, 'do not turn your head away. Those
were just the beginning and the end of your life.
Keep on looking, and you shall see everything
that is and everything that may be. And when
you have reached the highest point of rapture,
the mirror will even show you things which can-
not possibly be.'"*

—Chin Nung, "All about Mirrors"

When I was a young man I lived in a seventeenth-century house
on the Keizersgracht in Amsterdam. In one of the larger rooms
there were *trompe-l'oeil* paintings above the doors. These mural
paintings, carried out in many combinations of varying shades
of gray, achieved so plastic an impression that one could not
escape the conviction that they were marble reliefs—a deception,
an illusion that never ceased to astonish. And perhaps even more
skillful still are those ceiling paintings in churches in central
and southern Europe where two-dimensional paintings and three-
dimensional sculpture and architecture pass over from one to the
other without any visible joins.

This playful exercise has its roots in the representational meth-
ods of the Renaissance. The three-dimensional world had to be
reproduced as faithfully as possible on the flat surface, and in
such a way that image and reality might be indistinguishable
to the eye. The idea was that the painting should conjure up
warm, voluminous reality.

In the case of the *trompe-l'oeil* paintings, ceiling paintings, and
those portraits which keep on staring at one from whichever point
one looks at them, it is a question of playing the game for the
game's sake.

It is no longer a matter of representational verisimilitude in the
things that are being portrayed, but of downright optical illusion,
of superdeception in the service of deceit. The painter takes a
delight in this deceit, and the viewer is determined to be deceived
willy-nilly, deriving therefrom the same sort of sensation as when
he is being taken in by a magician. The spatial suggestion is so
strong, so exaggerated, that nothing short of actual touch can

2. Pieter de Wit, "Trompe l'oeil" painting (the Rijksmuseum, Amsterdam)

9

reveal to us that we are dealing with pictures on a flat surface.

A great deal of Escher's work is related to this supersuggestion of the spatial to which we have just referred. However, the suggestion itself is not what he is primarily aiming at. His prints are much rather the reflection of that peculiar tension inherent in any flat representation of a spatial situation. In many of his prints he causes the spatial to emerge from the flat surface. In others he makes a conscious attempt to nip in the bud any spatial suggestion that he may have brought about. In the very highly developed wood engraving *Three Spheres I* (1945), which we shall discuss more fully at a later stage, he carries on a discussion with the viewer: "Now, isn't that one at the top a splendid round globe? Wrong! You are quite mistaken — it is completely flat! Now, just look, in the middle I have drawn the thing folded over. So you see it really must be flat, or I could not have folded it. And at the bottom of the print I have laid the thing down horizontally. And in spite of this, I guess your imagination will go and turn it into a three-dimensional egg. Just satisfy yourself about this with the touch of your fingers over the paper — and feel how flat it really is. Drawing is deception; it suggests three dimensions when there are but two! And no matter how hard I try to convince you about this deception, you persist in seeing three-dimensional objects!"

With Escher, optical illusion is achieved by means of a representational logic that hardly anyone can evade. By his method of drawing, by his composition, he "proves" the genuineness of the suggestion that he has brought into being. And the fascinated viewer, on coming to his senses, realizes that he has been taken in. Escher has literally conjured up something before his eyes. He has held before him a magic mirror whose spell has been cast as a compelling necessity. In this Escher is an absolute master, and unique at that. Let us take the lithograph *Magic Mirror* (1946) to illustrate this. By standards of artistic criticism, perhaps it is not a successful print. It is set before us like some tangled skein. There is certainly something taking place, but what it is is far from clear. There is obviously a story in it, but both beginning and end remain so far unrevealed.

It all begins at a very inconspicuous spot. At the edge of the mirror nearest to the viewer, immediately underneath the sloping bar, we can perceive the tip of a small wing, together with its reflection. As we look further along the mirror, this develops into a complete winged hound and its mirror image. Once we have allowed ourselves to be inveigled into accepting the wing-tip as a possibility, we now have to swallow the compelling plausibility of the whole strange setup. As the real dog turns away from the mirror toward the right so his reflection turns to the left, and this reflection looks so real that it is no surprise whatever to us to see him continue walking away behind the mirror, quite undeterred by the mirror frame. And now winged hounds move off to left and right, doubling themselves twice en route; then they advance upon each other like two armies. However, before an actual confrontation takes place, there is a falling off in their spatial quality and they become flat patterns upon the tiled floor. If we watch closely, we see the black dogs turning into white ones the moment they pass through the mirror, doing this in such a way that they exactly fill up the lighter spaces left between the black dogs. These white gaps disappear and eventually no trace of the dogs remains. They never did exist anyway — for winged dogs do not come to birth in mirrors! And yet the riddle is still there — for in front of the mirror stands a globe, and in the mirror, sloping away at an angle, we can still see just a portion of its reflection. And yet there also stands a globe behind the mirror — a real enough object in the midst of the left-hand mirror-world of the dogs.

Who is this man that possesses this magic mirror? Why does he produce prints like this one, obviously without any consideration of aesthetics? In chapters 2, 3, and 4 we shall discuss his life story and throw some light on his character, insofar as this emerges from his letters and his personal conversations. Chapter 5 gives an analysis of his work as a whole. And the following chapters discuss in detail the inspiration, working methods, and the artistic results of this unique talent.

2 The Life of M.C. Escher

Not Much of a Scholar

Maurits Cornelis Escher was born in Leeuwarden in 1898, the youngest son of a hydraulic engineer, G.A. Escher.

In his thirteenth year he became a pupil of the high school in Arnhem, a town to which the family had moved in 1903. He could hardly be described as a good student. The whole of his school days was a nightmare, the one and only gleam of light being his two hours of art each week. This was when he made linocuts, together with his friend Kist (later to be a children's-court judge). Twice Escher had to repeat a grade. Even so he failed to obtain a diploma on leaving, having achieved only a number of grade fives, a few sixes, and—a seven in art. If anything, this result gave more distress to his art teacher (F. W. van der Haagen) than it did to the candidate himself. Such work as has survived from Escher's school days clearly indicates a more than average talent; but the bird in a cage (the set piece for his examination) was not highly thought of by the examiners.

Escher's father was of the opinion that his son ought to be given a sound scientific training and that the most suitable plan for the boy to aim at—for after all, he was really quite gifted artistically—would be to become an architect. In 1919 he went to Haarlem to study at the School of Architecture and Decorative Arts under the architect Vorrink. However, his architectural training did not last very long. Samuel Jesserun de Mesquita, a man of Portuguese extraction, was lecturing in graphic techniques. It took no more than a few days to show that the young man's talents lay more in the direction of the decorative arts than in that of architecture. With the reluctant agreement of his father (who could not help regarding this as being probably inimical to his son's future success) young Maurits Escher changed courses and de Mesquita became his main teacher.

Work from this period shows that he was swiftly mastering the technique of the woodcut. Yet even in this Escher was by no means regarded as outstanding. He was a keen student and worked well, but as for being a true artist . . . well, no, he was certainly not that. The official college report, signed by both the director (H.C. Verkruysen) and de Mesquita, read: ". . . he is too tight, too literary-philosophical, a young man too lacking in

3. Maurits Escher as a fifteen-year-old boy, spring, 1913

4. Escher in Rome, 1930

feeling or caprice, too little of an artist."

Escher left in 1922, after two years of study in the art school. He had a good grounding in drawing and, among graphic techniques, he had so mastered the art of the woodcut that de Mesquita had reached the conclusion that the time had come for him to go his own way.

Until early 1944, when de Mesquita, together with his wife and family, was taken away and put to death by the Germans, Escher maintained regular contact with his old teacher. From time to time the former pupil would send the master copies of his latest pieces of work. It was in reference to *Sky and Water I* (1938), which de Mesquita had pinned up on the door of his studio, that the teacher recounted without the slightest tinge of jealousy how a member of his family had exclaimed with admiration, "Samuel, I think that is the most beautiful print you have ever made."

Looking back on his own student days, Escher could see himself as a rather shy young man, not very robust in health but with a passion for making woodcuts.

Italy

When he left art school in the spring of 1922, Escher spent about two weeks traveling through central Italy with two Dutch friends; and in the autumn of that same year he was to return there on his own. A family with whom he was friendly was going

to Spain on a cargo boat, and Escher was able to go with them, as "nursemaid" to their children. After a short stay in Spain he boarded another cargo boat at Cadiz, en route for Genoa, and the winter of 1922 and the spring of 1923 were spent in a pension in Siena. It was here that his first woodcuts of Italian landscape were produced.

One of the pension guests, an elderly Dane who had taken note of Escher's interest in landscape and architecture, inspired him with an enthusiasm for southern Italy, and told him in particular, that he would find Ravello (to the north of Amalfi, in Campania) to be bewitchingly beautiful. Escher traveled there and did indeed discover and take to his heart a landscape and an architecture in which Moorish and Saracen elements were attractively interwoven.

In the pension where he was staying he met Jetta Umiker, the girl whom he was to marry in 1924. Jetta's father was Swiss and, prior to the Russian Revolution, had been in charge of a silk-spinning factory on the outskirts of Moscow. Jetta drew and painted, and so did her mother, although neither of them had had the benefit of any training in these arts.

The Escher family came over from Holland for the wedding, which was held in the sacristy and town hall of Viareggio. Jetta's parents set up house in Rome and the young pair went to live with them. They rented a house on the outskirts of the city, on the Monte Verde. When their first son, George, was born, in 1926, they moved to a larger dwelling, where the third floor became their living quarters and the fourth floor was made into a studio. This was the first place in which Escher felt that he could work in peace.

Until 1935 Escher felt quite at home in Italy. Each spring he would set off on a two-month journey in the Abruzzi, Campania, Sicily, Corsica, and Malta, usually in the company of brother artists whom he had come to know in Rome. Giuseppe Haas Trivero, a former house painter turned artist, accompanied him on practically every one of these journeys. This Swiss friend was about ten years older than he and also lived on Monte Verde. Robert Schiess, another Swiss artist, and member of the Papal Guard, sometimes went too. In the month of April, when the Mediterranean climate begins to be at its loveliest, they would set off by train, but mostly they would travel on foot, with rucksacks on their backs. The purpose of these journeys was to collect impressions and make sketches. Two months later they would return home, thin and tired but with hundreds of drawings.

Many an anecdote could be told about this period; a few morsels of traveler's tales must suffice here, to sketch in the atmosphere a little.

A journey through Calabria brought the artists to Pentedattilo, where five rocky peaks rise out of the landscape like giant fingers. The company was more numerous than usual, for a Frenchman called Rousset, who was engaged in historical research in southern Italy, was also with them. They found a lodging in the tiny hamlet—one room with four beds. Meals consisted mainly of hard bread (baked once a month) softened in goat's milk; also honey and goat's-milk cheese. At this period Mussolini had already taken power firmly into his hands. A Pentedattilo woman asked the travelers if they would take a message to Mussolini on behalf of the village. "If you see him, tell him we are so poor here we have not got a well, or even a plot of land where we can bury our dead."

After a stay of three days they tramped the long road back to Melito station on the south coast. A man on horseback came toward them on the narrow, rocky path, and, seizing his enormous camera, Rousset started to film the rider. The man dismounted, and with southern courtesy pressed the travelers to go with him to his home in Melito. He proved to be winegrower and had a very fine cellar. This last was not merely inspected but was so long and so excessively sampled that, a few hours later,

12

5. Color sketch of Amalfi, south of Italy

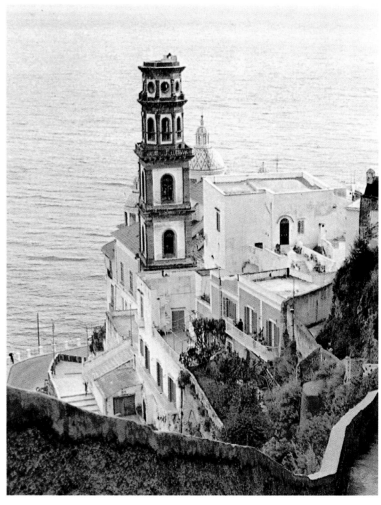

6. Photograph taken by the author of the same spot, March 1973

the travelers arrived in a remarkable state of reckless abandon at the station at Melito. Schiess took his zither from its case and began to play just as the train was due to leave. Out got the passengers and so did the engine driver. Even the stationmaster was so enthusiastic that he started to dance to the music.

Later Rousset recalled the memories of the journey in a letter to Escher and commemorated the incident in this epigram:

Barbu comme Appollon, et joueur de cithare,
Il fit danser les Muses et meme un chef-de-gare.

Sometimes the zither playing caused astonishment. It seemed to be a better means of communication than eloquent speech or anything else, as instanced in a travel story which Escher himself once published (in the *Groene Amsterdamer*, April 23, 1932).

Usually the only connecting link between the unknown mountain eyries in the inhospitable interior of Calabria and the railroad which runs right along the coast is a mule-path. Anyone wishing to pass this way has to go on foot if he has no mule at his disposal. One warm noontide in the month of May, at the end of a tiring tramp in the blazing sun, the four of us, loaded up with our heavy rucksacks, sweating profusely and pretty well out of breath, came through the city gate of Palazzio. We strode purposefully to the inn. It was a fairly large, cool room, with light streaming in through the open doorway, and smelled of wine and its countless flies. We had long been accustomed to the dourness of the people of Calabria, but never before had we met with such an attitude of antagonism as we sensed on this occasion. Our friendly questions brought forth only gruff and incomprehensible replies. Our light hair, strange clothing, and crazy baggage must have evoked considerable suspicion. I am convinced that they suspected us of

gettature and *mal occhio*. They literally turned their backs on us and barely managed to put up with our presence among them.

With a glum expression and without a word spoken, the innkeeper's wife attended to our request for wine. Then, calmly and almost solemnly, Robert Schiess took his zither out of its case and began to strum, very softly at first, as though he were immersed in and carried away by the magic that was coming from the instrument. As we watched him and the men around us, we witnessed the wonderful way in which the evil spell of enmity was broken. With a great deal of creaking a stool was turned around; instead of the back of a head, a face came into view . . . then another and another. Hesitatingly the landlady approached, step by step, and stood there with her mouth open, one hand on her hip and the other smoothing her skirt. When the strings went mute and the zither player raised his eyes, there stood around him a deep rank of onlookers who burst into applause. Tongues were loosed: "Who are you? Where do you come from? What have you come here for? Where are you going next?" We were pressed to accept wine, and we drank much too much of it, which was very pleasant, and our good relationship was even further increased.

The Abruzzi mountains are impressively somber in comparison with other Italian landscapes. In the spring of 1929, Escher went there entirely on his own in order to sketch. He arrived rather late in the evening in Castrovalva, found a lodging, and went straight to sleep. At five in the morning he was awakened by a heavy thumping on his bedroom door. *Carabinieri!* Whatever could they be wanting with him? He was ordered to go to the police station with them. A great deal of argument was required in order to persuade the constable to postpone the hearing until seven o'clock. In any case he impounded Escher's passport. When Escher arrived at the police station at seven o'clock, it appeared

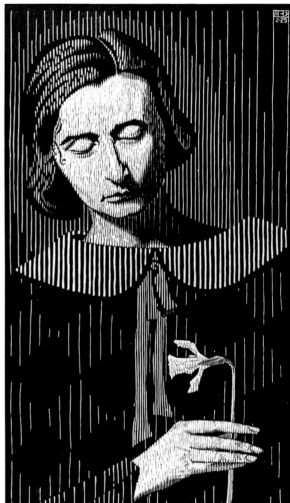

7. Sketch of Jetta

8. *Woman with Flower* (Jetta), woodcut, 1925

that the inspector was not up yet; and it was almost eight before this official put in an appearance. There was certainly a serious accusation; Escher was suspected of having made an attempt on the life of the king of Italy. The incident in question had occurred the previous day in Turin—and Escher was a foreigner, he had arrived late at night, and he had taken no part in the procession that had been held in Castrovalva during the evening. A woman had noted that he had an evil expression *(guardava male)* and had reported this to the police.

Escher was furious about this crazy story and threatened to make a row about it in Rome, with the fortunate result that he was swiftly set at liberty.

What is more, Escher made some sketches for one of his most beautiful landscape lithographs, *Castrovalva* (1930), so impressive in its breadth and height and depth. He himself has said of it, "I spent nearly a whole day sitting drawing beside this narrow little mountain path. Up above me there was a school and I enjoyed listening to the clear voices of the children as they sang their songs." *Castrovalva* is one of the first of his prints to draw high praise from several critics: "In our judgment the view over Castrovalva in the Abruzzi can be regarded as the best work Escher has so far produced. Technically it is quite perfect; as a portrayal of nature it is wonderfully exact; yet at the same time there is about it an air of fantasy. This is Castrovalva viewed from without, but even more so it is Castrovalva from within. For the very essence of this unknown place, of this mountain path, these clouds, that horizon, this valley, the essence of the whole composition is an inner synthesis, a synthesis which came into

being long before this work of art was made . . . it is on this imposing page that Castrovalva has been displayed in all its fearsome unity." (Hoogewerff, 1931)

At this period Escher was not very well known. He had held a few small exhibitions and illustrated one or two books. He hardly sold any work in its own right, and to a great extent he remained dependent on his parents. Not until many years later, in 1951, did a portion of his income derive from the production of his prints. In that year he sold 89 prints for a total of 5,000 guilders. In 1954 he sold 338 prints for about 16,000 guilders — but by this time he had become well known, not for his landscapes and town scenes but for graphic representations of the most appealing concepts that had occurred to his mind up to then.

What a pity it was that his father, the very one who had made it possible for his son to evolve so tranquilly and to reach a stage at which his work bore the stamp of exceptional originality, was never able to appreciate fully the value of this work! Escher senior died in 1939, in his ninety-sixth year. The print *Day and Night* (1938), the first great synthesis of his son's new world of thought, made scarcely any impression on him. It is significant that Escher's own sons also, who had experienced at such close quarters the creation of so many prints, have but little of their father's work hanging in their homes. Escher's comment on this was, "Well, yes, *Ripple* does hang in my son's house in Denmark, and when I see it there, I think it is quite a nice picture, really."

14

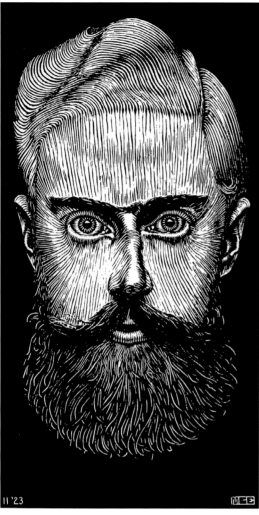

9. *Self-Portrait*, woodcut, 1923

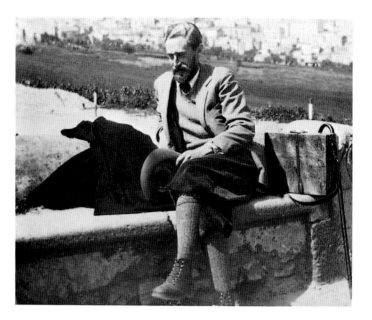

Switzerland, Belgium, The Netherlands

In 1935, the political climate in Italy became totally unacceptable to him. He had no interest in politics, finding it impossible to involve himself with any ideals other than the expression of his own concepts through his own particular medium. But he was averse to fanaticism and hypocrisy. When his eldest son, George, was forced, at the age of nine, to wear the Ballila uniform of Fascist Youth in school, the family decided to leave Italy. They settled in Switzerland, at Chateau d'Oex.

Their stay was of short duration. Two winters in that "horrible white misery of snow," as Escher himself described it, were a spiritual torment. The landscape afforded him absolutely no inspiration; the mountains looked like derelict piles of stone without any history, just chunks of lifeless rock. The architecture was clinically neat, functional, and without any flights of fancy. Everything around him was the exact opposite of that southern Italy which so charmed his visual sense. He lived there, even taking ski lessons, but he remained an outsider. His longing to be free from these frigid, angular surroundings became almost an obsession. One night he was awakened by a sound like that of the murmur of the sea . . . it was Jetta combing her hair. This awoke in him a longing for the sea. "There is nothing more enchanting than the sea, solitude on the foredeck of a little ship, the fishes, the clouds, the ever-changing play of the waves, the constant transformations of the weather." The very next day he wrote a

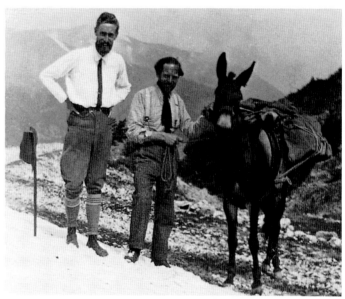

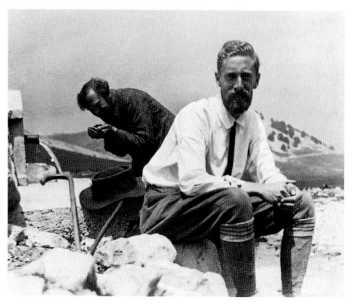

10. Travel snapshots in central Italy

11. Escher and a colleague at an exhibition both held together in Switzerland

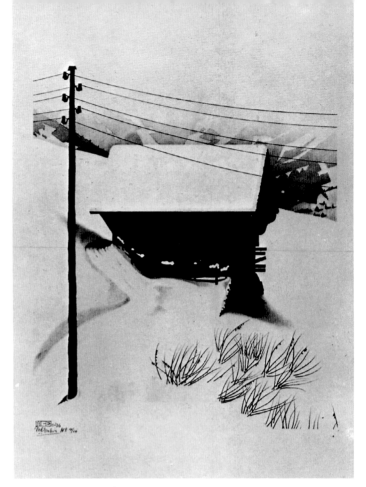

13. *Snow in Switzerland*, lithograph, 1936

12. *Marseilles*, woodcut, 1936

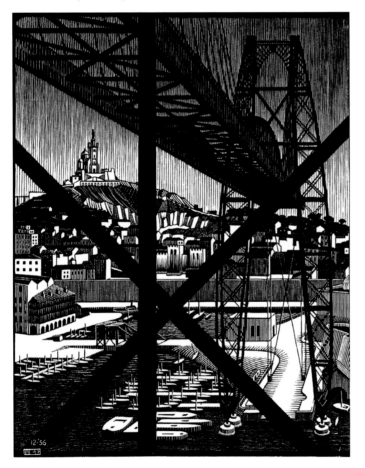

letter to the Compagna Adria in Fiume, a shipping line that arranged voyages in the Mediterranean region on cargo vessels with a limited amount of accommodation for passengers. His proposal is noteworthy: he wanted to pay the price of the cruise, for himself and his wife, with forty-eight prints; that is, four copies each of twelve prints, which he would make from sketches made en route. The shipping company's reply is even more noteworthy. They accepted his offer. Nobody in the company knew Escher, and it is even open to question whether a single member of the management had any interest in lithographs. A year later Escher made this note in his account book:

> 1936. Jetta and I made the following voyages on freighters of the Adria Line:
> I, from April 27, 1936, to May 16, 1936, from Fiume to Valencia.
> I, from June 6, 1936, to June 16, 1936, from Valencia to Fiume.
> Jetta, from May 12, 1936, to May 16, 1936, from Genoa to Valencia.
> Jetta, from June 6, 1936 to June 11, 1936 from Valencia to Genoa in exchange for the following prints which I executed during the winter of '36–'37.

Then follows a list of prints, among which we find *Porthole*, *Freighter*, and *Marseilles*. These are bracketed together with the figure of 530 guilders, and Escher has added the note: "Value of the voyages received to the tariff charges of the Adria Line, plus an amount of 300 lire which I received to cover expenses."

So there was once a period when the value of a print by Escher could be assessed according to the passenger fares of a cargo boat!

16

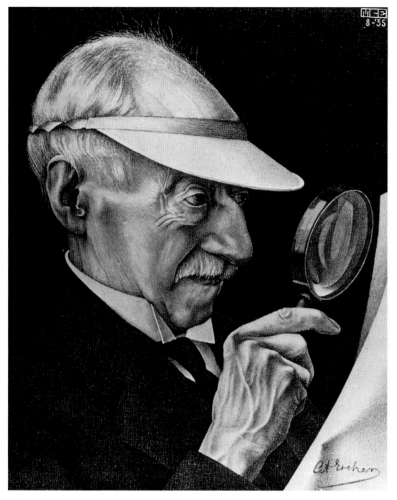

14. *Portrait of G. A. Escher*, the artist's father, in his ninety-second
year, lithograph, 1935

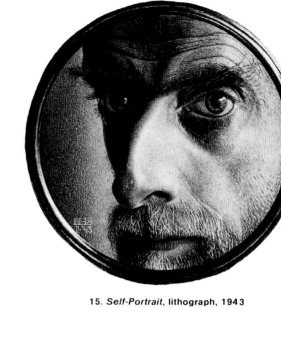

15. *Self-Portrait*, lithograph, 1943

This journeying, partly comprising travels in the south of Spain, had a profound influence on Escher's work. He and his wife visited the Alhambra in Granada, where he studied with intense interest the Moorish ornamentations with which the walls and floors were adorned. This was his second visit. This time with his wife, he spent three whole days there studying the designs and copying many of the motifs. Here it was that the foundation was laid for his pioneering work in periodic space-filling.

It was also during the course of this Spanish journey that, because of a misunderstanding, Escher found himself under arrest for a few hours. In Cartagena he was drawing the old walls that straddle the hills there. A policeman regarded this as highly suspicious; here was a foreigner making drawings of Spanish defense works . . . he must surely be a spy. Escher had to accompany him to the police station and his drawings were confiscated. Down in the harbor there sounded the hooter of the cargo boat on which Escher was traveling: the captain was giving warning of departure. Jetta went back and forth as courier between ship and police station. An hour later he was allowed to leave, but he never got his drawings back. It still made him angry when he sat discussing it thirty years later.

In 1937 the family moved to Ukkel, near Brussels, Belgium. The outbreak of war seemed imminent and Escher wanted to be near his homeland. War did come, and residence in Belgium became psychologically difficult for a Netherlander. Many of the Belgians tried to escape to the south of France, and among those who remained behind there grew a tacit resentment of "foreigners" who were eating up the diminishing food supplies.

In January, 1941, Escher moved to Baarn, Holland. The choice of Baarn was determined primarily by the good name of the secondary school there.

In spite of the none-too-friendly climate in Holland, where cold, damp, and cloudy days are dominant and where sun and warmth come as a pleasant bonus, it was in this country that the richest work of the artist quietly flourished.

Outwardly there were no more events or changes of importance. George, Arthur, and Jan grew up, completed their studies, and made their way in the world.

Escher still went on several freighter voyages in the Mediterranean region, but these did not afford any further direct inspiration for his work. However, new prints came into being with clockwork regularity. Only in 1962, when he was ill and had to undergo a serious operation, did production cease for a while.

In 1969 he made yet another print, *Snakes*, and it proved that there was no diminution in his skill; it was a woodcut which still indicated a firm hand and a keen eye.

In 1970 Escher moved to the Rosa-Spier Home in Laren, North Holland, a home where elderly artists can have their own studios and at the same time be cared for. There he died on the 27th of March, 1972.

3　An Artist Who Could Not Be Pigeonholed

Mystics?

"A woman once rang me up and said, 'Mr. Escher, I am absolutely crazy about your work. In your print Reptiles you have given such a striking illustration of reincarnation.' I replied, 'Madam, if that's the way you see it, so be it.'"

The most remarkable example of this *hineininterpretieren* (hindsighted interpretation) is surely the following: it has been said that if one studies the lithograph *Balcony* one is immediately struck by the presence of a hemp plant in the center of the print: through the enormous blow-up toward the middle Escher has tried to introduce hashish as a main theme and so point us to the psychedelic meaning of the whole work.

And yet, that stylized plant in the middle of *Balcony* has no connection with a hemp plant, and when Escher made this print, the word hashish was to him no more than a word in a dictionary. As far as any psychedelic meaning to this print is concerned, you can observe it only if you are so color-blind that black looks white and white black.

Hardly any great artist manages to escape from the arbitrary interpretations people give to his work, or from their attachment to meanings that were never, even in the slightest degree, in that artist's mind; indeed, which are diametrically opposed to what the artist had in mind. One of Rembrandt's greatest creations, a group-portrait of the Amsterdam militia, has come to be called "Night Watch" — and not only in popular parlance either, for even many art critics base their interpretations of the picture on a nocturnal event! And yet Rembrandt painted the militia in full daylight — indeed, in bright sunshine, as became obvious when the centuries-old yellowed and browning layers of smoke-stained varnish had been removed.

Quite possibly the titles that Escher gave to some of his prints, or for that matter the very subjects that he used, have given rise to abstruse interpretations quite unconnected with the artist's intentions. For this reason he himself regards the titles *Predestination* and *Path of Life* as being really too dramatic, as is also the death's-head in the pupil of the print *Eye*. As Escher himself

has said, one must certainly not try to read any ulterior meaning into these things. "I have never attempted to depict anything mystic; what some people claim to be mysterious is nothing more than a conscious or unconscious deceit! I have played a lot of tricks, and I have had a fine old time expressing concepts in visual terms, with no other aim than to find out ways of putting them on to paper. All I am doing in my prints is to offer a report of my discoveries."

Even so, it remains a fact that all of Escher's prints do have something strange, if not abnormal, about them, and this intrigues the beholder.

This has been my own experience. Nearly every day for a number of years I have looked at *High and Low*, and the more I have delved into it the more strangely has the lithograph affected me. In his book *Graphic Work*, Escher goes no further than a bald description of what anyone can see for himself. ". . . if the viewer shifts his gaze upward from the ground, then he can see the tiled floor on which he is standing, as a ceiling repeated in the center of the composition. Yet at the same time its function there is that of a floor for the upper portion of the picture. At the very top the tiled floor is repeated once again, but this time only as a ceiling." Now this description is so obvious and so straightforward that I said to myself, "In that case, how does all this fit together, and why are all the 'vertical' lines curved? What are the basic principles hiding behind this print? Why did Escher make it?" It was just as though I had been vouchsafed a glimpse of the front surface of a complicated carpet pattern, and the very pattern itself had given rise to the query, "What does the reverse side look like? How is the weave put together?" Because the only person who could enlighten me on this point was Escher himself, I wrote and asked him for an explanation. By return mail I received an invitation to come along and talk it over with him. That was in August, 1951, and from then onward I visited him regularly. He was extremely happy to be questioned on the background of his work and about the why and the wherefore; he always showed great interest in the articles which I wrote on the subject. When I was preparing this book in 1970, I had the privilege of spending a few hours with him each week throughout practically the whole year.

At that period he had only just recovered from a serious opera-

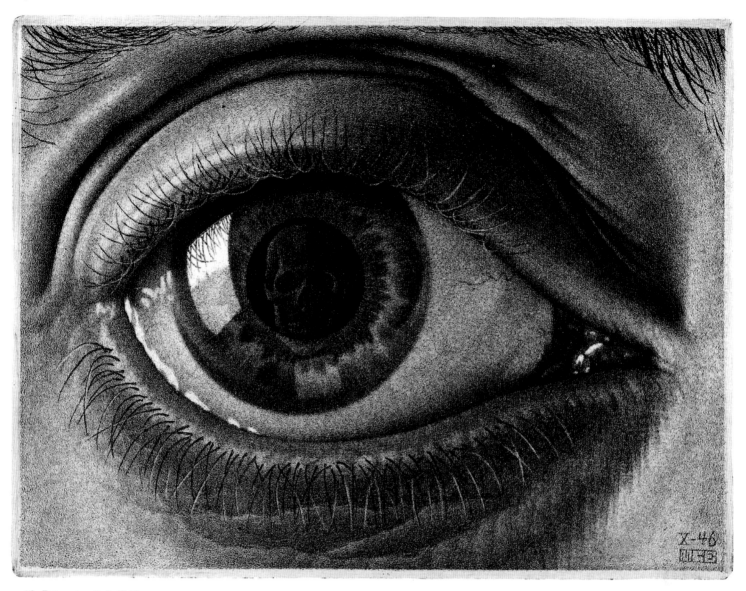

16. *Eye*, mezzotint, 1946

tion and sometimes these conversations were extremely tiring for him. Yet he wanted to go through with them, and he felt a need to explain how it was that he had come to produce his prints, and to expound their origin with the help of the many preparatory studies for them, which he still kept.

Art Critics

Until recently almost all Dutch print collections had omitted to build up any fair-sized section of Escher's work. He was simply not recognized as an artist. The art critics could not make head or tail of him, so they just ignored his work. It was the mathematicians, crystallographers and physicists who first showed great interest. And yet . . . anyone who is willing to approach his work without preconceived ideas will derive enjoyment from it, whereas those whose only approach is through commentaries

provided by art historians will discover that these latter are no more than a hindrance.

Now that the tide has turned and the public at large seems captivated by Escher's work, official art criticism is bringing up the rear and showing an interest. It really was quite pathetic to see how, on the occasion of the great retrospective exhibition at The Hague, held to commemorate Escher's seventieth birthday, an attempt was made to establish historical parallels. It did not succeed; Escher stands apart. He cannot be slotted in, for he has totally different aims from those of his contemporaries.

It is not fitting to ask of a modern work of art what its meaning is supposed to be. It is presumed that there *is* meaning and that the questioner is therefore an ignoramus. Far better to keep one's mouth shut about it, or to confine oneself to such remarks as "A nice bit of carving," "A clever piece of work," "Isn't that fascinating?" "It does something to one, doesn't it?" and so on.

It is quite a different story with Escher's work. Perhaps this is the reason for his own reluctance to reply when asked what his place is in the present-day world of art. Before 1937, a reply would not have been so difficult to give, for at that time his work was, generally speaking, entirely pictorial. He sketched and drew whatever things he found to be beautiful and did his best to depict them in woodcuts, wood engravings, and lithographs.

Had he continued in this vein he would have attained a comfortable place among the graphic artists of his time. As far as work of this period is concerned one would have no trouble in writing about an artist whose landscapes were at once poetic and attractive, who was capable of producing portraits with a remarkably literal likeness (although, apart from himself, he made portraits only of his father, his wife, and his children). He was clearly an artist with a mastery of technique and great virtuosity. The whole of that well-worn jargon with which the art critic normally tries to introduce an artist's work to the general public could have been easily and aptly used when writing about all his work.

After 1937 the pictorial became a matter of merely secondary importance. He was taken up with regularity and mathematical structure, by continuity and infinity and by the conflict which is to be found in every picture, that of the representation of three dimensions in two. These themes haunted him. Now he was treading paths which no others had yet trodden and there was an infinity of discoveries to make. These themes have their own underlying principles which have to be ferreted out and then obeyed. Here chance holds no sway; here nothing can come into being in any way other than that in which it does come. The pictorial is an extra bonus. From this time onward art criticism can get no purchase on his work. Even a critic who is very sympathetic expresses himself with a certain skepticism: "The question which continually comes up in regard to Escher's work is whether his more recent efforts can come under the heading of art . . . he usually moves me deeply, yet I cannot possibly describe all his work as good. To do so would be ridiculous, and Escher is wise enough to realize this." (G. H. 'sGravesande, *De Vrije Bladen*, The Hague, 1940.) It is worthy of note that this was said about work which we have now come to hold in the highest esteem. This same critic went on to say, "Escher's birds, fishes, and lizards defy description; *they call for a mode of thought which is only to be found among few people."*

Time has proved that 'sGravesande underestimated his public, or maybe he was thinking only of that tiny group of people who faithfully tramp the galleries and the exhibitions, and never miss a single concert.

It is astonishing how Escher himself, apparently unmoved by the criticism of his work, forged ahead on his chosen way. His work was not selling well, official art criticism passed him by; even his closest associates thought little of it, and yet he still went on making pictures of the things that possessed his mind.

Cerebral

To those who regarded art as the expression of emotions, the whole of Escher's post-1937 work will be a closed book. For it is cerebral both in aim and in execution, although this does not take away from the fact that, alongside the message, alongside the intellectual content which he is aiming to display, the thrill of discovery comes over also, often in the panache (though not sentimental) of the picture. Yet all the critics who admire Escher try to avoid using the word cerebral. In music, and even more so in the plastic arts, this word is almost synonymous with antiart. It really is rather odd that the intellectual element should be so rigorously excluded. The word cerebral hardly ever plays any part in dissertations on literature, and it is certainly not a term which indicates disapproval or rejection. There it is quite obviously mainly a question of getting a thought content across, but of course in such a form as to fascinate, and to stir the emotions. In my view, it is irrelevant whether a work is called cerebral or not. The simple fact is that at the present time, artists are not sufficiently concerned with thought content to be able to draw on it for inspiration for their work. What matters most is that the artist should be able to give unique form to whatever it is that has taken hold of his mind, so that which cannot be expressed in words will come across pictorially. In Escher's case these ideas center on regularity, structure, continuity, and an inexhaustible delight at the way in which spatial objects can be represented on a flat surface. Such ideas he cannot put into words but he certainly can make them explicit in pictures. His work is cerebral to a high degree in the sense that it is of the mind—a pictorial representation of intellectual understanding.

The most important function of an art critic is to talk about a work in such a way as to help the viewer make contact with it, so to direct his attention to it that the work of art itself begins to speak to him.

With Escher's work, in one respect the critic would seem to have a remarkably easy time of it. He has to give an accurate description of what is to be seen in the print; he does not have to display his own subjective emotions. And for a preliminary acquaintance this is more or less all that is needed to get almost any viewer close enough to the print for the "understanding" of the print to be coupled with the excitement of discovery. It was this excitement that formed the kernel of Escher's own inspiration, and the whole aim of the print has been to transmit the excitement his own discovery brought him.

However, most of the prints have something more than this to offer. Every one of Escher's prints is (albeit temporarily) an end phase. Those who wish to understand and enjoy this end phase in any but a purely superficial way will have to be confronted with the total context. His work bears the character of a quest. He is using the print to make a report, a statement of provisional findings. This is where the critic's task becomes more difficult, for now he has to delve into the general underlying problem postulated by the print, and show how the print fits into it. And if the solution arrived at is on a constructional level, then he will have to throw some light on the mathematical background of the print, through a study of the many preparatory sketches that Escher made.

If he does this then he will help the viewer to see the print in all the fire of its creation, thus adding a new dimension to his viewing. Only then can the print become a living experience, its richness and variety harmonizing with its original inspiration.

Speaking of this inspiration, Escher has said, "If only you knew the things I have seen in the darkness of night . . . at times I have been nearly demented with wretchedness at being unable to express these things in visual terms. In comparison with these thoughts, every single print is a failure, and reflects not even a fraction of what might have been."

4 Contrasts in Life and Work

Duality

Escher's predilection for contrast of black and white is paralleled by his high regard for dual concepts in thought.

Good cannot exist without evil, and if one accepts the notion of God then, on the other hand, one must postulate a devil likewise. This is balance. This duality is my life. Yet I'm told that this cannot be so. People promptly start waxing abstruse over this sort of thing, and pretty soon I can't follow them any further. Yet it really is very simple: white and black, day and night — the graphic artist lives on these.

In any case it is obvious that this duality underlies his whole character. Over against the intellectuality of his work and the meticulous care that goes into the planning of it, there is the great spontaneity of his enjoyment of nature's beauty, of the most ordinary events of life, and of music and literature. He was very sensitive and his reactions were emotional rather than intellectual. For those who did not know him personally perhaps this can best be illustrated with a few extracts from the many letters he has written to me.

October 12, 1956
. . . meanwhile I am annoyed that my writing should be so shaky; this is due to tiredness, even in my right hand in spite of the fact that I draw and engrave with my left. However, it seems that my right hand shares so much in the tension that it gets tired in sympathy.

The refraction effect of the prisms is so amazing that I should like to try my hand at one or two. [I had sent him a couple of prisms and had drawn his attention to the pseudoscopic effect that can be achieved with them.] As far as my experiments with them have gone, the most striking effect is that of the way in which the far distance comes forward. The farthest branches, half in the mist, suddenly appear smack in front of the tree close at hand like a magic haze. How is it that a phenomenon like this should move us so? Undoubtedly a good deal of childlike wonder is necessary.

And this I do possess in fair quantity; wonderment is the salt of the earth.

November 6, 1957
To me the moon is a symbol of apathy, the lack of wonderment which is the lot of most people. Who feels a sense of wonder any more, when they see her hanging there in the heavens? For most people she is just a flat disc, now and then with a bite out of her, nothing more than a substitute for a street lamp. Leonardo da Vinci wrote of the moon, *'La luna grave e densa, come sta, la luna?'* *Grave e densa* — heavy and compact one might translate it. With these words Leonardo gives accurate expression to the breathless wonder that takes hold of us when we gaze at that object, that enormous, compact sphere floating along up there.

September 26, 1957
Home once more, after a six-and-a-half-week voyage by freighter in the Mediterranean. Was it a dream, or was it real? An old steamship, a dream-ship, bearing the name of *Luna*, bore me, its passenger bereft of will, right beyond the sea of Marmora to Byzantium, that absolutely unreal metropolis with its population of one and a half million Orientals swarming like ants . . . then on to idyllic strands with their tiny Byzantine churches among the palms and agaves. . . .

I am still under the spell of the rhythmic dreamswell which came to me under the sign of the comet Mrkos (1957d). For a whole month and more I followed it, night after night, standing on the pitch-dark deck of the *Luna* . . . as in the glittering heavens, with its slightly curved tail, it displayed itself fiercely and astonishingly . . .

December 1, 1957
As I write, there, immediately in front of my large studio window I can watch a fascinating performance, played out by a highly proficient troupe of acrobats. I have stretched a wire for them a few feet away from my window. Here my acrobats do their balancing act with such consummate skill, and get such enjoyment out of their tumbles that I can scarcely keep my eyes off them.

My protagonists comprise coaltits, bluetits, marshtits, long-tailed tits, and crested tits. Every now and then they are chased away by a pair of fierce nuthatches (blue back and orange belly), with their stubby supporting tails and woodpecker type of beak. The shy little robin redbreast (although as intolerant and selfish as any other individual among his own family) can muster up only enough courage to peck the odd seed from time to time, and clears off the moment a tit lays claim to the bird table. I have not seen the spotted woodpecker yet; normally he does not arrive until later in the winter season. The simple, innocent blackbirds and finches stay on the ground and content themselves with the grains that fall down from above. And quite an amount does fall; the nuthatches especially are as rough, ill-mannered and messy as any pirate; so the seed comes raining down on the ground when they are tucking in on the bird table. Every year the tits have to go through the process of learning how to hang head downward so as to peck the threaded peanuts. To start with they always attempt to remain balanced, with flapping wings about the swinging peanut pendant. But it seems that it is impossible for them to peck while flapping or to flap while pecking. And so at last they make the discovery that the best position for pecking at peanuts is hanging upside down.

Fellow Men

My work has nothing to do with people, nor with psychology either. I have no idea how to cope with reality; my work does not touch it. I'm sure this is all wrong . . . I know you are supposed to rub shoulders with folk, and to help them so that everything turns out for the best for them. But I do not have any interest in humanity; I have got a great big garden for the express purpose of keeping all these folks away from me. I imagine them breaking in and shouting, "What's the big idea of this huge garden?" They

are quite justified of course, but I cannot work if I find them there. I am shy and I find it very difficult to get along with strangers. I have never enjoyed going out. . . . With my work one needs to be alone. I can't bear to have anybody go past my window. I shun both noise and commotion. I am psychologically incapable of making a portrait. To have someone sitting there right in front of me is inhibiting.

Why have we got to have our noses rubbed in all this wretched realism? Why can't we just enjoy ourselves? Sometimes the thought comes to me: "Ought I to be going on like this? Is my work not serious enough? Fancy doing all this stuff, while on TV there is this terrible Vietnam affair . . ."

I really don't feel all that brotherly. I don't have much belief in all this compassion for one another. Except in the case of the really good folk; and they don't make a song about it.

All these rather cynical utterances come from an interview with a journalist from the magazine *Vrij Nederland.* They could be supplemented by many comments taken from personal conversations, ranging from the deceit that is practiced by those who persist in talking people into having religious feelings, through Escher's opinion that all men are at each other's throats and that the strongest always wins, to his views on suicide (viz., if you have had enough you ought to be able to decide for yourself whether or not you want to disappear).

When Escher gave vent to these thoughts he meant them from the bottom of his heart, but here too there emerges a remarkable dichotomy. In his dealings with others he was a truly gentle and kindly person who could not possibly do ill to any man nor dream of harming anyone.

In the same interview in which he expressed his disgust over the fact that there are still people who sacrifice their lives to a false idea by living in monasteries, he showed me with great enthusiasm a newspaper article containing the report of a nun who had dedicated herself entirely to the relief of suffering in Vietnam.

Escher never had money troubles, but if the need arose his father would always give him financial help. When, after 1960, he began to earn large sums for his work, he showed no interest whatsoever in the money. He continued to live frugally, just as he always had, and that means *very* frugally, not far short of asceticism. It gave him pleasure to think that his work should sell so well, and he regarded success as a sure sign of appreciation. The fact that his bank balance was increasing as a result left him cold. "At the moment I am able to sell an incredible amount of my work. If I had assistants in my studio I could be a multimillionaire. They could spend the whole day running off woodcuts to satisfy the demand. I have no intention of doing any such thing; I wouldn't dream of it!"

"That would be no better than a bank note; you just print it off and get so much cash for it." In a personal interview he said, "Do you realize I worked for years on a design for the 100-guilder note, on commission from the Netherlands Bank? That did not come to anything, but nowadays I'm turning out my own five-hundred-dollar bills by my own primitive method!"

When, in later years, he became less financially dependent on his parents and his work suddenly started to bring in a great deal of money, he went on living frugally and gave away much of his earnings to help others who were in difficulties. And all this in spite of his notion that every man ought to fend for himself and that the sufferings of others were really no concern of his.

This ambivalence is a permanent part of his character. Perhaps one can explain the conjunction of such contrasting elements in the one personality by Escher's aversion to all compromise and by his thirst for honesty and clarity. He was aware of his lack of involvement, and that he therefore missed out on a certain something which might have helped him to be more at ease with his fellow men. On the other hand he was never willing to put up any pretense. He was far too absorbed in his work and in those

ideals which are exclusively connected with the sphere of his art to be able to concern himself with the weal and woe of the great family of man. Because he was so well aware of this, and indeed sad about it, he could avoid the admission that the sufferings of others did not concern him. Nevertheless, when he did feel obliged to take to heart the lot of others, he refused to fall back on words only, but helped with deeds.

All this may give the impression that he had no need of any fellow feeling for his work, or that positive and negative criticism alike left him cold. It is true that he found his own direction and style, in spite of the minimal interest in it which he had to endure. But the fact is that his entire way of working was oriented toward widespread distribution. He made no once-for-all prints. Nor did he ever limit the number of impressions. He printed off slowly and carefully, and then only as the requests came in. And when I asked him if I might have six full-sized prints published, so that they could be offered at cost price to young readers of the mathematical magazine *Pythagoras,* he did not have the slightest objection. When the bibliophile De Roos Foundation asked him to write and illustrate a short book, he wrote to me thus:

. . . it has a magnificently precious cover (in my opinion far too splendid, but then so are all these half-baked bibliographies), in a limited edition of 175 copies, destined exclusively for members of De Roos — who have to pay through the nose for the privilege. This whole preciousness of theirs is quite foreign to my nature and I thoroughly deplore the fact that the majority of the copies will come into the hands of people who set more store by the form than by the contents and who will read little or nothing of the text. . . . I always feel a little scornful and aggravated when books are brought out in a limited edition for a so-called select group.

Escher was very proud when Professor Hugh Nichol, in 1960, wrote an article about his work and entitled it *Everyman's Artist.*

It affected him deeply when people whom he knew to have little money purchased his prints: "They save up their precious pennies for them and that speaks volumes; I only hope they get inspiration in return." And happily and tenderly he once showed me a letter he had received from a group of young Americans; underneath a drawing, they had written, "Mr. Escher, thank you for being."

It is sometimes claimed that Escher was a difficult man to get on with; yet I can call to mind very few men more friendly than he. But he resented being approached by people who had no real appreciation of his work, who simply wanted to be able to say that they had once spoken to Escher, or people who wanted to make use of him. He regarded his time as being too valuable to waste on sycophants.

His prints and his work took precedence over everything else. Yet he had the capacity to look at it all from the angle of an outsider, and in relation to the whole output of mankind. While he was actually engaged in making a print, it was to him the most important thing in all the world, and during this time he would not tolerate the slightest criticism, even from the most intimate friends. This would simply have served to take the heart out of any further work on it. Yet once the print reached its final form, then he himself would adopt an attitude of extreme criticism toward it and become open to criticism from others. "I find my work to be the most beautiful and the most ugly!"

His own work was never found in his house, or even in his studio; he could not bear to have it around him.

What I produce is not anything very special. I can't understand why more people don't do it. People ought not to get infatuated by my prints; let them get on and make something for themselves; surely that would give them more enjoyment.

While I am on with something I think I am making the most beautiful thing in the whole world. If something comes off well, then I sit there in the evening gazing lovingly at it. And this love is far greater than any love for a person. The next day, one's eyes are opened again.

18. Jesserun de Mesquita 19. Print by de Mesquita, trampled by a German army boot

Escher and Jesserun de Mesquita

It is characteristic of Escher and of his faithfulness and gratitude to his teacher in the art of the woodcut, Jesserun de Mesquita, that he always kept a photograph of his teacher pinned on a cupboard door in his studio. When I asked him if I might have a reproduction made of it, he agreed so long as he could have it back within a week. Escher had a similar attachment to one of Mesquita's prints which he had found in the deserted house after Mesquita had been taken away to a German concentration camp. The words which Escher wrote on the back of this print, in 1945, testify, with his usual precision, to an underlying intensity of emotion:

"Found at the end of February, 1944 at the home of S. Jesserun de Mesquita, immediately behind the front door, and trampled on by German hob-nailed boots. Some four weeks previously, during the night of January 31 to February 1, 1945, the Mes-

quita family had been hauled out of bed and taken away. The front door was standing open when I arrived at the end of February. I went upstairs to the studio; the windows had been smashed and the wind was blowing through the house. Hundreds of graphic prints lay spread about the floor in utter confusion. In five minutes I gathered together as many as I could carry, using some pieces of cardboard to make a kind of portfolio. I took them over to Baarn. In all there turned out to be about 160 prints, nearly all graphic, signed and dated. In November, 1945 I transferred them all to the Municipal Museum in Amsterdam, where I plan to organise an exhibition of them, along with such works of de Mesquita as are already being kept there, and those in the care of D. Bouvy in Bussum. It must now be regarded as practically certain that S. Jesserun de Mesquita, his wife and their son Jaap all perished in a German Camp.

November 1, 1945. M. C. Escher."

5 How His Work Developed

Themes

Viewing Escher's work as a whole, we find that, in addition to a number of prints which have primarily southern Italian and Mediterranean landscape as their theme, and which were nearly all made prior to 1937, there are some seventy prints (post-1937) with a mathematical flavor.

In these seventy prints Escher never repeats himself. He indulged in repetition only if he was working on a commission. From his free work one can see that from first to last he is engaged in a voyage of discovery and that every print is a report on his findings. In order to gain an insight into his work one must not only make a careful analysis of each separate print but also take all seventy prints and read them as a logbook of Escher's voyage of discovery. This voyage spans three areas—that is to say, the three themes that can be discerned among the mathematical prints.

1. *Spatial structure.* Viewing his work as a whole, one can observe that even in the pre-1937 landscape prints it was not so much the picturesque that was being aimed at, but rather, structure. Wherever this latter feature was almost entirely lacking, as in ruins, for instance, Escher had no interest in the scene. In spite of his ten-year sojourn in Rome, all among the remains of an ancient civilization, he scarcely devoted a single print to it, and visits to Pompeii have left no trace whatsoever in his work.

After 1937 he no longer dealt with spatial structure in an analytical way. He no longer left space intact just as he found it but produced a synthesis in which differing spatial entities came together in one, *and in the same* print, with compelling logic. We see the results of this in those prints where different structures interpenetrate. Attention to strictly mathematical structures reaches its height at a later stage and originates in his admiration for the shapes of crystals. There are three categories of this spatial structure theme:

 a. Landscape prints.
 b. Interpenetration of different worlds.
 c. Abstract, mathematical solids.

2. *Flat surface structure.* This begins with an interest in regular tessellations (i.e., identical or graduated surface divisions),

stimulated in particular by his visits to the Alhambra. After an intensive study, by no means an easy task for a nonmathematician, he worked out a whole system for such periodic drawings.

Finally the periodic drawing turns up again in his approaches to infinity, although in this case the surface is filled up not with congruent figures but with those of similar shape. This gives rise to more complicated problems and it is not until later that we find this kind of print appearing.

Thus flat surface structure studies can be basically divided into these categories:

 a. Metamorphoses.
 b. Cycles.
 c. Approaches to infinity.

3. *The relationship between space and flat surface in regard to pictorial representation.* Escher found himself confronted at an early stage with the conflicted situation that is inherent in all spatial representation—i.e., three dimensions are to be represented on a two-dimensional surface. He gave expression to his amazement about this in his perspective prints.

He subjects the laws of perspective, which have held sway in spatial representation ever since the Renaissance, to a critical scrutiny, and, having discovered new laws, illustrates these in his perspective prints. The suggestion of three dimensions in flat-picture representation can be taken to such lengths that worlds which could not even exist in three-dimensional terms can be suggested on a flat surface. The picture appears as the projection of a three dimensional object on a flat surface, yet it is a figure that could not possibly exist in space.

In this last section too we find three groups of prints:

 a. The essence of representation (conflict between space and flat surface).
 b. Perspective.
 c. Impossible figures.

Chronology

Careful analysis of the post-1937 prints shows that the different themes appear at different periods. That this fact has not been

1. Spatial structure

Landscape prints **Interpenetration of different worlds** **Abstract, mathematical solids**

Town in Southern Italy

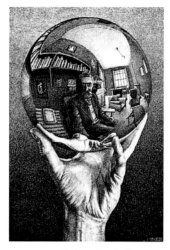

Hand with Reflecting Sphere

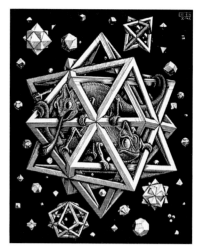

Stars

2. Flat surface structure

Metamorphoses **Cycles** **Approaches to infinity**

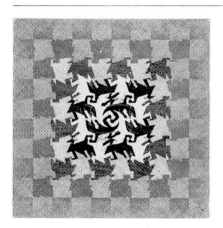

Development I

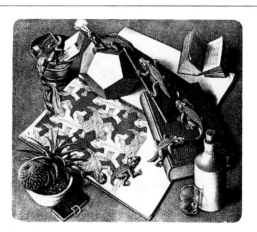

Reptiles

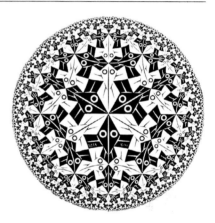

Circle Limit I

3. Pictorial representation of the relationship between space and flat surface

The essence of representation **Perspective** **Impossible figures**

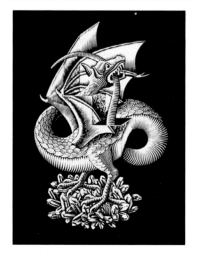

Dragon

Depth

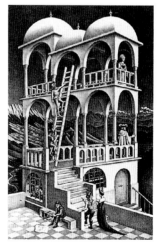

Belvedere

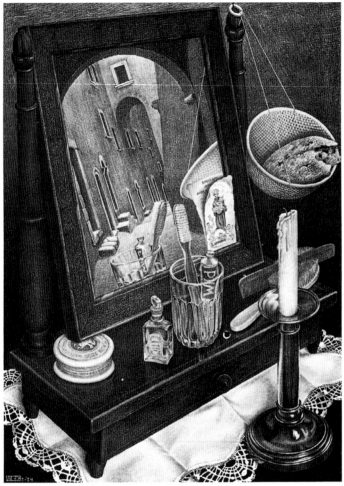

23. *Still Life with Mirror*, lithograph, 1934

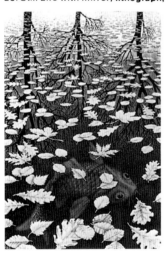

24. *Three Worlds*, lithograph, 1955

noticed sooner is probably due to the difficulty of analyzing the prints and to the fact that in any given period a number of themes occupied Escher's mind simultaneously. Moreover, each period had its time of predevelopment, and so did not announce its arrival very clearly; what is more, a particular theme might very well turn up again even when the time of full attention to that theme had passed.

We shall try to assign years to the various periods, marking their beginning and end with certain prints. We shall also try to state which print, in our view, may be regarded as the highest point of the period in question.

1922–1937 Landscape Period

Most of these prints depict landscapes and small towns in southern Italy and the Mediterranean coastal areas. Apart from that, there are a few portraits and some plants and animals. A high point was undoubtedly reached with *Castrovalva* (1930), a large-sized lithograph of a small town in the Abruzzi. A new line of thought was showing itself in 1934, in the lithograph *Still Life with Mirror*, in which the mingling of two worlds was achieved by the reflection in a shaving mirror. This theme, which can be seen as a direct continuation of the landscape prints, is the only one which is not tied to any particular period. The last print of this type, which incidentally we might count as the high point, and which appeared in 1955, was *Three Worlds*, a lithograph full of calm, autumn beauty; and the unsuspecting viewer can scarcely realize what a triumph it was for Escher to succeed in representing here three different worlds in the one place, and so realistically too.

1937–1945 Metamorphoses Period

The print which heralds this period, *Metamorphosis I* (1937), shows the gradual transformation of a small town, through cubes, to a Chinese doll.

It is not easy to point to any high-water mark in this period. I will pick out *Day and Night* (1938) for this. All the characteristics of the period are to be found in it; it is a metamorphosis and at the same time a cycle, and, what is more, we can observe the change-over from two-dimensional forms (via ploughed fields) to three-dimensional ones (birds). The final metamorphosis-cycle print of this period *(Magic Mirror)* appeared in 1946.

The essence of representation that is already implicitly enunciated in the first of the metamorphosis prints (i.e., transformation from the two-dimensional to the three-dimensional) is explicitly stated only at the latter end of the period, in the print *Doric Columns* (1945). In 1948 there came the most beautiful print, *Drawing Hands*, and the very last print on this theme was made in 1952 *(Dragon)*. These last-mentioned prints extend chronologically far into the following period.

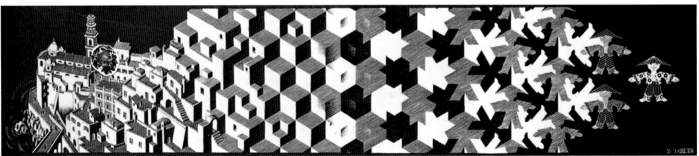

25. *Metamorphosis I*, woodcut, 1937

With the making of *St. Peter's, Rome* in 1935 and the *Tower of Babel* in 1928, all Escher's special interest in unconventional standpoints came to the fore. Already it was not so much a question of what one was trying to depict in the picture but rather of the idiosyncracies of the perspective that was being used in it. But it was in 1946 that the great quest really began into the regions beyond the traditional rules of perspective. The mezzotint *Other World* (1946), though not wholly successful as a print, introduced a point which was simultaneously zenith, nadir, and vanishing point. The best example of this period is undoubtedly *High and Low* (1947), in which in addition to a relativity of vanishing points we note bundles of parallel lines depicted as convergent curves.

At the close of this period there is a return to traditional perspective *(Depth)* when Escher is aiming at suggesting the infinity of space.

During this same period Escher's interest in straightforward geometrical spatial figures, such as regular multisurfaces, spatial spirals, and Moebius strips, came to the fore. The origin of this interest is to be found in Escher's delight in natural crystal shapes. His brother was a professor of geology and wrote a scientific handbook on minerology and crystallography. The first print was *Crystal* (1947). *Stars* (1948) is almost certainly the high point. In 1954 the last of the prints entirely devoted to stereometric figuration *(Tetrahedral Planetoid)* was made.

We do meet with a few more spatial figures in later prints, but then only as incidental ornamentation, such as the figures standing on the corner towers in *Waterfall* (1961).

In spite of the fact that they appeared at a later stage, the Moebius prints really belong to this period. Such figures were completely unknown to Escher at the time, but as soon as a mathematician friend of his pointed them out to him, he used them in prints, almost as if he wanted to make good an omission.

1956-1970 Period of Approaches to Infinity

This period started off in 1956 with the wood engraving *Smaller and Smaller I*. The colored woodcut *Circle Limit III* (1959) was, even in his own opinion, much the best print dealing with this subject. Escher's very last print, in the year 1969 *(Snakes)*, is an approach to infinity.

In this period also the so-called impossible figures appeared, the first being *Convex and Concave* (1955) and the last *Waterfall* (1961).

The cleverest and most impressive print of this period, without doubt a highlight in the whole of Escher's work, is *Print Gallery* (1956). If one were to apply to it the same aesthetic standards as to art of an earlier time, then one could find a great deal of fault with it. But what applies to every one of Escher's prints applies here: an approach through the senses would miss entirely the deepest intentions of the artist. Escher's own opinion was that in *Print Gallery* he had reached the furthest bounds of his thinking and of his powers of representation.

Prelude and Transition

The remarkable revolution that took place in Escher's work was between 1934 and 1937. This transition definitely coincided with a change of domicile, although it is in no way explained by it. As long as Escher remained in Rome he continued to be entirely oriented toward the beauty of the Italian landscape. Immediately after his move, first to Switzerland, and then to Belgium

26. *Crystal*, mezzotint, 1947

27. *Moebius Strip II*, wood engraving, 1963

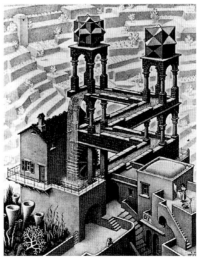

28. *Waterfall*, lithograph, 1961

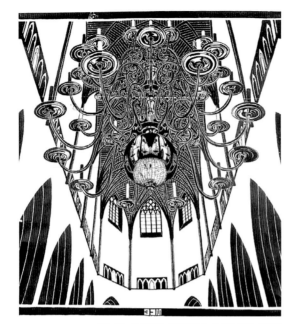

29. *St. Bavo's, Haarlem*, India ink, 1920

30. *Self-Portrait in Chair*, woodcut

31. *Sky and Water I*, woodcut, 1938

and Holland, an inward change took place. No longer could he find the same inspiration in the outer visual world, but rather in mental constructions which can be expressed and described only mathematically.

It is obvious that no artist can experience such an abrupt transformation out of the blue. Had there not been a predisposition for it, the mathematical turn in his work could never have come about. However, it would be wrong to look for this predisposition in any scientifically mathematical interest. Escher bluntly declared to all who were willing to listen that he was a complete layman in the sphere of mathematics. He once said in an interview, "I never got a pass mark in math. The funny thing is I seem to latch on to mathematical theories without realizing what is happening. No indeed, I was a pretty poor pupil at school. And just imagine—mathematicians now use my prints to illustrate their books. Fancy me consorting with all these learned folk, as though I were their long-lost brother. I guess they are quite unaware of the fact that I'm ignorant about the whole thing."

And yet, this is indeed the truth. Anyone who tried to get a mathematical statement out of Escher, at any rate one which goes beyond what the merest secondary-school student knows, had the same sort of disappointment as that experienced by Professor Coxeter, who was fascinated by Escher's work because of its mathematical content. He took the artist along to attend one of his lectures, convinced that Escher would surely be able to understand it. Coxeter's lecture was about a subject that Escher had used in his prints. As might have been expected, Escher did not understand a thing about it. He had no use for abstract ideas, even though he agreed that they could be very brilliant, and admired anyone who felt at home among abstractions. But if an abstract idea had a point of contact with concrete reality then Escher was able to do something about it, and the idea would promptly take on a concrete form. He did not work like a mathematician but much more like a skilled carpenter who constructs with folding rule and gauge, and with solid results in mind.

In his earliest work, even when he was still at college in Haarlem, we can detect a prelude, although these recurring themes will be revealed only to those who really do know his later work. He did a large pen-and-ink drawing in St. Bavo's Cathedral, in 1920, on a sheet measuring more than a meter square. An enormous brass candelabrum is, so to speak, imprisoned in the side aisles of the cathedral. But in the shining sphere underneath the candelabrum we can see the whole cathedral reflected, and even the artist himself! Here, already, is an involvement with perspective and with the intermingling of two worlds by means of a convex reflection.

Self-portraits are usually made in front of a mirror, but in one of the self-portraits of this period (a woodcut) the mirror, although obviously being used, is invisible. Escher has placed the mirror at an angle at the edge of the bed, and so achieves an unusual viewpoint for this portrait.

A woodcut made in 1922, very early in his career, shows a large number of heads filling the entire surface. It was printed by the repetition of a single block on which eight heads had been cut, four of them right-side up and four upside-down. This sort of thing was not in the program of his teacher, de Mesquita. Both the complete filling up of the surface and the repetition of theme by making imprints of the same block next to each other were done on Escher's own initiative.

After he had visited the Alhambra for the first time, we can see a new attempt to make use of periodic surface-division. A few sketches of this, together with a few textile-design prints, have survived from 1926.* They are somewhat labored and awkward efforts. Half of the creatures are standing on their heads, and the little figures are primitive and lacking in detail. Surely these attempts serve to show very clearly how difficult any exploration in this field was, even for Escher!

After a second visit to the Alhambra, in 1936, and the subsequent systematic study of the possibilities of periodic surface-division, there appeared, in quick succession, a number of prints of outstanding originality: in May, 1937, *Metamorphosis I;* in November *Development;* and then in February, 1938, the well-known woodcut *Day and Night,* which immediately made a vital impact on those who admired Escher's work and which, from that moment onward, was one of the most sought-after of his prints. In May, 1938, the lithograph *Cycle* appeared, and in June more or less the same theme as in *Day and Night* was taken up again, in *Sky and Water I.*

The south Italian landscape and town scenes had now disappeared for good. Escher's mind was saturated with them and his portfolios were filled with hundreds of these sketches. He was to make use of them later, not as main subjects for prints, but rather as filling, as secondary material for prints with totally different types of content. In 1938 G. H. 'sGravesande devoted an article to this new work, in the November number of *Elsevier's Monthly Magazine:* "But the never-ending production of landscapes could not possibly satisfy his philosophical mind. He is in search of other objectives; so he makes his glass globe with the portrait in it a most remarkable work of art. A new concept is forcing him to make prints in which his undoubted architectural propensities can join forces with his literary spirit. . . ." Then there follows a description of the prints made in 1937 and 1938.

At the end of an article written, once again, by 'sGravesande, we read, "What Escher will give us in the future—and he is still a comparatively young man—cannot be predicted. If I interpret things aright, then he is bound to go beyond these experiments and apply his skill to industrial art, textile design, ceramics, etc., to which it is particularly suited." True enough—no prediction could be made, by 'sGravesande or even by Escher himself.

Escher's new work did not result in making him any more widely known; official art criticism passed him by entirely for ten whole years, as we have already seen. Then in the February, 1951, issue of *The Studio,* Marc Severin published an article on Escher's post-1937 work. At a single blow, this made him widely known. Severin referred to Escher as a remarkable and original artist who was able to depict the poetry of the mathematical side of things in a most striking way. Never before had so comprehensive and appreciative an appraisal of Escher's work been made in any official art magazine, and this was heart-warming for the fifty-three-year-old artist.

An even more outspoken and perceptive critique appeared in an article by the graphic artist Albert Flocon, in *Jardin des Arts* in October, 1965.

> His art is always accompanied by a somewhat passive emotion, the intellectual thrill of discovering a compelling structure in it and one which is a complete contrast to our everyday experience, and, to be sure, even calls it in question. Such fundamental concepts as above and below, right and left, near and far appear to be no more than relative and interchangeable at will. Here we see entirely new relationships between points, surface, and spaces, between cause and effect, and these go to make spatial structures which call up worlds at once strange and yet perfectly possible.

Flocon placed Escher among the thinkers of art—Piero della Francesca, Da Vinci, Dürer, Jannitzer, Bosse-Desargues, and Père Nicon—for whom the art of seeing and of reproducing the seen has to be accompanied by a research into fundamentals. "His work teaches us that the most perfect surrealism is latent in reality, if only one will take the trouble to get at the underlying principles of it."

In 1968, on the occasion of Escher's seventieth birthday, a great retrospective exhibition of his work was held in the municipal museum at The Hague. As far as the numbers of visitors were concerned this exhibition did not fall behind the Rembrandt Exhibition. There were days on which one could scarcely get near the prints. The onlookers stood in serried ranks in front of the display walls, and the fairly expensive catalogue had to be reprinted.

The Netherlands Minister for Foreign Affairs commissioned a film about Escher and his work. This was completed in 1970. Inspired by Escher's prints, the composer Juriaan Andriessen wrote a modern work which was performed by the Rotterdam Philharmonic Orchestra, together with a synchronized projection of Escher's prints. The three performances, toward the end of 1970, drew full houses, with audiences especially of young people. Enthusiasm was so great that large sections of the work had to be repeated.

Now Escher is more widely known and appreciated as a graphic artist than any other member of his profession.

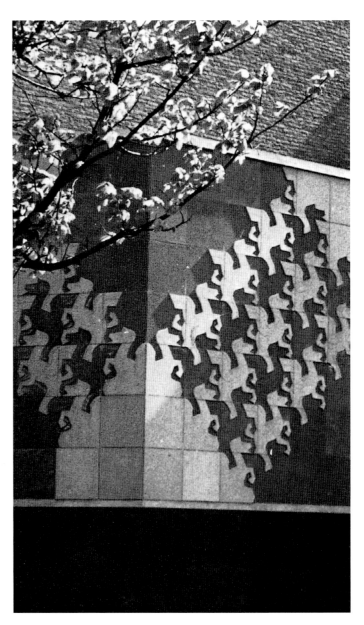

32. Tile mural, (First) Liberal Christian Lyceum, The Hague, 1960

* After reading this part of the manuscript, Escher added this comment: "He is also always concerned with the recognizability of the figures which go to make up his surface-filling. Each element must make the viewer think of some shape which he recognizes, be it in living nature (usually an animal, sometimes a plant) or at times an object of daily use."

6 Drawing Is Deception

If a hand is drawing a hand and if, at the same time, this second hand is busy drawing the first hand also, and if all this is illustrated on a piece of paper fixed to a drawing board with thumb tacks . . . and if the whole thing is then drawn again, we may well describe it as a sort of superdeception.

Drawing is indeed deception. We are being persuaded that we are looking at a three-dimensional world, whereas the drawing paper is merely two-dimensional. Escher regarded this as a conflict situation and he tried to show this very closely in a number of prints, such for instance as the lithograph *Drawing Hands* (1948). And in this chapter we shall deal not only with those particular prints but also with some in which this conflict appears as a secondary incidental feature.

The Rebellious Dragon

At first sight, the wood engraving *Dragon*, made in 1952, merely depicts a rather decorative little winged dragon, standing on a clump of quartz crystals. But this particular dragon is sticking his head straight through one of his wings and his tail through the lower part of his body. As soon as we realize that this is happening, and in a peculiar mathematical way at that, we arrive at an understanding of what the print is all about.

We would not give a second thought to a dragon like the one in figure 35; but then it is worth bearing in mind that in this case, as with all the pictures, the dragon is flat. He is two-dimensional! Yet we are so accustomed to pictures of three-dimensional things expressed in the two dimensions of drawing paper, photograph, or movie screen, that we do in fact see the dragon in three dimensions. We think we can tell where he is fat and where he is thin; we could even try estimating his weight! An arrangement of nine lines we immediately recognize as a spatial object, *i.e.*, a cube. This is sheer self-deception. This is what Escher tried to demonstrate in this *Dragon* print. "After I had drawn the dragon [as shown in figure 35] I cut the paper open at *AB* and *CD*, folding it to make square gaps. Through these openings I pulled the pieces of paper on which the head and the tail were drawn. Now it was obvious to anybody that it was completely flat. But the dragon

33. *Drawing Hands*, lithograph, 1948

didn't seem too pleased with this arrangement, for he started biting his tail, as could only be done in three dimensions. He was just poking fun—and his tail—at all my efforts."

The result is an example of flawless technique, and when we look at the picture we can scarcely realize how immensely difficult it has been to achieve so clear a representation of the conflict between the three dimensions suggested and the two dimensions available for doing it. Fortunately, a few preparatory sketches for this print have been preserved. Figure 36 shows a pelican sticking his long beak through his breast. This particular subject was rejected—because it did not offer enough possibilities.

In figure 37 we find a sketch of the dragon in which all the essential elements of the print are already present. Now comes the difficult task of getting the cut-open and folded part into correct perspective, so that the viewer will unmistakably recognize the gaps. For Escher can suggest that the dragon is completely flat only if he depicts the two incisions and the foldings very

realistically—that is to say, three-dimensionally. The deception is thus revealed by means of another deception! The diamond shapes in figure 38 will help us to follow this perspective more easily. In figure 39 the dragon is really and truly flat, cut, and folded. Finally, figure 40 introduces a possible variation; in this case the folds are not parallel but are at right angles to each other. This idea has not been worked out any further.

And Still It Is Flat

The upper section of the wood engraving *Three Spheres I* (1945), consists of a number of ellipses, or, if one prefers it that way, a number of small quadrangles arranged elliptically. We find it practically impossible to rid ourselves of the notion that we are looking at a sphere. But Escher would like to get it into our heads that no sphere is involved at all; the whole thing is flat. So he folds back the topmost section and re-draws the resultant figure beneath the so-called sphere. But still we find ourselves given over to a three-dimensional interpretation; we can now see a hemisphere with a lid! Right, so Escher draws the top figure once again but this time lying flat. Yet even now we refuse to accept it, for what we see this time is an oval, inflated balloon, and certainly not a flat surface with curved lines drawn on it. The photograph (figure 42) illustrates what Escher has done.

The engraving *Doric Columns*, made in the same year, has precisely the same effect. It really is too bad that we cannot be convinced of the flatness of the print; and what is worse, the very means that Escher uses are exactly the same as the malady that

34. *Dragon*, **wood engraving, 1952**

35. The paper Dragon

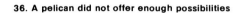

36. A pelican did not offer enough possibilities

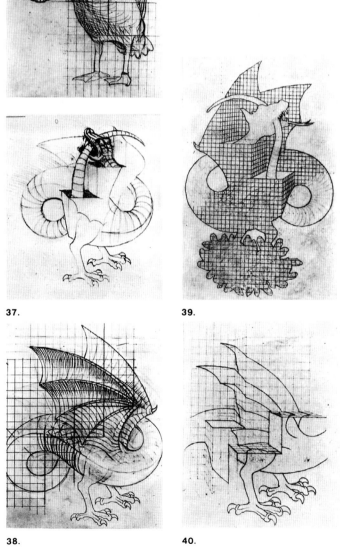

37. **39.**

38. **40.**

Preparatory studies for the wood engraving, Dragon

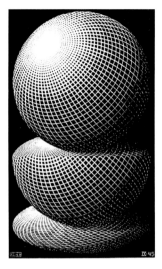

41. *Three Spheres I*,
wood engraving, 1945

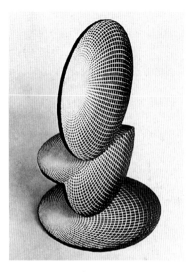

42. **Photograph of three spheres—
not spheres, but flat circles**

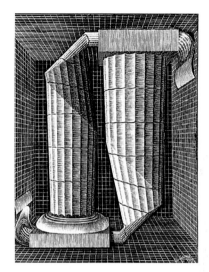

43. *Doric Columns*, wood engraving, 1945

he is trying to cure. In order to make it appear that the middle figure is on a flat drawing surface, he makes use of the fact that such a surface can be used to give an impression of three dimensions.

Both from a structural point of view and as a wood engraving, this print is incredibly clever. In earlier days this would have been regarded as a master test for a wood engraver.

How 3-D Grows Out of 2-D

Because drawing is deception—i.e., suggestion instead of reality—we may well go a step further, and produce a three-dimensional world out of a two-dimensional one.

In the lithograph *Reptiles* (1943) we see Escher's sketchbook, in which he has been putting together some ideas for periodic drawings. At the lower left-hand edge the little, flat, sketchy figures begin to develop a fantastic three-dimensionality and

thereby the ability to creep right out of the sketch. As this reptile reaches the dodecahedron, by way of the book on zoology and the set square, he gives a snort of triumph and blows smoke from his nostrils. But the game is up, so down he jumps from the brass mortar on to the sketchbook. He shrivels back again into a figure and there he remains, stuck fast in the network of regular triangles.

In figure 45 we see the sketchbook page reproduced. The remarkably interesting thing about this surface division is the existence of three different types of rotation point. These are: where three heads come together, where three feet touch, and where three "knees" meet. If we were to trace the design on transparent paper, and then stick a pin through both tracing paper and drawing at one of the above named points, we could turn the tracing paper through 120 degrees, and this would make the figures on the tracing paper fit over those of the drawing once again.

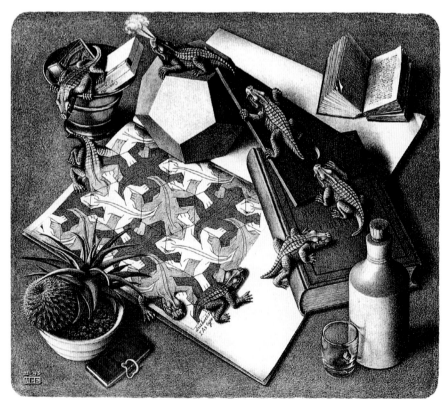

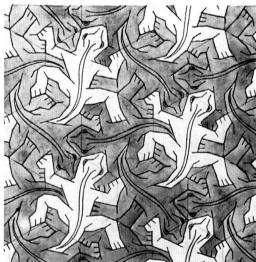

45. **Sketch for** *Reptiles*, **pen, ink, and watercolor,**
1939

44. *Reptiles*, lithograph, 1943

32

46. Sketch for *Encounter*, pencil, 1944

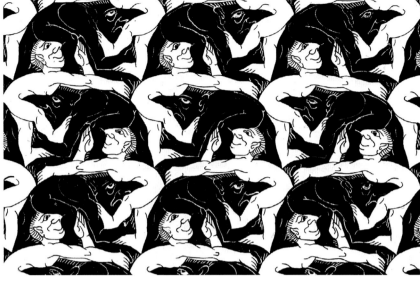

48. The periodic space-filling that was the basis for *Encounter*, pencil and India ink, 1944

White Meets Black

In the lithograph *Encounter* (1944) we can see a periodic draw-ing division consisting of black and white figures painted on a wall. At right angles to the wall there is fixed a floor with a large circular hole in it. The little men seem to sense the proximity of the floor, because as soon as they get near to it they step down from the wall, take on a further dimension in doing so, and then shuffle in rather a wooden fashion along the edge of the chasm. By the time the black and white figures meet, the transformation into real people is so far advanced that they are able to shake hands. The first time this print was reproduced an art dealer rather hesitated to put it on display because the little white man resembled Colijn, a popular Dutch prime minister! Escher had not intended this in the least; the figures had, so to speak, evolved spontaneously out of the periodic division of the surface.

This periodic drawing has two different axes of glide reflection,

running vertically. By using tracing paper one can easily find them. We shall return to this in the next chapter.

Day Visits to Malta

On his cargo-boat voyages through the Mediterranean Escher called at Malta on two occasions. These were only short visits and lasted hardly a whole day, just long enough for the ship to load and unload. A sketch of Senglea (a little harbor town on Malta) has been preserved, dated March 27, 1935. In October of that same year Escher made a three-colored woodcut from it. This print is reproduced here, because it is not very well known and because he was later to use several important elements from it for two other prints.

A year later (June 18, 1936), when Escher escaped from Swit-zerland to make the Mediterranean tour which was to have so

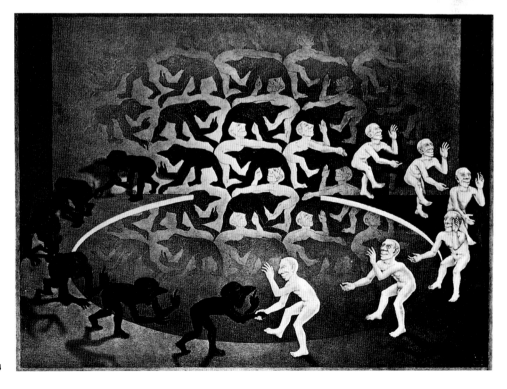

47. *Encounter*, lithograph, 1944

great an influence on his work, the ship called once again at Malta and Escher sketched practically the same part of the little harbor town.

There must have been something very fascinating about the structure of this backdrop of buildings, because ten years later, when he was looking for a lively, well-balanced, rhythmic grouping of buildings for a print in which the center could be subjected to expansion *(Balcony)* his choice fell on this 1935 Malta print. And after yet another ten years he used the same sketch again for his unique print *Print Gallery* (1956). In this we can recognize not only the various groups of houses and the rocky coastline (as in *Balcony*) but this time the freighter as well.

Blow-up

In *Balcony* the center of the print is enlarged four times relative to its edges. We shall look presently at the method Escher used to achieve this effect. The result is a splendid bulge. It is as though the print had been drawn on a sheet of rubber and then inflated from behind. Details that hitherto had been of altogether minor importance have now been transformed and become the center of our attention. If we compare the print with the working sketch that was made for it, and in which the same scene is shown in its undeveloped form, then this particular balcony is not all that easy to find; it is in fact the fifth balcony from the bottom. In the working sketch the four lowest balconies are almost equidistant from each other, whereas in the print the distances between those nearest the bulge have been very considerably

50. *Senglea*, woodcut, 1935

49. Sketch for Malta

compressed. For the inflation of the central area has got to be compensated for somewhere else, because the total content of the scene is the same in both working sketch and final print.

In figure 52 we see a square divided up into small squares. The broken circle marks the boundary of the above-mentioned distortion. The vertical lines PQ and RS and the horizontal lines KL and MN reappear in figure 53 as curved lines. In figure 54 the center is inflated. A, B, C, and D are displaced toward the edge and take up the position A', B', C', and D'. And it is possible to reconstruct the whole network in this way, of course. So we find that an expansion has taken place around the center of the circle and a squeezing together at its circumference; the horizontal and vertical lines have been, so to speak, pressed outward toward the edge of the circle. Figures 51 and 55 show the pictorial contents deformed and undeformed. And that is how the enormous blow-up in the center of *Balcony* has been brought about.

Growing 256 Times Over

Print Gallery arose from the idea that it must also be possible to make an annular bulge. First of all, let us approach the print as an unsuspecting viewer. At the lower right-hand corner we find the entrance to a gallery in which an exhibition of prints is being held. Turning to the left we come across a young man who stands looking at a print on the wall. On this print he can see a ship, and higher up, in other words in the upper left-hand corner, some houses along a quayside. Now if we look along to the right, this row of houses continues, and on the far right our gaze descends, to discover a corner house at the base of which is the entrance to a picture gallery in which an exhibition of prints is being held. . . . So our young man is standing inside the same print as the one he is looking at! Escher has achieved the whole

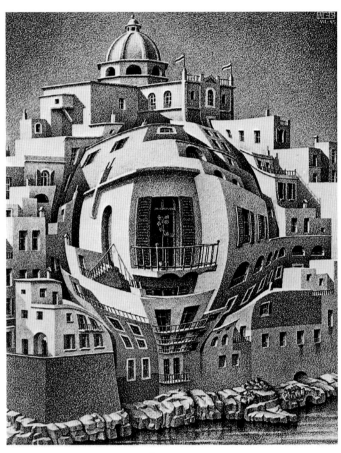

51. *Balcony*, lithograph, 1945

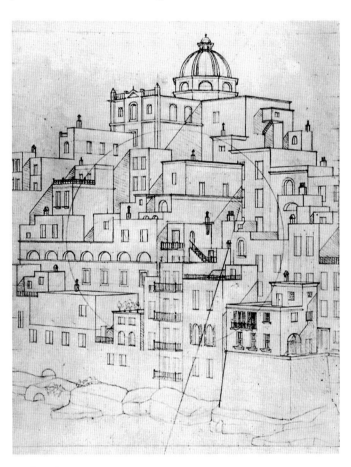

55. Sketch before the center was blown up

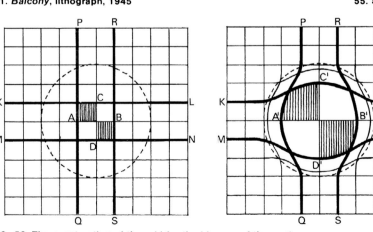

52.–53. The construction of the grid for the blow-up of the center

54. The blown-up center

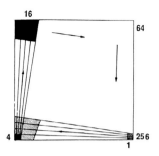

57.–58. The development of the expansion

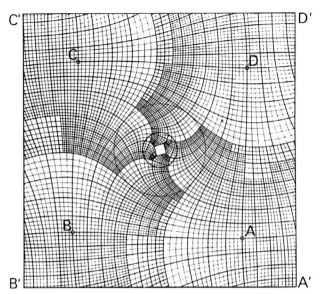

59. Grid for *Print Gallery*

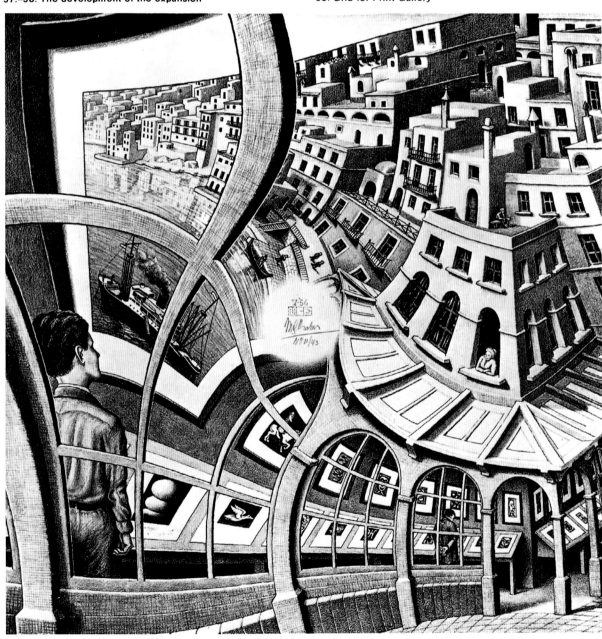

56. *Print Gallery*, lithograph, 1956

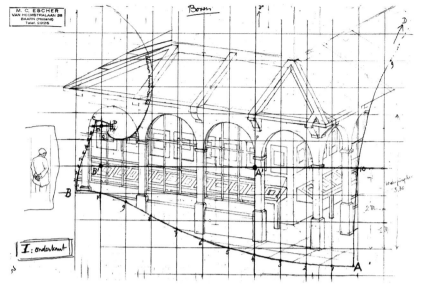

60. Print Gallery before the expansion

61a,b. How the circular expansion was obtained

of this trickery by constructing a grid that can be used as a framework for the print, marking out a bulge in a closed ring formation and having neither beginning nor end. The best way to gain an understanding of this construction is to study a few schematic drawings.

At the lower right of the square, figure 57, a small square has been drawn, and as we move along the bottom edge toward the left we note that this figure keeps increasing in size, until at the left-hand edge it has reached a fourfold enlargement. The dimensions of the original figure have now become four times as great. Passing upward along the left-hand edge we find a further fourfold increase, thus multiplying the original dimensions by sixteen. Go to the right along the top edge and the dimensions are sixty-four times as great as the original ones; keep on down the right-hand side and the enlargement is 256 times by the time we arrive back at the exit. What originally measured 1 centimeter in length has now become 2 meters 56! It would of course be quite impossible to carry out this exercise in full in the whole picture. In the actual figure we do not get any further than the first two stages (or indeed only one full stage, for at the second enlargement only a small section of the already enlarged figure is used).

At first Escher tried to put his idea into practice using straight lines, but then he intuitively adopted the curved lines shown in figure 58. In this way the original small squares could better retain their square appearance. With the aid of this grid a large part of the print could be drawn, but there was an empty square left in the middle. It was found possible to provide this square with a grid similar to the original one, and, by the repetition of this process a few more times, the grid shown in figure 59 came into being. $A'B'C'D'$ is the original square and $ABCD$ is an outward expansion that was a necessary consequence and a logical outcome. This marvelous grid has astonished several mathematicians, and they have seen in it an example of a Riemann surface.

In our figure 58 only two stages of the enlargement are shown. This is in fact what Escher has done in his print. We can see the gallery getting larger from right to left. The two further stages could not possibly be carried out within the square, because an ever-increasing area is required to represent the enlargement of the whole. It was a brilliant notion of Escher's to cope with the last two stages by drawing attention to one of the prints in the gallery, for this print itself can be enlarged within the square. Another invention of his was to illustrate within the aforementioned print a gallery that coincided with the gallery he started with.

Now we must find out how Escher, starting out as he did with a normal drawing, was able to transfer this onto his prepared grid. We shall concentrate on only a small part of this rather complicated process. Figure 60 shows one of the detailed drawings, that of the gallery itself. A squared grid was placed over the drawing. We come across the points A, B, and A' again of figure 59. And we also find there the same grid but this time in an altered form—that is to say, becoming smaller to the left. Now the image of each little square is transferred to the equivalent square on the grid. In this way the enlargement of the picture is automatically achieved. For example, the rectangle in figure 61a, $KLMN$, is transferred thus to $K'L'M'N'$ in figure 61b.

I watched *Print Gallery* being made, and on one of my visits to Escher I remarked that I thought the bar to the left of the center horribly ugly; I suggested that he ought to let a clematis grow up it. Escher returned to this matter in a letter:

No doubt it would be very nice to clothe the bars of my *Print Gallery* with clematis. Nevertheless, these beams are supposed to be dividing bars for window panes. What is more I had probably used up so much energy already on thinking out how to present this subject that my faculties were too deadened to be able to satisfy aesthetic demands to any greater degree. These prints, which, to be quite honest, were none of them ever turned out with the primary aim of producing "something beautiful," have certainly caused me some almighty headaches. Indeed it is for this reason that I never feel quite at home among my artist colleagues; what they are striving for, first and foremost, is "beauty"—albeit the definition of that has changed a great deal since the seventeenth century! I guess the thing I mainly strive after is wonder, so I try to awaken wonder in the minds of my viewers.

Escher was very fond of this print and he often returned to it.

Two learned gentlemen, Professor van Dantzig and Professor van Wijngaarden, once tried in vain to convince me that I had drawn a Riemann surface. I doubt if they are right, in spite of the fact that one of the characteristics of a surface of this kind seems to be that the center remains empty. In any case Riemann is completely beyond me and theoretical mathematics are even more so, not to mention non-Euclidian geometry.

So far as I was concerned it was merely a question of a cyclic expansion or bulge, without beginning or end. I quite intentionally chose serial types of objects, such, for instance, as a row of prints along the wall and the blocks of houses in a town. Without the cyclic elements it would be all the more difficult to get my meaning over to the random viewer. Even as things are he only rarely grasps anything of it.

Bigger and Bigger Fish

In 1959, Escher used the same idea and almost the same grid system for a more abstract woodcut, *Fish and Scales*. On the left we see the head of a large fish; the scales on the back of this fish gradually change, in a downward direction, into small black and white fish, which in turn increase in size. They form two schools swimming in among each other. We can see almost exactly the same thing happening if we start with the big black fish on the right. Figure 63 shows the scheme for the lower half of the print, and we find the upper half if we turn figure 64 through 180 degrees about the center of the drawing (small black block)—except that in the upper half the eyes and mouth are reversed in such a way that not a single fish is to be found upside down. Arrows indicate the directions in which the black and white fish are swimming.

Then we find that the scale *A*, swelling into a little fish at *B*, goes on to *C* and grows into the big black fish in the top half of the print. If we draw in lines above and below the swimming directions and then carefully extend this same system of lines to left and right, a rough outline appears of the grid that is used in the print. Thus we can get a much better understanding of what is happening. We can start at *P*, where we find a scale belonging to the big black fish on the right moving upward. This scale grows and changes into the little fish at *Q*. If we move to the left, this little fish goes on increasing in size until it has turned into the big black fish on the left. Now, if we should wish to move downward from *R*, this fish would have to be succeeded by still larger fish, and this is impossible within the compass of this print. Therefore, just as in *Print Gallery* he switched over from the gallery to the print as soon as available space became too small, so now Escher has selected one of the scales from the large fish so as to continue the enlargement process from *R* to *S*. The large fish plays her part in this, for before she has even reached her full size, she bursts open and brings forth some new little fish. In this way the enlargement continues without a break from *S* onward. The little fish at *S* swells up into the big fish on the right, from which once again we can select a scale—and so on.

It will be quite obvious that the grid for *Fish and Scales* is a mirror image of the one for *Print Gallery*.

Now, in *Fish and Scales* two further favorite themes of Escher's are brought out—i.e., periodic drawings and metamorphosis (from scales to fish).

Drawing is deception. On the one hand Escher has tried to reveal this deception in various prints, and on the other hand he has perfected it and turned it into superillusion, conjuring up with it impossible things, and this with such suppleness, logic, and clarity that the impossible makes perfect sense.

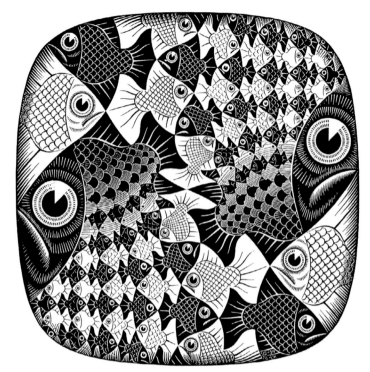

62. *Fish and Scales*, woodcut, 1959

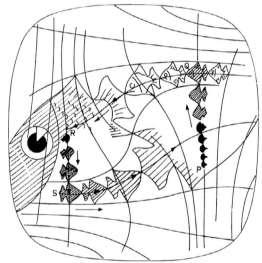

63. From scale into fish

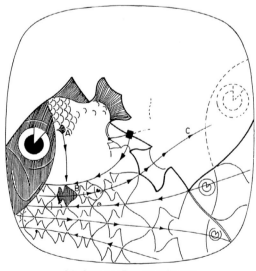

64. Grid for *Fish and Scales*

38

7 The Art of the Alhambra

65. First attempt at regular division of a plane, with imaginary animals (detail), pencil and watercolor, 1926 or 1927

The Stubborn Plane

No theme or topic lay closer to Escher's heart than *periodic drawing division.* He wrote a fairly extensive treatise on the subject, going into technical details. There is only one other theme about which he has written—although by no means at such length—and that is *approaches to infinity.* What he says on the latter subject can perhaps be applied with even more justice to periodic drawing. It is a question of confession:

> I can rejoice over this perfection and bear witness to it with a clear conscience, for it was not I who invented it or even discovered it. The laws of mathematics are not merely human inventions or creations. They simply "are"; they exist quite independently of the human intellect. The most that any man with a keen intellect can do is to find out that they are there and to take cognizance of them.

He also writes (in this instance in regard to regular tessellation): "It is the richest source of inspiration that I have ever tapped, and it has by no means dried up yet."

We can see how very much predisposed Escher was to the discovery and application of the principles of tessellation, even in the earliest work reproduced here, done when he was still studying under de Mesquita in Haarlem. The most detailed and fully developed production of this period is certainly the woodcut *Eight Heads* (1922). Eight different heads are cut on the one wood block, four of them right way up and four upside down. Here, in figure 66, we see the block printed four times over. These thirty-two heads have a certain theatrical air about them, false, unreal, *"fin de siècle."*

Neither the covering of the entire surface with recognizable figures nor the repeated printing from the one block to produce a rhythmic repetition of the motif (in this case the eight heads form a single motif) were due to the influence or the inspiration of de Mesquita.

Until 1926 it looked as though these efforts were to be confined to a youthful period and could not be regarded as a bud of promise destined later to come into full bloom. In 1926, having already had some acquaintance with the Alhambra on the occa-

sion of a brief visit, Escher made tremendous efforts to express a rhythmic theme on a plane surface, but he failed to bring it off. All he could manage to produce were some rather ugly, misshapen little beasts. He was particularly annoyed at the stubborn way in which half of these four-footed creatures persisted in walking around upside down on his drawing paper (figure 65).

It would not have been surprising if Escher, after the failure of all these serious attempts, had come to the conclusion that he was not going to achieve anything in this sphere. For ten whole years space-filling was out for him—until, in 1936, accompanied by his wife, he paid another visit to the Alhambra. For the second time he was impressed by the rich possibilities latent in the rhythmic division of a plane surface. For whole days at a time he and his wife made copies of the Moorish tessellations, and on his return home he set to work to study them closely. He read books about ornamentation, and mathematical treatises he could not understand and from which the only help he got was to be found in the illustrations; and he drew and sketched. Now he could see clearly what it was he was really searching for. He built up a wholly practical system that was complete, in broad outline, by 1937, and which he set out in writing in 1941 and 1942. But by that time he was busy assimilating his discoveries in metamorphosis and cycle prints. The full story of how Escher struggled with this stubborn material and how he conquered it so well that, as he said later, he himself did not have to think up his fishes, reptiles, people, houses, and the rest, but the laws of periodic space-filling did it for him—all this would itself call for more space than the whole of this present book. We shall have to content ourselves with a short introduction, in the hope that it will give the reader a greater insight into this important (in Escher's view the *most* important) aspect of his work.

Principles of Plane Tessellations

In figure 68 we see a simple design: the entire surface is covered with equilateral triangles. Now we must discover in what ways this design can be "mapped onto" itself—that is, brought to coincide with itself. For this purpose we must make a duplicate of it by tracing it on transparent paper, and then laying it over the original pattern so that the triangles cover each other.

If we shift the duplicate over the distance *AB* it will cover the underlying pattern once again. This movement is referred to as *translation*. Thus we can say that the design maps onto itself by translation.

We can also turn the duplicate through 60 degrees about the point *C*, and we find that once again it covers the original pattern exactly. Thus this design can be said to map onto itself by *rotation*.

If we draw in the dotted line *PQ* on both the original pattern and the duplicate, and then remove the duplicate from the figure, turn it, and lay it down again in such a way that the dotted lines coincide, we shall notice that once more duplicate and original cover each other. We term this movement *reflection* on the mirror axis *PQ*. The duplicate is now the mirror image of the original figure, and yet it still coincides with it.

Translation, rotation, reflection, and—to be considered later—glide reflection; these are the possible shifts whereby a pattern can be made to map onto itself. There are some patterns that admit only of translation and there are others that are susceptible of both translation and reflection, and so on.

If we categorize the patterns according to the kinds of shifts whereby they map onto themselves, we discover that there are seventeen different groups. This is no place to list them all or even to summarize them, but we may at least point to the remarkable fact that Escher discovered all these possibilities without

66. *Eight Heads*, woodcut, 1922

The same print, turned 180°

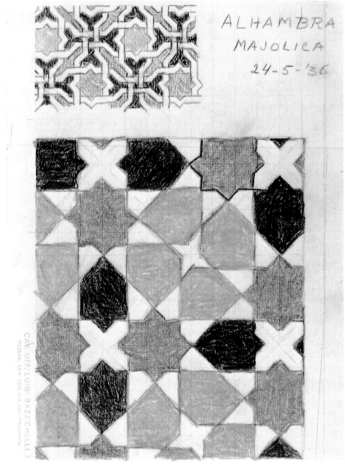

67. Sketches made in the Alhambra, pencil and colored crayon, 1936

68. Possible movements in a flat surface

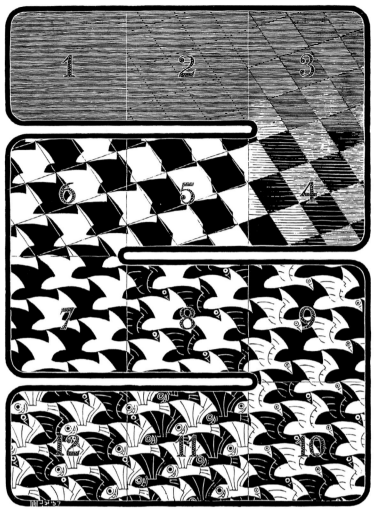

69. In this drawing Escher shows the creation of a metamorphosis

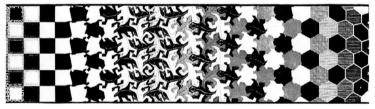

Detail of *Metamorphosis II*

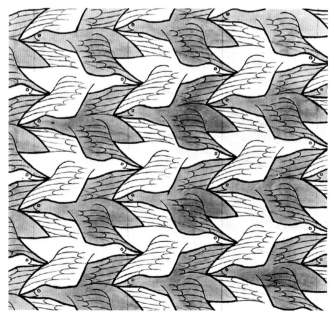

70. The periodic space-filling that forms the basis for *Day and Night*

the benefit of any appropriate previous mathematical knowledge. In her book *Symmetry Aspects of M. C. Escher's Periodic Drawings* (published in 1965 for use by students of crystallography), Professor C. H. McGillavray speaks of her astonishment at the fact that Escher even discovered new possibilities whereby color too might play an important role, and which had not been mentioned in scientific literature before 1956.

A particular characteristic of Escher's tessellations (and in this he is well-nigh unique) is that he always selects motifs that represent something concrete. On this subject he writes:

> The Moors were masters in the filling of a surface with congruent figures and left no gaps over. In the Alhambra, in Spain, especially, they decorated the walls by placing congruent multicolored pieces of majolica together without interstices. What a pity it was that Islam forbade the making of "images." In their tessellations they restricted themselves to figures with abstracted geometrical shapes. So far as I know, no single Moorish artist ever made so bold (or maybe the idea never dawned on him) as to use concrete, recognizable figures such as birds, fish, reptiles, and human beings as elements of their tessellations. Then I find this restriction all the more unacceptable because it is the recognizability of the components of my own patterns that is the reason for my never-ceasing interest in this domain.

Making a Metamorphosis

Escher always regarded periodic surface-division as an instrument, a means to an end, and he never produced a print with this as the main theme.

He made the most direct use of periodic surface-division in connection with two closely related themes: the metamorphosis and the cycle. In the case of the metamorphosis we find vague, abstract shapes changing into sharply defined concrete forms, and then changing back again. Thus a bird can be gradually transformed into a fish, or a lizard into the cell of a honeycomb. Although metamorphosis in the sense described above also appears in the cycle prints, nevertheless the accent is more on continuity and a return to the starting point. This is the case, for instance, with the print *Metamorphosis I* (1937), a typical metamorphosis print in which no cycle appears. *Day and Night* is also a metamorphosis print in which scarcely any cyclic element is found. But most of the prints display not only metamorphosis but also a cycle, and this is because Escher derived more satisfaction from turning the visual back upon itself than from leaving his picture open-ended.

In his book *Plane Tessellations* (1958), he shows us in a most masterly way, by both text and illustration, how he brings a metamorphosis into being. We give a brief resume of his argument by means of figure 69.

At 4 the surface is divided into parallelograms, distinguished from each other by virtue of the fact that a white one is always bounded by a black.

In 5 the rectilinear nature of the black-and-white boundaries is slowly changing, for the boundary lines curve and bend in such a way that an outward bulge on the one side is balanced with an equal-sized inward bulge in the opposite side.

In 6 and 7 the process continues, in the sense that there is a progressive alteration, not in the nature or in the position of the outward and inward bulges, but in their size. The shape arrived at in 7 is maintained up to the end. At first sight nothing remains of the original parallelogram, and yet the area of each motif stays exactly the same as that of the original parallelogram, and the points where the four figures meet are still in the same positions relative to each other.

In 8, details are added to the black motifs to signify birds, so that the white ones become the background, indicating sky.

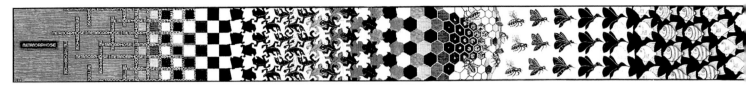

71. *Metamorphosis II*, woodcut, 1939-40

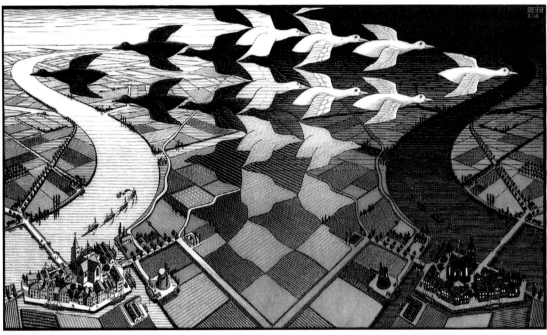

72. *Day and Night*, woodcut, 1938

9. This can be just as easily interpreted the other way round, with white birds flying against a dark sky. Night has fallen.

10. But why not have white *and* black birds simultaneously covering the whole surface?

11. The motif appears to allow of two different interpretations, for by drawing into the tails of the birds an eye and a beak, and turning the heads into tails, the wings almost automatically become fins, and from each bird a flying fish is born.

12. Finally, of course, we may just as well unite the two sorts of creature in one tessellation. Here we have black birds moving to the right and white fishes to the left — but we can reverse them at will.

The refinement with which Escher was so soon able to develop the metamorphosis can be seen in the woodcut *Metamorphosis II* (1939–40), the largest print Escher ever made. It is 20 centimeters high and 4 meters long! And later, in 1967, he added a further three meters when the print, greatly enlarged, was to be used as a mural for a post office. It is not so much the change-over, say from honeycomb to bees, that is of interest (for these depend more on the association of ideas); but when squares change, by way of lizards, into hexagons, he displays a tremendous virtuosity in the handling of his material. There is also *Verbum* (1942), not reproduced here, which comes definitely within the category of metamorphosis, and which is taken to its furthest possible extreme. In later prints we find a decline in the exercise of virtuosity for its own sake; and the metamorphoses come to be more subservient to other representational concepts, for instance in *Magic Mirror*.

The Most Admired Picture of Them All

Figure 70 illustrates one of the simplest possibilities of surface-filling. The pattern of white and black birds maps onto itself by translation only. If we shift a white bird over to the right and upward, the same pattern is found there again. There would be more possibilities if the white bird and the black bird were congruent. Escher used this type of tessellation in the woodcut *Day and Night* (1938) which is, to date, the most popular of all Escher's prints. This print definitely introduces a new period, as was clear even to the critics of that time. From 1938 to 1946 Escher sold 58 copies of this print, up to 1960 the total rose to 262, and in 1961 alone he sold 99! The popularity of *Day and Night* exceeded that of the other much-sought-after prints *(Puddle, Sky and Water I, Rippled Surface, Other World, Convex and Concave, Belvedere)*, so much so that we may safely conclude from this that Escher has succeeded, in this print more than in any other, in putting across to the viewer his sense of wonderment. In the center above us we see much the same tessellation as in figure 70, but this does not provide the basis for *Day and Night* — that is to be found in the center below the print. There one finds a white, almost diamond-shaped field, and our gaze is automatically drawn upward from it; the field changes shape, and very swiftly at that, for it takes only two stages to turn into a white bird. The heavy, earthy substance is suddenly whisked aloft to the sky and is now quite capable of flying to the right, flying as a bird high above a little village by the riverside, enveloped in the darkness of the night.

We could just as easily have chosen one of the black fields down there, to the right and left of the center line. And as it too rises in the air it turns into a black bird and flies away to the left, up above a sunny Dutch landscape which, in a most remarkable way, turns out to be a mirror image of the nocturnal landscape on the right!

From left to right there is a gradual transformation from day to night and from below upward we are slowly but surely raised

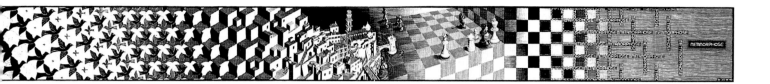

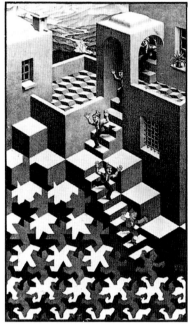

73. *Cycle*, lithograph, 1938

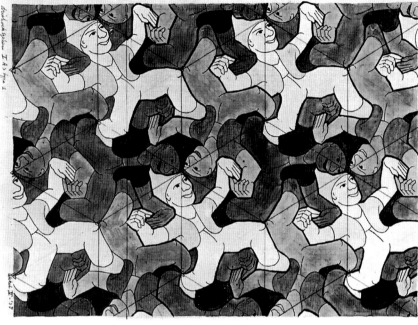

74. Study of periodic space-filling of a plane with human figures, India ink, pencil, and watercolor, 1938

toward the heavens . . . and the fact that this can be achieved through the vision of the artist explains, in my view, why this print appeals to so many people.

The Stone Lad

In *Cycle* (1938) we see a quaint little fellow emerging, gay and carefree, from a doorway. He rushes down the steps, oblivious of the fact that he is about to disappear down below and become dissolved into a whimsical geometric design. At the bottom of the print we come across the same pattern as in figure 74, about which more anon. It turns out to be this lad's birthplace.

This metamorphosis from human figure to geometric pattern is, however, not the end of the affair, for at the top left the pattern gradually changes to simpler, more settled shapes, until these achieve a diamond form; then the diamonds go to make up a block that is used as building material or as the pattern of the tiled floor of the little walled courtyard.

Thereupon, within some secret chamber of the house, these lifeless shapes seem to undergo a further transformation, being turned back into little men, for we see that cheerful young fellow leaping out of his doorway once again.

The periodic pattern used here has three axes of symmetry, and these are of three different types: that in which the three heads meet, that with three feet coming together, and one where three knees touch. At each one of these points the whole pattern can be mapped onto itself by rotation through an angle of 120 degrees. Of course, the little men will change color with each rotation.

Angels and Devils

The same kind of space-filling is basic to the print *Reptiles* (figure 44) and *Angels and Devils*.

In figure 75 we see a periodic space-division with fourfold symmetry. At every point where wing tips touch we can turn the whole pattern through 90 degrees and cause it to fit over itself. Yet these points are not equal. The point of contact of the wing-tips in the center of the picture at *A* and the points *B, C, D,* and *E* are not the same. However, the points *P, Q, R,* and *S* do have exactly the same context as *A*.

Now we can draw horizontal and vertical lines through the body axes of all the angels and devils (in the sketch these lines are indicated by the letter *m*). These lines are mirror axes. Lastly, there are still axes of glide reflection, which make angles of 45 degrees with the reflection axes. They are also the lines we can draw through the heads of the angels, labelled *g* in the figure 76. The only way in which we are likely to be able to prove that axes of glide reflection are present is to carry out an actual glide-reflection shift. For this purpose, trace the outlines of the angels onto transparent paper and at the same time the axes of reflection *g*. Now rotate the tracing paper and lay it down again in such a way that *g'* on the tracing coincides with *g* of the original. If you take care, at the same time, to ensure that the head of the angel furthest to the left coincides with its original, you will have effected a reflection.

It can be seen that with this reflection the traced pattern does not cover the original one. However, if you shift the tracing diagonally upward along the axis of reflection you will notice that both patterns map onto each other the moment you get the traced angel head onto the next angel head in the original — something you might not have expected.

It was not because of any aesthetic excellence that I chose

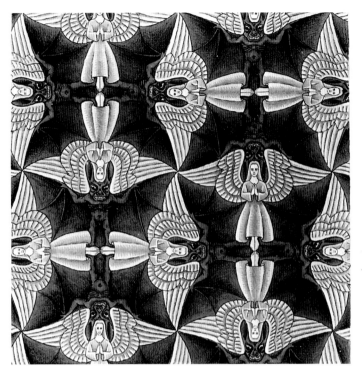

75. Periodic space-filling in *Angels and Devils*, pencil, India ink, crayon, and gouache, 1941

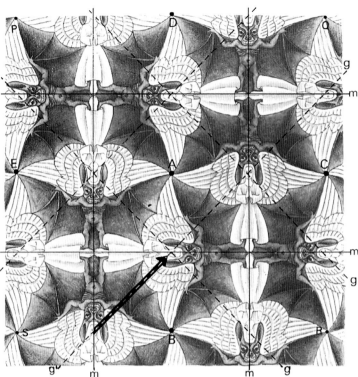

76. Rotation points, mirror axes, and glide-reflection axes in the flat pattern of *Angels and Devils*

figure 75 out of all the others — indeed, the angels might well have stepped straight out of some pious print of the thirties. But it is astonishing that such detailed figures as these can fill up the entire surface without leaving any gaps whatever, and in such a wide variety of orientations, and yet can still map onto themselves in so many different ways.

Escher never made use of the above version of his angels and devils, but at a later date, in 1960, he did make a circular print of them (figure 77). For a description of the circle limit prints, see chapter 15. Here we have not only fourfold axes but threefold as well. This can be seen where three angels' feet come together.

At a later date the same angel-devil motif was adapted to a spherical surface. On commission from Escher's American friend, Cornelius Van S. Roosevelt, who has one of the biggest collections of his work, and by means of instructions and drawings that Escher furnished, two copies of an ivory ball were produced in Japan by an old *netsuke* carver. The entire surface of the little sphere is filled by twelve angels and twelve devils. It is interesting to note how, in the hands of the old Japanese carver, the facial characteristics of the little angels and devils have taken on a typically Oriental look.

Thus Escher has made three variations of this surface-filling:

1. On a boundless flat surface, there is an interchange of double and quadruple axes.

2. On the (bound) circle-limit we find triple and quadruple axes.

3. On the spherical surface the same motif is used again, with double and triple axes.

A Game

When dealing with periodic space-filling I cannot refrain from describing a game that took Escher's fancy in 1942, and to which he attached no importance beyond that of a private diversion. He never reproduced it or made use of it in any more serious work.

Escher carved a die shown by figure 79a. On each side of the square, three corresponding connections are possible. If one prints from this stamp a number of times, so that the imprints come next to each other, then the bars form continuous lines throughout the whole figure.

Because the stamp can be printed off in four different positions, and because Escher cut the figure again in its mirror image (once again capable of being printed in four positions), it is possible to use it to conjure up a large number of interesting designs. In figure 79b you can see a few examples, and in figures 80 and 81 two of the many designs Escher colored in.

A Confession

The significance periodic space-division has had for Escher is difficult to overestimate. In this chapter we have shown something of it with just a few, indeed all *too* few, examples. This restriction does not tally with Escher's own view of his work.

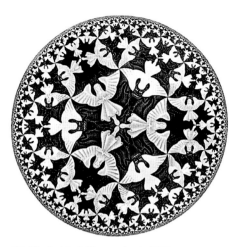

77. *Circle Limit IV*, woodcut, 1960

78. *Sphere with Angels and Devils*, stained maple, 1942 (diam. 23.5 cm.)

So let us allow Escher to have the last word in this chapter:

> . . . I wander totally alone around the garden of periodic draw-
> ings. However satisfying it may be to possess one's own domain,
> yet loneliness is not as enjoyable as one might expect; and in this
> case I really find it incomprehensible. Every artist, or better every
> *person* (to avoid as much as possible using the word art in this
> connection), possesses a high degree of personal characteristics
> and habits. But periodic drawings are not merely a nervous tic,
> a habit, or a hobby. They are not subjective; they are objective.
> And I cannot accept, with the best will in the world, that some-
> thing so obvious and ready to hand as the giving of recognizable
> form, meaning, function, and purpose to figures that fill each other
> out, should never have come into the head of any other man but me.
> For once one has crossed over the threshold of the early stages
> this activity takes on more worth than any other form of decorative
> art.
>
> Long before I discovered a relationship with regular space-
> division through the Moorish artists of the Alhambra, I had al-
> ready recognized it in myself. At the beginning I had no notion of
> how I might be able to build up my figures systematically. I knew
> no rules of the game and I tried, almost without knowing what I
> was about, to fit together congruent surfaces to which I tried to
> give animal shapes . . . later the designing of new motifs gradually
> came with rather less struggle than in the early days, and yet this
> has remained a very strenuous occupation, a real mania to which I
> became enslaved and from which I can only with great difficulty
> free myself.
>
> —M. C. Escher, *Regelmatige Vlakverdeling*
> *(Periodic Space-Filling)*,
> Utrecht, 1958

79a. Stampform for flat patterns

79b. Possible positions of the stamp and its mirror image

80. Stamped and colored ornament I

81. Stamped and colored ornament II

8 Explorations into Perspective

Classical Perspective

From the very first moment that man started to draw and paint he represented spatial reality on a flat surface. The objects which the primitive cave-dweller wanted to reproduce were quite definitely spatial—bison, horses, deer, etc., and he painted them on a rock wall.

But the common method of representation we now call perspective came into being only in the fifteenth century. We can see that Italian and French painters wanted to make their pictures duplicates of reality. When we are looking at the illustration we are supposed to get exactly the same image on our retina as when we are looking at the actual object that is being illustrated.

In earlier days this was done intuitively, and many mistakes were made, but as soon as a mathematical formula for this method of representation had been worked out, it became clear that both architect and artist approached space in the same way.

We can define the mathematical model as in figure 84: the eye of the beholder is situated at O; some distance in front of him we are to imagine a perpendicular plane, i.e., the picture. Now the area behind the picture is transferred to it point by point; in order to do this a line is drawn from point P to the eye, and the point of intersection of this line with the picture is the point P', at which P is depicted.

This principle was well demonstrated by Albrecht Dürer (1471–1528) who took great interest in the mathematical side of his craft (figure 82). The artist has a glass screen in front of him (i.e., the picture) and he draws the man sitting behind the screen point by point. The extremity of a vertical bar fixes the position of the artist's eye.

Of course it is not at all feasible for any artist to work like this. Indeed Dürer's apparatus was used only to solve difficult problems of representation. In the majority of cases the artist relied on a number of rules which could be deduced from the mathematical model.

Here are two important rules:

1. Horizontal and vertical lines running parallel to the picture are to be depicted as horizontal and vertical lines. Like distances along these lines in reality are to be shown as like distances in the picture.

2. Parallel lines that recede from us are to be depicted as lines passing through a single point, i.e., the vanishing point. Like distances along these lines are not to be depicted as like distances in the picture.

Escher meticulously concurred with these rules of classical perspective in the construction of his prints; and it is for this reason that they are so suggestive of space.

In 1952 there appeared a lithograph called *Cubic Space Division*

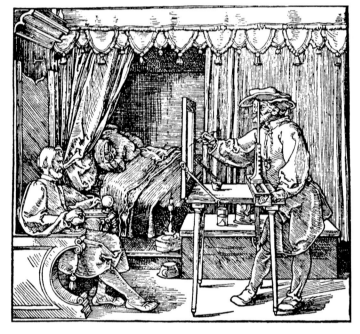

82. Dürer's demonstration of the principles of perspective

in which the sole aim was to depict an infinite extent of space, and no means were used other than the laws of classical perspective. It is true that we can see this infinite extent of space through a square window, as it were, but because this space is divided up into completely similar cubes by bars running in three directions, a suggestion of the whole of space has been achieved.

If we project the vertical bars they appear to meet at a single point, which is the footprint or nadir. There are two further vanishing points, and these can be obtained by projecting the bars that point upward to the right and the bars that point upward to the left. These three vanishing points lie far beyond the area of the drawing, and Escher had to use very large sheets of drawing paper for the construction.

The aim of the wood engraving *Depth* (1955) was much the same, but in this case the small cubes marking the corners of the large ones were replaced by what look like flying fish, and the joining bars are nonexistent. Technically, this problem was much more difficult, for the fish had to be drawn decreasing in size, with very great accuracy; also, in order to enhance the suggestion of depth, the further away they got the less contrast had to be shown. This would have been fairly simple in a lithograph, but it is much more difficult with a woodcut because every bit of the print must be either black or white, and therefore it

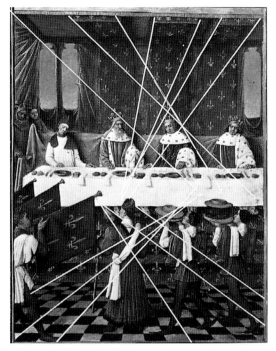

83. Intuitive perspective—all lines running away from the spectator should converge in the same vanishing point

85. *Cubic Space Division*, lithograph, 1952

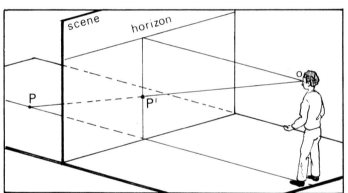

84. The principles of classic perspective

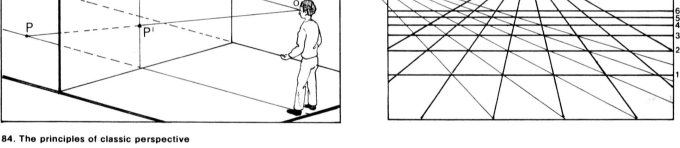

is impossible to achieve contrast by using gray. However, by using two colors Escher has managed to introduce what is known as light-perspective as a means of increasing the suggestion of space, beyond the considerable limitations imposed by geometric perspective. Figure 87 shows how exactly Escher worked out in perspective the situation around each grid-point.

The Discovery of Zenith and Nadir

Classical perspective lays it down that sets of parallel lines also running parallel with the picture are to be depicted as parallel lines themselves. This means that these sets of lines have no vanishing point, or, in the terminology of projective geometry, their point of intersection is at infinity. Now this would seem to belie our own experience; when we are standing at the bottom of a tower we see the rising vertical lines converging toward one point, and if we look at a photograph taken from this same viewpoint it becomes clearer still. However, the rules of classical perspective are in fact being followed, for the simple reason that our picture is no longer perpendicular to the ground. If we lay

the picture down horizontally and look down on it, then we shall see all the vertical lines converging toward a single point under our feet—in other words, the nadir. Escher took up just such an extreme viewpoint in an early woodcut *Tower of Babel* (1928), in which we can see the tragedy of the great confusion of tongues as described in the Bible played out on each of the terraces. In the wood engraving *St. Peter's, Rome* (1935) Escher has had a "personal experience" of the nadir, for here we have a case not merely of construction but of reality perceived. He spent hours on the top-most gallery of the dome sketching the scene that lay below him, and when tourists inquired, "Say, don't you get giddy up here?" Escher's laconic reply was, "That's the whole point."

The first time he consciously used the zenith as a vanishing point was in 1946 when he was making a small engraving for the Netherlands Ex-Libris Club. This print showed somebody clambering out of a deep well into the light of day. The caption ran. "We will come out of it"—a reference, this, to the aftermath of World War II.

Figure 91 shows how the zenith comes to be the point of intersection for the vertical lines. The photographer or painter lies on the ground and looks straight ahead and upward. The parallel lines l and m now appear at l^i and m^i in the picture, and they intersect at the zenith immediately above the observer.

86. Jean Fouquet, *The Royal Banquet* (detail) (the Bibliotheque Nationale, Paris). A natural impression is achieved notwithstanding the incorrect perspective

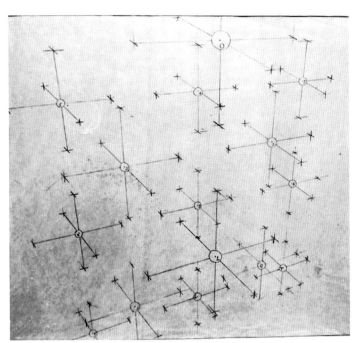

87. Preliminary study for *Depth*, pencil, 1955

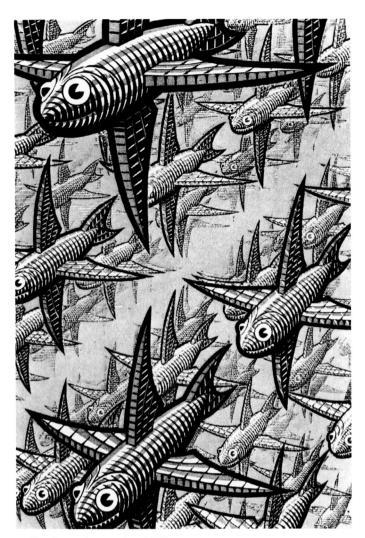

88. *Depth*, wood engraving, 1955

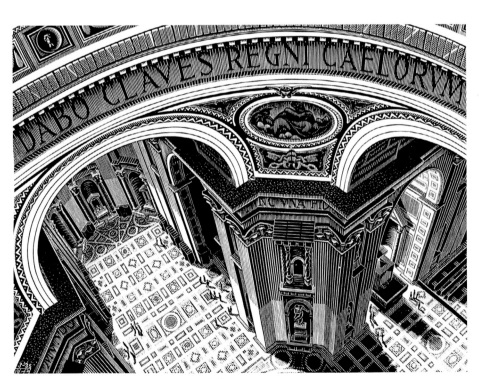

89. *St. Peter's, Rome*, wood engraving, 1935

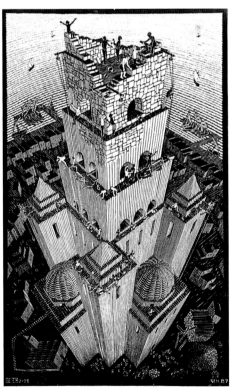

90. *Tower of Babel*, woodcut, 1928

49

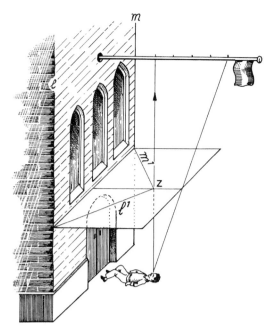

91. The zenith as vanishing point

The Relativity of Vanishing Points

If we draw a number of lines converging on a single point, then this point can represent all kinds of things, including zenith, nadir, point of distance, and so on. Its use depends entirely on its context. Escher was trying to demonstrate this discovery in the prints *Other World I* and *Other World II*, in 1946 and 1947.

In the 1946 mezzotint we see a long tunnel with arched openings. This tunnel runs, in rather hazy darkness, to a point that may be used, according to the context, as zenith, nadir, or distance point. If we look at the tunnel wall on the right and on the left, then what we observe is a lunar landscape lying horizontally. And the tunnel's arches are so drawn that they fit into the horizontal aspect of this landscape. In this context the vanishing point of the tunnel limits takes on the function of distance point.

However, if we turn to the upper part of the picture, we now find ourselves looking straight down on a lunar landscape, and we see a Persian man-bird and a lamp from above. (This sculpture is called a *simurgh* and was a present from Escher's father-

92. *Other World*, **mezzotint, 1946**

93. *Other World*, **wood engraving, 1947**

NEDERLANDSCHE EXLIBRIS-KRING 1 JAN. 1947

WIJ KOMEN ER UIT !

94. Bookmark with zenith as vanishing point (We Will Come Out of It), woodcut, 1947

in-law, who had bought it in Baku, Russia). So now this same vanishing point has changed to the nadir.

The final use for this vanishing point is that of zenith for the lower part of the print, for this time we are looking up into the heavens and seeing the bird and the lamp from below.

Escher himself was not at all happy with this print; the tunnel had no clear limits, the vanishing point was shrouded in darkness, and it took *four* planes to represent three landscapes.

A year later he produced a new version, in which he eliminated these (to him) irritating shortcomings. This four-colored woodcut holds together in a most ingenious way. The long tunnel has disappeared and we find ourselves in a strange room where "above," "below," "right," "left," "in front," and "behind" can be interchanged at will, according to whether we decide to look out of one or another of the windows. And he has thought up a very clever solution of the problem of how the threefold function of the single vanishing point can be suggested by giving the building three pairs of *almost* equal-sized windows.

In each of these *Other World* prints there is only one vanishing point. However, in *Relativity*, a lithograph made in 1953, there are three vanishing points lying outside the area of the print, and they form an equilateral triangle with sides two meters in length! Each of these points has three different functions.

Relativity

Here we have three totally different worlds built together into a united whole. It looks odd, yet it is quite plausible, and anybody who enjoys modeling could make a three-dimensional model of this print.

The sixteen little figures that appear in this print can be divided into three groups, each of which inhabits a world of its own. And for each group in turn the whole content of the print is *their* very own world; only they feel differently about things and give them different names. What is a ceiling to one group is a wall to another; that which is a door to one community is regarded by the other as a trapdoor in the floor.

In order to distinguish these groups from each other let us give them names. There are the Uprighters—for instance, the figure to be seen walking up the stairs at the bottom of the picture; their heads point upward. Then come the Left-leaners, whose heads point leftward, and the Right-leaners with their heads pointing to the right. We are incapable of taking a neutral view of these folks, for we obviously belong to the community of the Uprighters.

There are three little gardens. Upright number 1 (lower center)

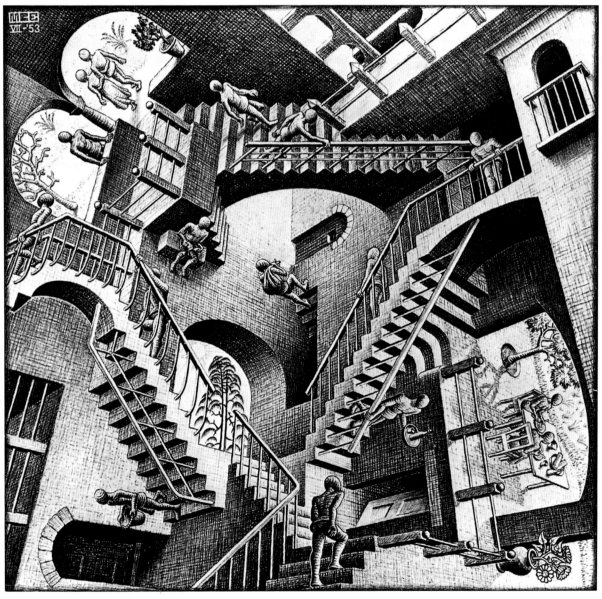

95. *Relativity*, lithograph, 1953

can reach his garden by turning to the left and walking up the stairs. All we can see of his garden is a couple of trees. If he stands beside the archway leading to his garden he has a choice of two stairways leading upward. If he takes the left-hand one he will come across two of his companions; up the right-hand stairway and along the landing, he will find the two remaining Uprighters At no point are we able to see the ground on which the Uprighters are standing, but quite large areas of their ceiling are visible in the upper part of the print.

In the center of the print, and up against one of the Uprighters' side walls, a Left-leaner sits reading. If he were to look up from his book he would see an Uprighter not far away from him. He would think this other's position very odd indeed, for he would appear to be gliding along in a recumbent pose. If he were to stand up and climb the stairs on his left, he would discover another remarkable figure skimming along over his floor, a Left-leaner this time; and the latter is quite convinced that he is on his way out of his cellar with a sack over his shoulder.

The Right-leaner goes up the stairs, turns to the right, and climbs a further stairway, where he meets up with one of his colleagues. There is someone else on this stairway—a Left-leaner who, in spite of the fact that he is moving in the same direction, is going *down*stairs instead of up. The Right-leaner and the Left-leaner are at right angles to each other.

We have no difficulty in discerning how the Right-leaner is going to reach his garden. But see if you can show that Left-leaner with the sack of coals on his back, and also the Left-leaner with the basket at the lower left of the print, how they can find theirs.

Two out of the three large stairways around the center of the print can be climbed on both sides. We have already seen that the Uprighters are able to use two of these stairways. How about

97. *Relativity* as woodcut. This block was never printed.

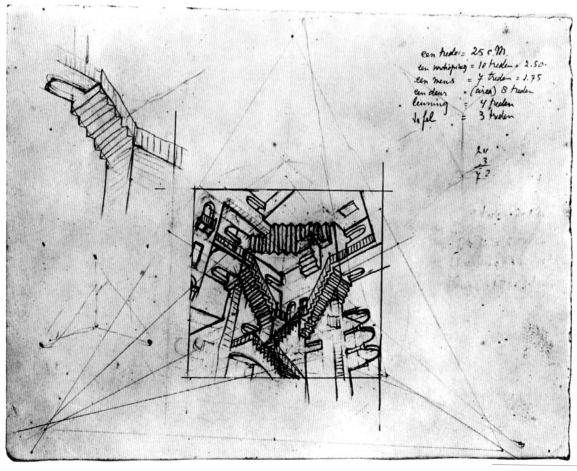

96. Study for *Relativity* with the three vanishing points, pencil, 1953

the Left-leaners and the Right-leaners—are they also able to walk up two or three stairways?

A very extraordinary situation arises on the stairway that runs horizontally across the top of the print. Is this same situation possible on the two other stairways?

Clearly there are three different forces of gravity working at right angles to each other in this print. This means that one of the three existing surfaces serves as a ground for each of the three groups of inhabitants, each of which is subject to the influence of only one of the fields of being.

I daresay an intensive study of this print would come in handy for astronauts; it might help them to get accustomed to the notion that every plane in space is capable of becoming a ground at will, and that one must be prepared to come across one's colleagues in any arbitrary position without getting giddy or confused!

Another version of *Relativity* is to be found, among Escher's nonmultiple reproduction work. That is, he made instead of a lithograph a woodcut of the same print. Apart from a proof, the block was never used for printing (figure 97).

New Rules

If we look at figure 98, then we shall see all the vertical lines converging toward the nadir, which is situated at the center of the lower edge of the drawing. It does not strike us as at all unnatural that these lines should be curved—rather than straight, as they ought to be according to the traditional rules of perspective.

This is one of the most important of all Escher's innovations

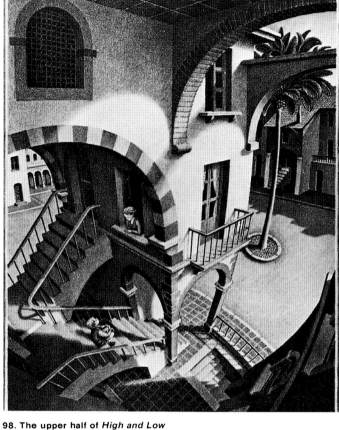

98. The upper half of *High and Low*

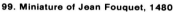
99. Miniature of Jean Fouquet, 1480

in the realm of perspective; these curved lines correspond to our view of space much more accurately than straight lines do. Escher never used this invention as the main subject of any print; he did, however, immediately start to bring it into play. Therefore, in order to give an idea of the way in which the new principle can be applied in a normal picture, we have reproduced just half of the print *High and Low*.

How is this exchange of straight lines for curved brought about? To find the answer to this we can look at figure 100. Here is a person lying on the grass between two telegraph poles and looking at two parallel wires. The points P and Q are closest to him. If he looks straight ahead, he sees the wires coming together at V_1; if he looks back over, he sees them meeting at V_2. Thus the telegraph wires, continuing endlessly on both sides, would be shown as the lozenge-shaped figure V_1QV_2P (figure 100b). But we simply don't believe it! We have never seen a kink like the one at P and Q, and so for the sake of continuity we end up with curved lines as in figure 100c.

We once confirmed the way in which this method of presentation tallies with what we really see, when we made a panoramic photograph of a river. We stood by the water's edge and took twelve photographs; after each exposure the camera was turned through about 15 degrees. When the twelve photographs were fixed together the picture of the river bank looked very much as in figure 101b.

Painters and draftsmen alike have arrived at this curved-line perspective. In a number of his works the miniaturist Jean Fouquet (*circa* 1480) "has drawn the straight lines curved" (figure 99) and Escher has told how once, when he was drawing a small cloister in a southern Italian village, he drew both the horizontal stretch of the cloister wall and the central church tower with curved lines—simply because that was how he saw them.

As we have said above, it is for the sake of continuity that we arrive at the use of curved lines. But what is the geometrical aspect of this? Is there any explanation of why these lines have

100. The telegraph-wire effect

101a.

101b.

102.

103a. **103b.**

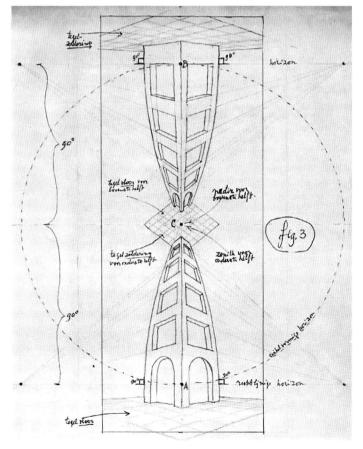

104-106. Escher's explanation of the construction of *High and Low*

got to be rendered as curved? And what sort of curves are they? Are they segments of a circle, parts of a hyperbola, or parts of an ellipse?

To get to the bottom of this matter we can study figure 101a. O is the eye of the man lying beneath the telegraph wires. When he looks straight ahead he can see the wires projected, as it were, onto a picture T_1. If he looks up a little then the picture moves up too (T_2). The picture always stands at right angles to the axis of his eye. The pictures T_1 to T_6 correspond to the series of river photographs. Of course it is artificial to take only six photographs; in reality their number is infinite (figure 101b). The whole picture, then, is cylindrical, and in this figure we see drawn a transverse section of it.

In figure 102 the whole cylinder is illustrated, and a is a line crossing the axis at right angles just as a telegraph wire would. Now how will this appear on the cylinder? To show this we must connect O to every point along a; and all the points where these connecting lines intersect the cylinder outline will be image-points of a.

Of course, we can also construct a surface passing through a and the point O. This plane intersects the cylinder in the form of an ellipse and a is shown as that part of it marked ABC.

In figure 103a, a and b are two telegraph wires, and also the cylindrical image is drawn in, together with the eye of the observer at O.

The pictures of a and b are the semiellipses a' and b'. We observe at the same time that they intersect at the vanishing points V_1 and V_2.

Finally we have to see that our picture comes out flat, because we want to show it on a flat surface. There is, however, no difficulty here. We cut through the cylinder along the lines PQ and RS and fold the upper portion flat (figure 103b); a' and b', though, no longer remain as semiellipses but turn into sinusoids. (Space does not allow of an explanation of this.)

Escher himself arrived at the above result by a process of intuitive construction. For instance he had no idea that his curved lines were sinusoids, yet it has been shown by measuring up his lines of construction that they do in fact correspond fairly accurately with sinusoidal curves. As he himself has explained in a letter on the subject of how he decided on curved lines, he used figures 104 to 106.

High and Low

As we have already remarked, Escher did not use sets of curved lines on their own in any print but proceeded to combine them with the relativity of vanishing points in the lithograph *High and Low* (1947). In the sketch (figure 106) he once sent to me with a view to clarifying the construction of *High and Low*, we can see not only the curves but also the dual function of the center point of the print, *i.e.*, as zenith for the lower tower and as nadir for the upper one.

Now, first of all, let us take a close look at *High and Low*. Together with *Print Gallery*, it is probably the best print in the whole of Escher's work. Not only is its meaning put over with very great skill, but the print itself is a remarkably handsome one.

Anyone coming up the cellar steps to the right of the bottom of the print will be quite incapable of understanding yet what his point of departure is. But he won't be allowed much time to stand around wondering; it is as though he were shot upward along the curved lines of the pillars and the palm trees to the dark tiled floors in the center of the print. But his eye cannot rest there; automatically it leaps further up again along the pillars and seems to be forced to swing away up the left across the archway, with its two-colored blocks of stone.

55

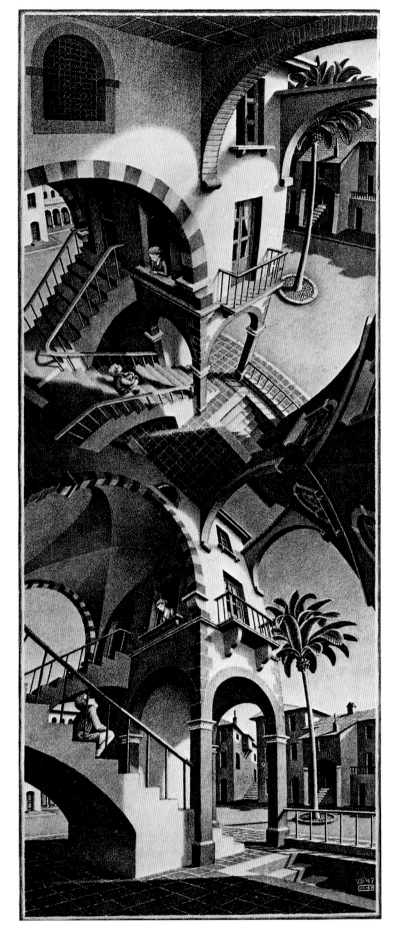

107. *High and Low*, lithograph, 1947

108. First version of *High and Low*, pencil, 1947

109. Second version of *High and Low*, pencil, 1947

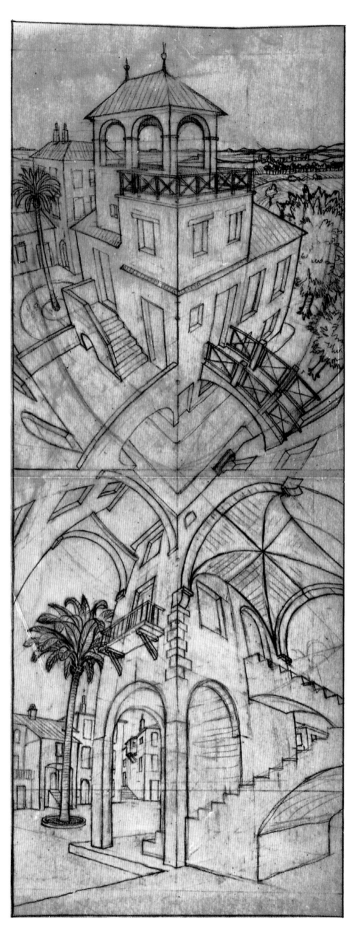

110. Version of *High and Low* with curved lines and two different images, pencil, 1947

We experience a similar soaring sensation if we try to follow the print from the top downward. At first, then, all we can do is leap up and down in this strange world where the main lines fan out from the center and plunge back into it again — such as the leaves of the palm tree, which appear twice in the print. To study this print in peace and calm, the best thing to do is to cover the upper half of it with a sheet of paper. There we find ourselves standing between a tower, on the right, and a house. At the top, the house is joined to the tower by two stones, and if we get the opportunity to stop and survey the scene we find we are looking down over a peaceful, sunny square such as might be met with anywhere in southern Italy.

On the left we can reach the first floor of the house up two flights of stairs, and here at the window a girl is looking down and holding a wordless conversation with the boy on the stairs. The house appears to stand at the corner of a street and to be joined to another house on the left, outside the print.

In the middle of the upper part of the uncovered section of the print we can see a tiled ceiling; this is immediately above us and its central point is our zenith. All rising lines curve inward toward this point. If we now slide the masking paper so that only the top half of the print is visible, as in figure 109, then we get a view of precisely the same scene again — the square, the palm tree, the corner house, the boy and the girl, the stairs, and the tower.

Just as forcibly as our gaze was at first dragged upward so it is now equally forcibly dragged downward. It is as though we are looking down on the scene from a great height; the tiled floor — yes indeed, a tiled *floor* now — comes at the bottom edge of the visible part of the sketch. Its central point is directly below us. What was at first ceiling is now floor, for the zenith has become the nadir and serves as vanishing point for all downward-curving lines.

At this point we can clearly see where it was we entered the print; we were entering from the door that leads to the tower.

And now we can take away the piece of paper and have a look at the complete drawing. The tiled floor (alias ceiling) appears three times over — at the bottom as a floor, at the top as a ceiling and in the center as both floor *and* ceiling. We are now in a position to study the tower on the right as a whole; and it is here that the tension between above and below is at its most acute. A little above the middle is a window, turned upside down, and a little below the middle is a window right way up. This means that the corner room at this spot takes on some highly unusual features. There must be a diagonal line running through this room, one that cannot be crossed without a certain amount of danger, because along this diagonal "above" and "below" change places, and so do the floor and the ceiling. Anyone who thinks he is standing fairly and squarely on the floor has only to take one step over the diagonal to find himself suddenly hanging down from the ceiling. Escher has not drawn this situation in the interior but he implies it by means of the two corner windows.

There is still more to observe in the middle of the print. Just go down the stairs toward the tower entrance; if you continue all the way down then you will be walking upside down toward the top of the tower. No doubt, on discovering this you will hurriedly return to walking right way up. Now just take a look out of the topmost window of the tower. Are you looking at the roofs of the houses, or at the underside of the square? Are you high up in the air or crawling about under the ground?

And then on the left, up along the stairway where the boy is sitting, there is a viewpoint from which you can get horribly giddy. Not only can you look down below to the central tiled floor, but you can look beneath-below. Are you hanging or standing? And how about the boy in the top half — suppose he should lean over the banisters and gaze down at himself on the lowest stair? And can the girl at the very top see the boy at the very bottom?

This is very much a print with a mind of its own, for the top

half is by no means the mirror image of the bottom half. Everything stays firmly in its right place. We can see above and below precisely as they are; only we are driven to take up two different standpoints. In the lower half of the print eye level comes just about where the letterboxes of the houses would have been, if drawn, and one's eye is instinctively drawn upward toward the center of the print. In the upper part of the print eye level is where the two highest windows come, and we look out of them almost automatically downward toward the center of the print. No wonder our eye cannot stay still, for it cannot decide between two equally valid standpoints. It keeps on hesitating between the scene above and scene below; and yet in spite of this the print comes over to us as a unity, a mysterious unity of two incompatible aspects of the same scene expressed visually.

Why did Escher draw this on his lithographic stone? What secret lurks behind this fantastic construction?

From the constructional point of view two main elements immediately come to the fore:

1. All vertical lines are curved. On closer inspection we find that some horizontal lines are also curved (for instance, those of the guttering on the tower, to the right of the center of the print).

2. All these "vertical curves" can be seen to radiate from the center of the print. Where the verticals in the top half are concerned, we interpret this central point, for the time being, as basepoint or nadir. Yet the same point also serves as zenith for the lower half.

The two elements mentioned above are independent of each other. Two very elaborate preparatory studies for the print *High and Low* were based on the second of these elements only—that is to say, the twofold function of an identical vanishing point in the drawing. Figure 108 does not use any curved lines. Escher considered this to be too uninteresting and so he turned the linear

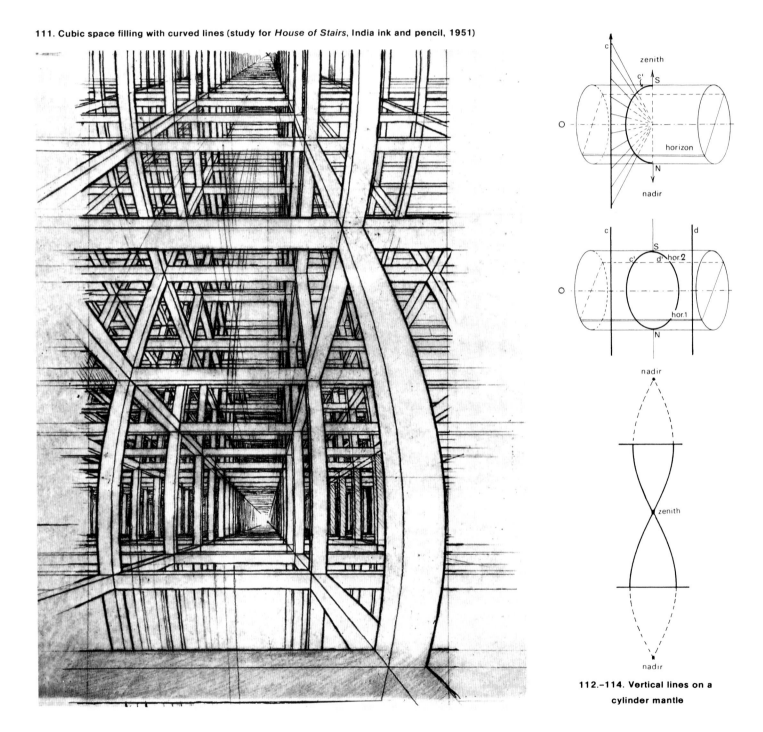

111. **Cubic space filling with curved lines (study for *House of Stairs*, India ink and pencil, 1951)**

112.–114. **Vertical lines on a cylinder mantle**

construction through 45 degrees. These drawings are thus in the same category as the *Other World* prints. It is not until one of the later preparatory drawings that we come across curved vertical lines pointing with increasing compulsion toward the zenith-cum-nadir point.

Strange as it may seem, this produces a greater suggestion of reality. The lower part of figure 110 is already very similar to the lower part of the finished print *High and Low*. However, none of the preparatory sketches approached here have yet managed to supply any satisfactory solution to the empty space around the zenith-nadir point. It has to be an area both of sky and of pavement, something which it is scarcely possible to draw. In the finished print, however, a truly remarkable unity has been achieved by the simple device of using only one picture twice. Thus the very difficult problem of the zenith-nadir point is solved with considerable charm; in the center we find some tiling that can serve both as floor covering and as ceiling decoration.

A New Perspective for Cubic Space-Filling

The drawing illustrated as figure 111 may be regarded as a trial run for the lithograph *House of Stairs* (1951). However, it deviates from it to such an extent that it would be preferable to deal with it as an entirely independent print, albeit one not intended for multiple reproduction. The subject is identical with that of *Cubic Space Division* (1952), which we have already considered, except that in this case the newly discovered laws of perspective, involving curved lines, have been applied and our eye is immediately caught by the relativity of vanishing points. Is the vanishing point at the top of the drawing a distance point or a zenith?

115. Grid for *House of Stairs*

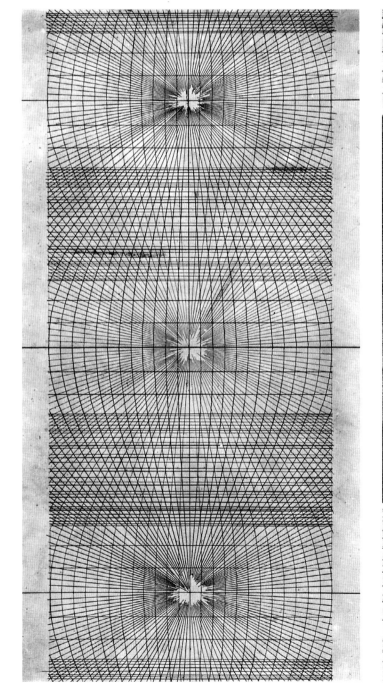

118. *House of Stairs*, lithograph, 1951

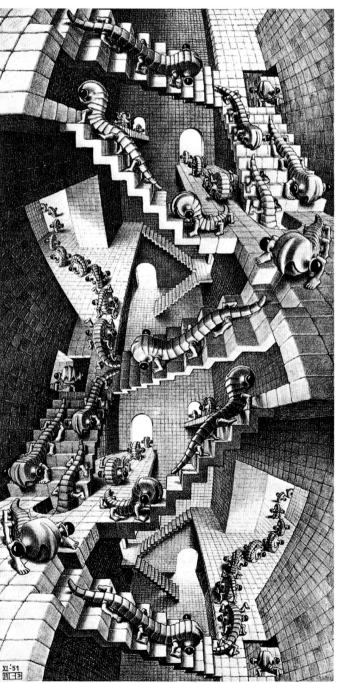

59

Let us reconstruct step by step the perspective grid that forms the basis of this drawing.

In figure 112, *O* is once again the position of the viewer's eye, and we can imagine a cylindrical image. How is the line *c* to be shown on the outline of the cylinder? If we construct a surface passing through *c* and *O* this will intersect the cylinder edge in the shape of an ellipse *c'* (only the front side of which has been drawn). In figure 113 we observe that the parallel vertical lines *c* and *d* are shown as the ellipses *c'* and *d';* the upper point of intersection is the zenith and the lower one is the nadir. If the cylinder side is then cut and folded open we arrive at figure 114, in which the sinusoids intersect at the zenith and then again at the nadir, the upper nadir point having coincided with the lower one on the cylinder.

Now we must find out what will appear on the side of the cylinder when both horizontal and vertical lines are drawn. Figure 116 shows the horizontal lines *a* and *b,* as already seen in figure 103a, coming out as *a'* and *b'*, and, at the same time, the vertical lines *c* and *d* coming out as *c'* and *d'*. Only the front half of these last two has been drawn, in order to keep the diagram easy to follow. Figure 117 gives the cylinder wall. The section between horizon 1 and horizon 2 almost coincides with the grid pattern

that Escher used for *High and Low*. But now comes the abstraction, on which the grid pattern has no bearing. We can imagine our sinusoids running upward and downward without limit. Every line that passes through a point of intersection on the vertical axis can represent a horizon, and any point of intersection can be zenith, nadir, or distance point, at random.

We have used only a few lines here in sketching a diagram of the guide pattern; a more complete version of it made by Escher, and which he used both for the drawing in figure 111 and for *House of Stairs*, can be seen in figure 115. Here only three vanishing points are to be seen; however, the diagram could be endlessly extended upward and downward.

House of Stairs

The basic pattern for this extremely complicated and sterile house of stairs, inhabited purely by mechanically moving beasts (Curl-ups, Escher calls them) — either walking on six legs or else, in their contracted state, rolling along like a wheel — is the grid shown in figure 115.

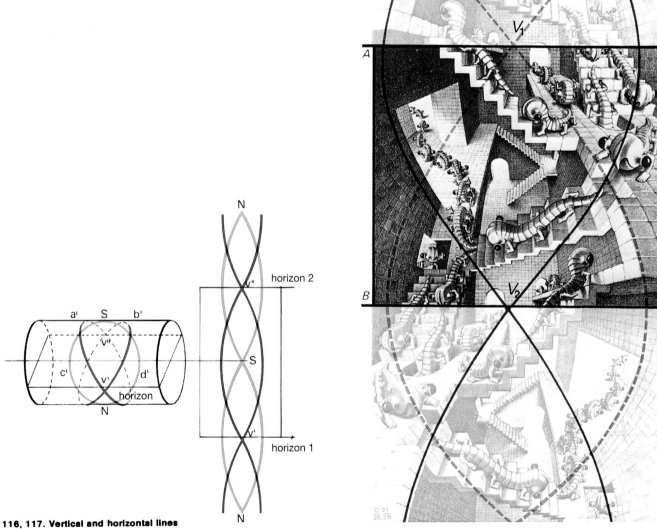

116, 117. Vertical and horizontal lines on the cylinder mantle

119. The construction of *House of Stairs*

In figure 119 we see a number of lines from this grid drawn across the print. It can be observed from this that the print has two vanishing points, through which horizontal lines are drawn. It can be quite unambiguously established for each Curl-up, whether such or such a vanishing point is zenith, nadir, or, for that matter, distance point. This is the case, for instance, with the large Curl-up, which is to be seen stretched out horizontally in the center of the plate. V_1 being its distance point and V_2 its nadir. A concomitant of all this is that the walls have a different significance for each one of the little creatures, and can serve not only as ground but also as ceiling or as side wall.

It is an infinitely complicated print yet one that is put together with the minimum of constructional material. Even the section between A and B contains all the essential elements. The section about it contains exactly the same elements as this A and B section, by means of glide reflection. This we can verify simply by transferring the A-to-B section, making a rough outline on tracing paper. If we turn this tracing over, with its underside uppermost, and then slide it upward, we shall find that it fits exactly over the higher section. The same thing applies to the section lower down. In this way it would be possible to make a print of infinite

length having congruent sections alternating with their mirror images. Figure 121 shows one of the many preparatory sketches for *House of Stairs*.

Perhaps it has already struck you that the cylinder perspective used by Escher, leading to curved lines in place of the straight lines prescribed by traditional perspective, could be developed even further. Why not a spherical picture around the eye of the viewer instead of a cylindrical one? A fish-eye objective produces scenes as they would appear on a spherical picture. Escher certainly did give some thought to this, but he did not put the idea into practice, and therefore we will not pursue this further.

120. Curl-up, the animal that lived in *House of Stairs*

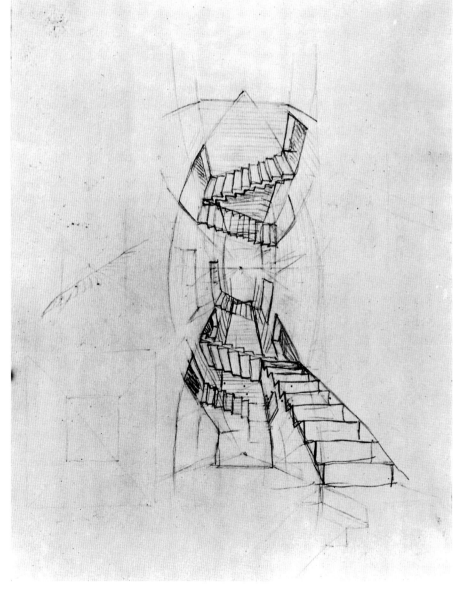

121. One of the preliminary studies for *House of Stairs*

9 Stamps, Murals, and Bank Notes

At first, Escher undertook almost every possible commission, for he felt duty bound to earn his own living, by his own work in so far as this was possible. He did illustrations for books. The last of these, a book about Delft for which he made the woodcuts in 1939, was never published. In 1956 Escher did both text and illustrations for a bibliophile edition published by the De Roos Foundation. Its subject is periodic surface-division. Escher found working on it a very tiresome experience. He had to try to put into words things he had long known but which he preferred to draw rather than write about. But what a pity it was that this book appeared in such a limited edition (of only 175 copies), for the text is excellent and makes a good introduction to the understanding of the prints in which Escher dealt with periodic surface-division.

In 1932 he even took over the job of official artist for an expedition in the boot of Italy. This expedition was under the leadership of Professor Rellini, and a Dutch participant was Leopold, codirector of the Netherlands Historical Institute in Rome. The drawings remained in Leopold's possession and nobody knows what became of them. Other smaller works commissioned included bookplates, wrapping paper and damask designs, magazine covers, and various solid items. These last were single pieces, except for a candy tin in the shape of an icosahedron decorated with starfish and shells, which was used by a firm of tin manufacturers (Verblifa) as a public-relations handout on the occasion of the seventy-fifth anniversary of the firm in 1963.

So there was, on the average, at least one commission a year to occupy Escher over and above his independent work. However, none of the commissions ever led to important new work. Inspiration did not flow from them; in fact the opposite was the case. He would choose for his commissioned work themes and designs he had already tried out in his independent work. This more or less goes without saying, for those who did the commissioning chose Escher for the job for the simple reason that they knew certain aspects of his work and wanted to have these expressed in the things they had ordered.

His designs for postage stamps can be counted among the most important of his commissions. He designed a stamp for the National Aviation Fund in 1935, one in 1939 for Venezuela, one for the World Postal Union in 1948, one for the United Nations in 1952, and a European stamp in 1956.

His work on the Netherlands bank notes was of longer duration. In July, 1950, he was commissioned to submit designs for the ten-guilder, twenty-five guilder, and hundred-guilder bills. Later there was the design for a fifty-guilder bill. He did some intensive work on it and had regular discussions about his designs with those who had commissioned them. In June, 1952, however, the commission was withdrawn; Escher had not been able to harmonize his designs with the requirements of the checkering machine used to produce the highly complicated curves needed to make forgery an exceedingly difficult operation. All that is now left of this work can be found in the museum of Johan Enschedé, bank-note printers in Haarlem.

He received the first commission for decorative work on a building in 1940, for three inlaid panels for the Leiden city hall; a fourth was added in 1941. Later commissions in this sphere were for work on interior and exterior walls, and on ceilings and pillars. Some of these he carried out himself—for instance, the wall paintings for the Utrecht cemetery; but in most cases he simply supplied the design.

The last great mural was completed in 1967. Engineer Bast, at that time director of posts and telegraphs, used to have the large 1940 *Metamorphosis* hanging in his board room and would gaze at it during boring meetings. So he recommended this self-same *Metamorphosis*, greatly enlarged, as a mural for one of the large post offices in The Hague. The original *Metamorphosis* print was four meters in length, and the plan was to make it four times as big. This did not work in very well with the dimensions of the wall, and so Escher spent half a year on an additional three meters. The final *Metamorphosis*, Escher's swan song, is now seven meters long. This print was enlarged with very great accuracy (to a length of 42 meters) on the post-office wall, to calm the troubled minds of all the people waiting at the counters.

A lesser commission, in 1968, was the very last—the tiling of two pillars in a school in Baarn.

Congratulations card commissioned by
Eugene and Willy Strens

122. Woodcut for a never published book about Delft, 1939

Escher working on mural for cemetery

125. Icosahedron with starfish and shells—a candy box produced by
Dutch can manufacturers as anniversary premium

123. The elongated version of *Metamorphosis* in the hall of the
Kerkplein Post Office, The Hague, 2006

126. Glazed tile column, new girl's
school, The Hague, 1959

124. Stamps designed by Escher

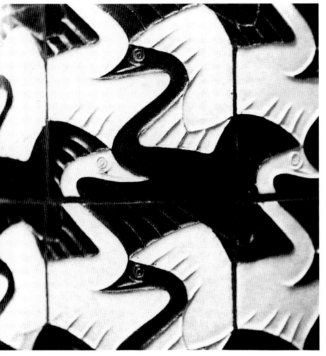

Detail of tiled column

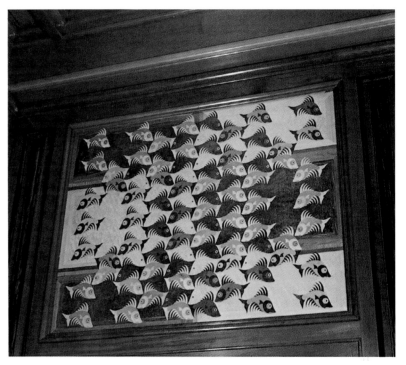

127. Two intarsia panels in the city hall of Leiden

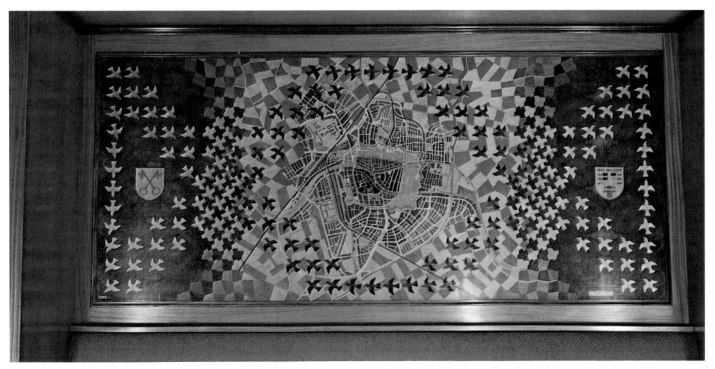

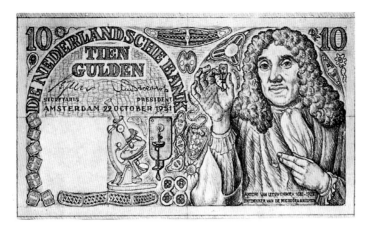
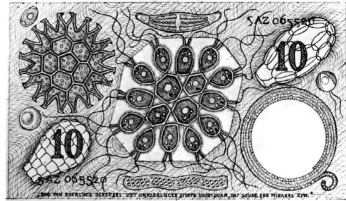
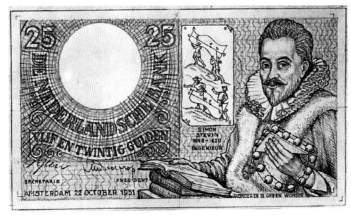
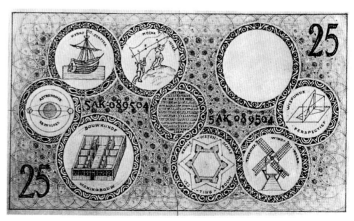
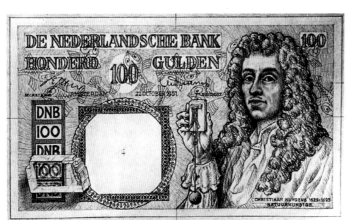
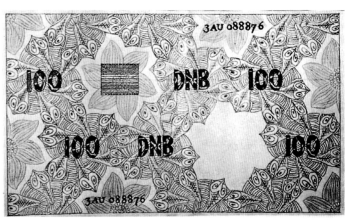

Design for a ten guilder bank note, with a portrait of Anthoni van Leeuwenhoek (1632-1723), the Dutch discoverer of microorganisms. Escher has gone to great pains to illustrate as many of van Leeuwenhoek's discoveries and pronouncements as he possibly can using both the obverse and reverse sides. The result is a pleasing if somewhat conventional composition.

Design for a 25 guilder note. The subject is the Dutch engineer Simon Stevin (1548-1620) whose writings contributed to the popularization of the natural sciences. The only typical trace of Escher to be found here is the ribbon-shaped ornamentation which encloses the nine circles on the reverse side.

Design for a 100 guilder note: obverse, reverse and watermark. The subject is the Dutch scientist Christian Huygens (1629-1695). At the bottom left corner of the obverse, we see a birefringent crystal, the properties of which were so profoundly studied by Huygens; and the way in which it is shown is typical of Escher. On the reverse there is a regular surface division with fish, and in the watermark a particularly attractive surface division with birds.

Courtesy of De Nederlandsche Bank N.V., Amsterdam

128. Bank note designs that were never used.

Part Two: Worlds that cannot exist

10 Creating Impossible Worlds

"Tell us, master, what is art?"

"Do you want the philosopher's answer? Or are you seeking the opinion of those wealthy folk who decorate their rooms with my pictures? Or again, do you want to know what the bleating herd think of it, as they praise or denigrate my work in speech or written word?"

"No, master — what is your own answer?"

After a few moments Apollonius declared, "If I see, or hear, or feel anything that another man has done or made, if in this track that he has left I can perceive a person, his understanding, his desires, his longings, his struggles — that, to me, is art."

I. Gall., Theories of Art

An important function of representational art is to capture an all-too-transient reality, to prolong its existence. The general notion is that anyone who has his portrait painted is being "perpetuated." Before photography brought this perpetuation within the grasp of all, it was *par excellence* the work of the artist. Not only in pictorial art, but throughout the whole history of artistic expression, we find the idealization of reality. The picture must be more beautiful than the actual object it represents. The artist must perforce correct any faults and blemishes by which reality is marred.

It was a very long time before people began to value, not the picture nor the idealization, but rather, the personal vision of the artist as it shows up in his work. Of course, the artist had never discarded this vision; it would have been impossible to do so. But he had not displayed the vision for its own sake, nor did those who commissioned the works, or the public themselves, value the artist for his self-revelation. It is expected of the present-day artist that his work should be first and foremost an expression of himself. Thus reality is now regarded more as a veil hiding the work of art than as the means whereby self-expression can be manifested. Thus we find emerging a nonfigurative art in which form and color are made the servants of the artist's self-expression. And at much the same time there has appeared a further negation of reality — that is to say, surrealism. Here shapes and colors are in no wise abstracted from reality. They do remain linked to recognizable things; a tree remains a tree — only its

leaves are not green; they are purple, or they have each taken on the shape of a bird. Or the tree has remained intact, in shape still a true-to-life tree, and yet its normal relationship to its surroundings has gone. Reality has not been idealized; it has been abolished, sometimes ending up in contradiction to itself.

If one should wish to see Escher's work, or at least a part of it, in the light of art history, then probably this can best be done against the background of surrealism — not that his work is surrealistic within the meaning attached to it by art historians. But the background of surrealism does serve as a contrast, and a selection of surrealistic work could be made at random for this purpose. We have chosen a few works by René Magritte, in the first place because Escher himself had a high regard for his work, and secondly because the extremely obvious parallels of subject matter, aim, and effect can be used to bring out the totally different nature of Escher's work.

In Magritte's *The Voice of Blood* (1961) we see a lonely plain. A river flows through it and a few trees stand at its edge: in the distance a dim mountain scene; in the foreground a hill on which there stands a mighty tree (an oak, perhaps), taking up more than half of the picture — strong and sturdy oak with an enormous crown of foliage. But Magritte makes the massive trunk come open, as though it were a tall, narrow, triple-doored cupboard revealing a mansion and a sphere. This is simply impossible. Such a "cupboard-tree" is a pure fake, quite incapable of growing or of producing any rich leafy adornment. What is worse, the dimensions of the mansion, with all its room lights blazing, are much greater than those of the hollow cupboard-tree itself. Or can it be a Lilliputian house? Is the sphere in the middle section also as big as the house? And what might be lurking behind that third door?

All we have to do is to close the doors and there stands a great and healthy tree once more: an impressive chunk of reality. Or is it really that? For, after all, we are now aware of the fact that ‚a house and a sphere live inside the trunk.

What are we to make of such a picture? Or rather: what does such a picture do to us? It is absurd, and yet it is attractive in its absurdity.

It is an impossible world. Such a thing cannot really exist. But then Magritte has in fact achieved it; he has turned a tree into a

129. René Magritte, *La Voix du Sang* (The Voice of Blood), 1961 (Museum des XX Jahrhunderts, Vienna, © Copyright ADAGP, Paris)

Here is a literary version of Magritte's visual absurdities. One can philosophize at great length over Magritte's surrealism but even his contemporaries and friends held radically different opinions about its meaning. I should like to look into the way in which Magritte uses, transforms — yes, does violence to reality, in order to stimulate our predilection for that which astonishes. In *The Voice of Blood* reality is upset in two ways. The massive interior of the tree trunk is made hollow; and different size-scales are used next to each other. Thus the thickness of a tree trunk becomes greater than the width of a fine big building. And so the resultant scene is presented as a bold assertion: "That's the way it is — crazy."

Nevertheless the whole rendering comes so close to reality that it is as though Magritte were telling us, "As a matter of fact, everything to do with our whole existence is crazy and absurd — a great deal more absurd than anything I have shown in this picture of mine." Magritte hides nothing, does nothing in secret. Our very first glance at his picture tells us, "This is impossible." And yet, if we take a closer look at it our intelligence begins to waver and we experience the pleasure which the abolition of reason brings. In our daily lives we are so imprisoned within the strait-jacket of reality that there is a great deal of pleasure to be obtained from giving ourselves over to surrealism, a temporary deliverance from reality. The discursive, reasoning intellect takes a vacation and we stagger around delightfully in an inexplicable world.

Anyone who tries to discover subtlety of meaning in all this, or who would like to know what it is all about in its deepest essence is probably looking for the very thing the painter is trying to release him from.

The impossible worlds Escher has made are something totally different from this. Although he expressed admiration for *The Voice of Blood* as a picture (and this is unusual in view of the low opinion that is all that he could muster for most of his contemporaries), he is not able to approve of the naivete with which Magritte sets forth his statements of visual absurdity. To Escher this is just shouting in the wind. It is all too easy to astound everybody momentarily with a daring statement decked out in attractive forms and colors. You must show that absurdity, *sur*-reality, is based on reality.

Escher has created impossible worlds of an entirely different character in that he has not silenced intellect but has in fact made use of it to build up the world of absurdity. Thus he creates two or three worlds that manage to exist in one and the same place simultaneously.

When Escher begins to experiment with the representation of simultaneous worlds he makes use of methods that display a remarkable similarity to those of Magritte. If we compare Magritte's *Euclidean Walks* (1955) with Escher's *Still Life and Street* (1937), it can be seen that the aims of the two artists do not widely diverge. In Magritte's case, inside and outside are mainly united by the painting on the easel, and in Escher's case by making the structure of the surface of the windowsill coincide with that of the pavement.

We find an even greater similarity when we compare Magritte's *In Praise of Dialectic* (1927) with Escher's *Porthole* (1937). With Magritte, any logic and any connection with reality are fortuitous; with Escher they are consciously pursued. The surrealist creates something enigmatic; and it must perforce remain an enigma to the viewer. Even if there were any solution to it, we should never be able to find it. We have to lose ourselves in the enigma, standing as it does for so much that is puzzling and irrational in our existence. With Escher, too, we find the enigma, yet at the same time — albeit somewhat concealed — the solution. With Escher it is not the puzzle that is of prime importance. He asks us to admire the puzzle but no less to appreciate its solution. To those who

cupboard and has placed a mansion on a shelf inside it. The title, *The Voice of Blood*, serves to heighten the absurdity. It would seem as though Magritte has chosen a title as difficult as possible to relate to the visual content.

In 1926 Rene Magritte wrote an unusual literary contribution to the first issue of a paper of which he himself was one of the editors: *"Avez-vous toujours la même épaule?"*

"Do you always have the same shoulder?" Thus one shoulder becomes a separate entity, and the possibility is introduced that one may or may not have it. The grammatical construction is perfectly normal but opens up something absurd: the possibility of being able to choose one's own shoulder at will. The meaning is surrealistic, but the statement is constructed from ordinary words and according to normal rules of grammar.

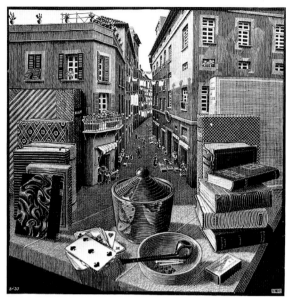

131. *Still Life and Street*, woodcut, 1937

130. René Magritte, *Les Promenades d'Euclide* (Euclidean Walks), 1953 (The Minneapolis Institute of Art, © Copyright ADAGP, Paris)

132. René Magritte, *L'Empire des Lumières II* (The Empire of Light II), 1950 (Museum of Modern Art, New York, © Copyright ADAGP, Paris)

cannot see this, or who, though seeing it, are incapable of evincing any appreciation of this highly rational element, the essential meaning of Escher's work remains a closed book.

Escher constantly returns to the theme of the mingling of several worlds. To the problems presented by this theme he finds ever more satisfying solutions. Furthest along this path stand *Rippled Surface* (1950) and *Three Worlds* (1955), prints of great skill and beauty; yet even they will reveal Escher's rational purpose only to such as have steeped themselves in the whole range of his work.

Magritte shows no signs whatever of being influenced in his work by the possibility of merged or interpenetrating worlds. On the contrary, the rational possibility of such merging would

be a hindrance to him, would reduce his power to surprise and be detrimental to the absurdity. How far apart from each other Escher and Magritte are, is perhaps best shown by a comparison between Magritte's *The Empire of Light II* (1950) and Escher's *Day and Night* (1938) or *Sun and Moon* (1948). *The Empire of Light* may be regarded as one of the most important of Magritte's works; for it he was awarded the Guggenheim Prize for Painting in Belgium. Magritte himself wrote of this picture:

What I put into a picture is what the eyes can see; it is the thing, or things, that people must know about already. Thus the things portrayed in the painting *The Empire of Light* are those things

69

133. *Porthole*, woodcut, 1937

134. René Magritte, *L'Éloge de la Dialectique* (In Praise of Dialectic), 1937 (Private Collection, London, © Copyright ADAGP, Paris)

which I know about, or, to be precise, a nocturnal scene together with a sky such as we can see in broad daylight. *It seems to me that this summoning up of night and day together gives us the power to be both surprised and delighted.* This power I call poetry.

By summoning up day and night together, Magritte seeks to surprise and to delight — to surprise because it is an impossibility. When Escher summons up *Day and Night* or *Sun and Moon* it is also in order to surprise . . . but precisely because it is not an impossibility. It does surprise and delight, simply because it has a look of the impossible about it. But it surprises still more because Escher has discovered a means, a perfect, complete pictorial logic, whereby the impossible can be turned into the possible.

If we seek a literary parallel to this we can find it, so far as Escher is concerned, essentially in the detective novel. The mystery makes no sense until it can be seen in the light of the more-or-less thrilling denouement. And, also in the detective novel, the mystery can take on an absurd, surrealistic form, as is often the case with G. K. Chesterton. In *The Mad Judge*, the judge playing hopscotch in a prison yard is a complete absurdity. In *The Secret Document*, a sailor jumps overboard; no splash is heard, no movement is seen in the water, the man has completely disappeared. Then we have somebody stepping out of the window and leaving no trace. A work of Magritte's such as *The Unexpected Answer* might well have served as an illustration for this. But Chesterton's triumph always turns up a dozen pages later, when he demonstrates that what at first seemed so weird is really strictly logical, normal, part of an overall grand design. The range of Escher's impossible worlds is much greater than the theme from which we

have so far drawn our examples. Escher shows us how a thing can be both concave and convex at one and the same time; that the people he has created can walk, at the same moment and in the same place, both upstairs and down. He makes it clear to us that a thing can be simultaneously inside and outside; or, if he uses differing scales in the one picture, there exists a representational logic capable of rendering this coexistence as the most natural thing in the world.

Escher is no surrealist, conjuring up for us some mirages. He is a constructor of impossible worlds. He builds the impossible according to a strictly legitimate method that everyone can follow; and in his prints he demonstrates not only the end product but also the rules whereby it was arrived at.

Escher's impossible worlds are discoveries; their plausibility stands or falls by the discovery of a plan of construction, and this Escher has usually derived from mathematics. And useful plans of construction were not just there for the picking!

Finally, we should like to point to one uniquely fascinating aspect of Escher's impossible worlds. A century ago it was impossible to travel to other planets or to transmit pictures of them. With the advance of science and technology all sorts of things that are still impossible today will become realities. Nevertheless, some things there are that are totally impossible, such as a squared circle. It is to this latter category that Escher's impossible worlds belong. They remain forever impossible and have their existence purely and simply within the bounds of the print, and by virtue of the imaginative power of the man who made them.

135. René Magritte, *La Reponse Imprevue* **(The Unexpected Answer), 1933**
(Museés Royaux des Beaux Arts de Belgique, Brussels)
(© Copyright ADAGP, Paris)

11 Craftsmanship

Drawing

"I am absolutely incapable of drawing!" This is a most extraordinary remark to come from someone who was busy drawing from earliest childhood to the age of seventy. What Escher really means is that he was incapable of drawing when relying only on his imaginative faculty. It is as though the essential link were between his eyes and his hands. In his case the intermediate emergence of visual concepts is but poorly developed. In his later prints, whenever buildings and landscapes were needed as a setting, he copied these with considerable accuracy from real life. In the calm period that followed the completion of a print he would go through his portfolios of travel sketches, for here was the source material he needed in order that new ideas should take shape.

Whenever he needed human or animal figures he had to draw these from nature. He modeled his Curl-up creatures, in various attitudes, in clay. The ants that are to be seen on *Moebius Strip II* were modeled in plasticine; a praying mantis that landed on his drawing pad during one of his wanderings in southern Italy was swiftly drawn and later pressed into service as a model for his print *Dream*, and when he was working on the last of his prints, *Snakes*, he bought some books of snake photographs. For his print *Encounter* he needed little people in all the required positions; then he posed himself in front of the mirror. "Yes, I am quite incapable of drawing, even the more abstract things such as knots and Moebius rings, so I make paper models of them first and then copy them as accurately as I can. Sculptors have a much easier job. Everyone can model clay—I have no difficulties with that. But drawing is terribly arduous for me. I can't do it well. Drawing, of course, is much more difficult, much more immaterial, but you can suggest much more with it!"

136. Clay models of Curl-ups for *House of Stairs*

139. Escher's first lithograph: *Goriano Sicoli, Abruzzi*, 1929

137. Ant, plasticine model for *Moebius Strip II*

138. Cardboard model for *Knots*

73

Lithographs and Mezzotints

During his time as a student Escher came to know several graphic techniques. But etching did not suit him at all because, owing to his allegiance to the linocut and woodcut, he had a predilection for working from black to white. To start with, all is black; whatever he cuts away will be white. This was how he made his scraper drawings. A sheet of paper was entirely blacked over with wax crayon, then, taking his knives and pens, he removed those parts that were to become white.

The need to be able to make reproductions of his work also led to the lithograph. At first he went to work on this medium just as though he were trying to execute a scraper drawing on the lithographic stone. The whole surface was blackened and the white was removed. All his early lithographs were produced in this way. In the first lithograph, *Goriano Sicoli* (1929), showing a small town in the Abruzzi, one can see how unaccustomed he still was to the new technique. He used too great an area of the stone, with the result that it is difficult to take good copies of the whole print.

From 1930 onward he was drawing on the stone normally, with lithographer's chalk. It gave him greater freedom of expression than the woodcuts. There was no longer any problem over a smooth transition from black, through gray, to white. He never printed his own lithographs. In Rome, this was done for him by a small commercial printing firm and in the Netherlands also he had a number of skilled people who could do it for him. It is a pity that when he began this work he used borrowed stone. Owing to the closure of a printing firm from which he had borrowed stones, these latter were lost, and so a large number of prints could no longer be printed.

To anyone who is very fond of the woodcut, with its striking contrast between black and white, a lithographic print is always something of a disappointment. The lithographic chalk drawing on the stone shows up blacks very clearly and well, and there is a good range of contrast. On printing, however, this contrast range recedes and becomes in fact less marked even than what can be achieved with a pencil drawing.

In Brussels Escher made the acquaintance of Lebeer, the keeper of the print room, who was also buying his work privately. Lebeer advised him to turn his attention to the mezzotint, sometimes called the black art. To initiate this process one takes a copper plate and roughens it all over (an endless task, done by hand). This roughened plate holds a great deal of ink and on printing leaves a deep black surface. For the parts that are to be white or a certain shade of gray the roughened plate has to rubbed more or less smooth with steel tools. This is also a technique working from black to white; thus, in contrast to the lithograph, it produces a good range of contrast.

Escher made only seven of these because the technique was particularly time-consuming and because only fifteen or so good prints can be made from each plate. Only if the copper plate is specially hardened or tempered beforehand are more prints possible. All his mezzotints were printed by the bank-note printing firm Enschede, in Haarlem.

Escher was not in any way fettered by the techniques which he

140. *Rome at night (Basilica di Massenzio)*, woodcut, 1934

used. He regarded them as a means to an end, and only experimented with them so long as they could be considered needful. If one studies the finest details of his woodcuts through a magnifying glass, one can form an idea of how keen was his eye and how firm his hand.

Multiple Reproduction

"I make things to be reproduced in quantity; that's just my way." When Escher was at high school in Arnhem he made linocuts. The fairly brief training that he received from de Mesquita consisted entirely in an extension of this work. He applied himself almost exclusively to woodcuts, using side-grained wood, which meant that the structure of the wood was still visible in the prints. One of the most beautiful examples of this is certainly the large portrait of his wife, *Woman with Flower* (1925). His virtuosity was apparent in a series of prints which he made of nocturnal scenes in Rome, in 1934. For some of these both sketch and woodcut were completed within twenty-four hours! And in each print he had restricted himself to cutting in one or more predetermined directions, so that this series of prints became a kind of sample card of possibilities.

He did make one more linocut, *Rippled Surface*, in 1950 (figure 149) and that was for the simple reason that he had no suitable wood on hand at the time.

As he came to feel the need to depict finer details, he gradually

began to change over from side-grain, which de Mesquita had so assiduously recommended, to end-grain wood. Then it was that the first wood engravings appeared: *Vaulted Staircase* (1931), and *Temple of Segeste, Sicily* (1932). The woodcuts and wood engravings were printed, not on a press, but by an old Japanese method using a bone spoon. The printing ink was spread over the wood with a roller and a sheet of paper was laid on it. Then each place of contact between wood and paper was rubbed over with the bone spoon. It is a primitive and complicated method, and yet the wood remains sound and serviceable for a much longer time than is the case with a press; with the latter one has to exert a much greater pressure in order to obtain a good print.

If more than one block of wood was needed, he used an equally primitive method to ensure that the various blocks were printed in the correct positions. Notches on the edge of each block indicate the points where the block is to be held in position with pins. By making notches on the second block correspond with those of the one that was used first, it can be fixed accurately in place.

Modern Art

When an exhibition was held showing the work of twenty-two Dutch artists (at which one of Escher's prints was hung) he sent me the complimentary copy of the catalog he had received. On the cover he had scribbled, "Whatever do you make of such a sick

141. *Rome at Night (Column of Trajanus)*, woodcut, 1934

142. *Vaulted Staircase*, wood engraving, 1931

75

effort as this? Scandalous! Just throw it away when you have looked at it."

His unsympathetic attitude toward most expressions of modern art served as a key to his view of his own work. He could not put up with anything obscure. During an interview with a journalist, the conversation turned on the work of Carel Willink. "If Willink paints a naked woman in a street, I wonder to myself, 'Now, why should he do that?' and if you ask Willink you'll get no reply. Now, with me, you will always get an answer to the question why."

When the conversation turned to the high prices that modern art fetches, Escher became furious. "They are complete fools! It's like the Andersen fairy tale—they buy the Emperor's new clothes. If the art-dealers smell a profit, the work is pushed and sold for big money." But then he took back his words somewhat. "I don't want to condemn it too much. I don't know—it's a closed door to me."

At that time Escher did not foresee that his work would also attract collectors to spend a lot of money on his prints, and that after his death thousands of dollars would be paid for a single copy!

He reproached most modern artists for their lack of professional skill, referring to them as daubers who can do no more than play around. For a Karel Appel he could not muster the slightest feeling of appreciation. But for Dali, on the other hand: "You can tell by looking at his work that he is quite an able man." And yet he was jealous of any artists who had a complete mastery of technique. Among the graphic artists he regarded Pam Ruiter and Dirk van Gelder as being more skilled than himself. However, he was not necessarily attracted by mere mathematical precision. Vasareli's abstract work he regarded as soulless and second-rate. "Maybe other artists can work up an appreciation of my work, but I certainly can't for most of what they turn out. Anyway, I don't want to be labelled as an artist. What I have always aimed at doing is to depict clearly defined things in the best possible way and with the greatest exactitude."

That spontaneity of work which the modern artist holds in such high esteem is altogether lacking in Escher. Every print called for weeks and months of thought and an almost infinite number of preparatory studies. He never allowed himself any "artist's license." Everything was the outcome of a long quest, because it had to be based on an inner principle. This detective work on underlying concepts is the most important feature of his work. The setting, the houses, the trees, and the people are all so many "supers" whose job it is to call attention to things that are taking place according to the rules in the print.

In spite of his infallible sense of composition, refinement of form, and harmony, these things are but by-products of a thoroughly explored inner discipline. When he had almost completed *Print Gallery*, I passed a remark about those ugly curved beams in the top left-hand corner; they were horrible! He looked at the drawing pensively for a while and then he turned to me and said, "You know, that beam has just got to go like that. I constructed it with great exactness; it can't go any other way!" His art consists of discovering principles. The moment he is on the track of something he has got to follow it with sensitivity and, indeed, obedience.

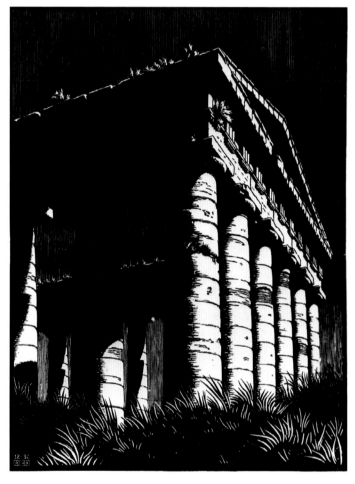

143. *Temple of Segeste, Sicily,* wood engraving, 1932

12 Simultaneous Worlds

144. Jan van Eyck, *The Arnolfini Marriage* (detail)
(The National Gallery, London)

Globe Reflections

Two different worlds existing in one and the same place at the same time create a sense of being under a spell. For this is an impossibility; where one body is, there the other cannot be. We have to think up a new word for this impossibility—"equilocal"— and this we can define as "occupying the same place simultaneously." None but an artist can give us this illusion, thereby procuring for us a sensation of the first order, a sense experience wholly new.

From 1934 onward Escher made prints in which he was consciously seeking this sensation of equilocality. He managed to unite two, and at times three, worlds so naturally in a print that the viewer feels, "Oh yes, that is quite possible; I am quite able to comprehend in thought two worlds at the same time."

Escher discovered an important expedient for these—reflections in convex mirrors. In one of his first great drawings, the *St. Bavo's, Haarlem* (figure 29) we can already see an intuitive adoption of it.

In 1934 *Still Life with Reflecting Sphere* appeared, a lithograph in which not only the book, the newspaper, the enchanted Persian bird, and the bottle can be seen, but also the whole room and the artist himself appear indirectly, as a reflection.

A simple construction taken from optical geometry (figure 148) shows us that this whole mirror-world is contained within a small area within the reflecting globe, and indeed that, in theory, the whole universe, except for that part of it immediately behind the sphere, can be reflected in such a globe.

This reflection in a convex mirror can be found among the works of several artists, as, for instance, in the famous portrait of the Arnolfinis where man and wife, together with the room in which they are standing, are shown again very clearly indeed, reflected in the mirror. But with Escher this is no mere fortuitous element, for he is consciously seeking new possibilities, and so, over a period of almost twenty years, prints keep appearing in which reflections serve to suggest simultaneous worlds.

In *Hand with Reflecting Sphere*, a lithograph made in 1935, this phenomenon is depicted in so concentrated a form that we could well class it as *the* globe reflection; for the hand of the

145. *Still Life with Reflecting Sphere*, lithograph, 1934

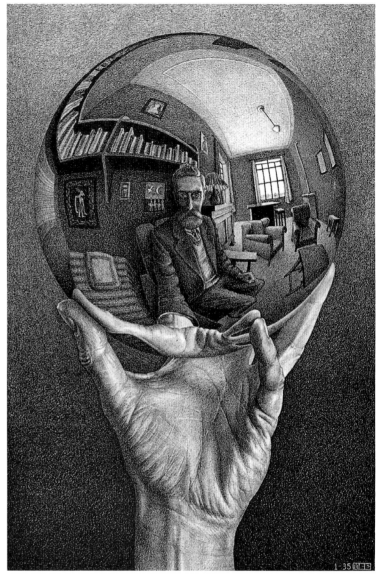

146. *Hand with Reflecting Sphere*, lithograph, 1935

artist is seen to be supporting not only the globe itself but also the whole of the area surrounding him, in this mirror-picture. The real hand is touching the reflected hand, and at their points of contact they each have the same dimensions. The center of this mirror world is, not by chance but in the essential nature of things, the eye of the artist as he stares at the globe.

In the mezzotint *Dewdrop* (1948) we can see three worlds at once, the succulent leaf, the magnified section of that leaf under the drop of water, and the mirror picture of the area facing the drop—all this in a perfectly natural setting; no man-made mirror is needed.

Autumn Beauty

It is also possible to suggest the interweaving of several different worlds by means of flat mirror reflections. We see a first attempt in this direction in 1934, in the lithograph *Still Life with Mirror*, in which a little street (drawn in the Abruzzi) comes right into the world of a bedroom.

In the linocut *Rippled Surface* (1950) all this takes place in a much more natural manner. A leafless tree is reflected in the surface of the water, which would not show up at all were it not for the fact that its smoothness is disturbed by a couple of falling raindrops. Now both mirror and mirror-picture manifest themselves in one and the same place. Escher found this an unusually difficult print to make. He had closely observed the scene in nature

147. *Dewdrop*, mezzotint, 1948 (detail)

78

148. In a convex mirror the eye sees the mirror image of the whole universe, with the exception of the part that is covered by the globe. The farther the eye is removed from the convex mirror, the larger the uncovered part becomes.

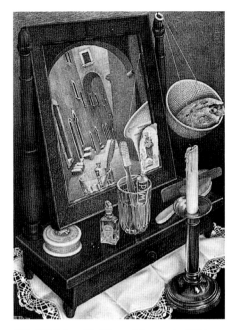

150. *Still Life with Mirror*, lithograph, 1934

149. *Rippled Surface*, linocut, 1950

151. Pencil study for *Rippled Surface*

152. *Three Worlds*, lithograph, 1955

153. *Magic Mirror*, lithograph, 1946

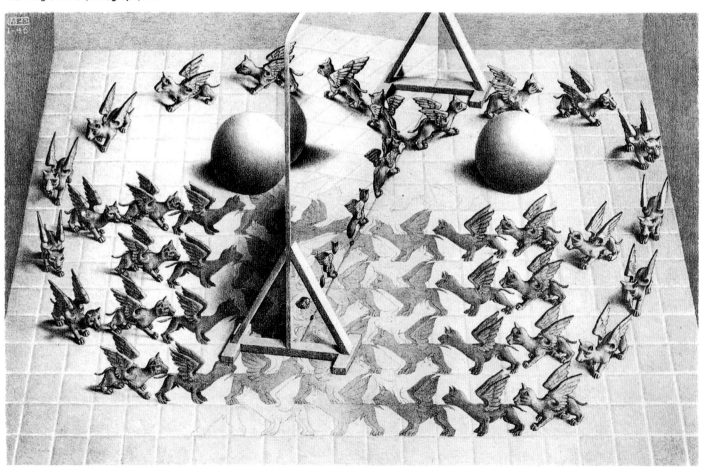

80

Studies for the fish in *Three Worlds*

154. *Sun and Moon*, woodcut, 1948

and reconstituted it at home without the aid of sketches or photographs. The circular waves had to be shown very precisely as ellipses, in order to suggest the reality of a water surface which was receding into the distance. One of the many working drawings is reproduced here (figure 151).

While *Rippled Surface* with its bare trees and pale solar disk, and its two worlds merged, gives an impression of winter or late autumn, the print *Three Worlds* is typically autumnal. "I was walking over a little bridge in the woods at Baarn, and there it was right before my eyes. I simply had to make a print of it! The title emerged directly from the scene itself. I returned home and started straight away on the drawing."

The direct world is represented here by the floating leaves; they indicate the surface of the water. The fish represents the underwater world and everything above the water is shown as a reflected image. All these worlds are intertwined in a perfectly natural way and presented with such an atmosphere of melancholy autumn mood that the real meaning of the print's title is clear only to those who will give it more than a moment's thought.

Born in a Mirror

In the lithograph *Magic Mirror* (1946), Escher takes things a step further. Not only is there a reflected image but it is even suggested that the reflections come to life and continue their existence in another world. This calls to mind the mirror world from *Alice in Wonderland* and *Through the Looking Glass*, stories that greatly delighted Escher!

On the side of the mirror nearest to the viewer we can see, under the sloping stay, a tiny wing appearing together with its mirror image. As we look further along the mirror there gradually emerges a fully winged dog. Yet this is not all, for its mirror image is growing similarly; and as the real dog moves away from the mirror so does the mirror dog on the other side. On arrival at the edge of the glass this mirror image appears to take on reality. Each line of animals doubles itself twice as it moves forward and so these lines together make a regular space-filling in which white dogs develop into black ones, and vice versa.

Both realities multiply and merge into the background.

Intermingling of Two Worlds

In the woodcut *Sun and Moon* (1948) Escher has used surface-division as a means of creating two simultaneous worlds. Fourteen white and fourteen blue birds fill the entire area. If we turn our attention to the white birds then we are transported into the night; fourteen bright birds show up against the deep blue night sky, in which we can observe the moon and other heavenly bodies.

Now if we concentrate on the blue birds we see these as dark silhouettes against the bright daytime sky, with a radiant sun forming the center. On closer inspection we discover that all the birds are different; so we are dealing here with one of the very few entirely free surface-fillings that Escher has made. (*Mosaic: I,* 1951, and *Mosaic: II,* 1957).

81

155. *Savona*, black and white crayon, 1936

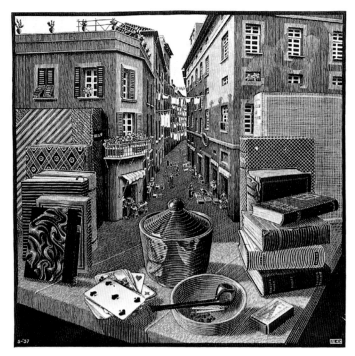

156. *Still Life and Street*, woodcut, 1937

Windowsill Turned Street

A small street in Savona, near Genoa, was the origin of the association of ideas to be found in the woodcut *Still Life and Street* (1937). Here we have two quite distinctly recognizable realities bound together in a natural, and yet at the same time a completely impossible, way. Looked at from the window, the houses make book-rests between which tiny dolls are set up. Looked at from the street, the books stand yards high and a gigantic tobacco jar stands at the crossroads. Actually, the fitting-together device is a very simple one. The borderline between windowsill and street is dispensed with, and the materials of the windowsill merge with those of the street.

In the same year, 1937, Escher made the woodcut *Porthole*, and in this we can see a ship through a porthole and can at the same time take the print to be a painting of a ship in a frame shaped like a porthole. In *Dream* (1935), we see the effigy of a sleeping bishop surrounded by vaulted archways. A praying mantis is sitting on the effigy's chest. But the world of the marble bishop and that of the praying mantis are totally different. The praying mantis is magnified more than twenty times.

Thus we find running through the whole of Escher's work attempts, often with completely different means, to connect different worlds together, to make them pass through one another, to weave them together—in short, to make them coexist. Even in prints that do not have this amalgam of worlds as their main objective, we still find the theme appearing obliquely, as for instance in the mezzotint *Eye* (1946), *Double Planetoid* (1949), *Tetrahedral Planetoid* (1954), *Order and Chaos* (1950) and *Predestination* (1951).

The Print That Escher Never Made

There are many prints for which Escher drew sketches but which never reached completion. But for none of these did Escher so greatly grieve as for the one I am now going to describe to you. Do you know the fairy tale about the magic gate? In a completely normal landscape—meadows, clumps of trees, low hills—there stands a very ornamental gate. A senseless gate, for it gives access to nothing; all you can do is walk around it. But as soon as the gate opens it leads into a lovely, sun-drenched landscape, with strange kinds of plant growth, golden mountains, and rivers flowing with diamonds. . . .

This fairy tale is known in many countries and has numerous variations. This magic gate would fit perfectly into the series of prints we have been dealing with in this chapter. Did Escher ever consider making it? He had it on his mind first in 1963. What brought it to his attention was a visit from Professor Sparenberg, who told him something about Riemann surfaces and showed him a sketch (figure 158). Two weeks later Escher wrote a letter to the professor referring to the sketch and making a further suggestion. As the content of this letter is very indicative both of Escher's method of working and of his thought processes, we quote the following more important passages:

June 18, 1963
. . . This idea is so fascinating that I only hope . . . I shall be able to obtain the necessary peace and quiet and concentration to be able to work out your plan in a graphic print.

May I, in the first place, have a try at putting into words what I, as a mathematical layman, see in your sketch. . . .

For convenience' sake, I call your "two spaces" *Pr.* (for the Present) and *Pa.* (for the Past). It was only after the closer examination of your drawing that the key to it dawned on me, i.e., that *Pr.* may be regarded not only as a gap in *Pa.* but also as a disk masking a part of *Pa.* Thus *Pr.* is both in front of *Pa.* and also behind it; in other words they each exist as separate spatial projections in exactly the same area of the drawing.

Now there is something in your method of presentation that does not entirely satisfy me—that there is a much greater area devoted to *Pa.* than to *Pr.* Is the past so much more important than the present? As they are shown here as "moments" it would seem to me logical, and more aesthetically satisfying, from the point of view of composition, if they were each to take up an equal amount of space.

In order to achieve such an equivalence I submit the enclosed schematic sketch for your judgment [figure 158]. It may well be

157. *Dream*, wood engraving, 1935

158. Sketch made by Prof. Sparenberg and, *below*, Escher's interpretation of his idea.

that I am doing violence to Riemann with it and am adulterating the purity of mathematical thought.

It seems to me that the advantage of my apportionment over yours would be as follows. In the center two bulges lie next to each other; on the left is *Pa.*, ringed around by *Pr.*, and on the right *Pr.* ringed by *Pa.*

When I think of the flow of time I realize that it moves from the past, via the present, to the future. Leaving the future out of our consideration (for it is unknown and so cannot be depicted) there is a stream moving from *Pa.* to *Pr.* Only historians and archaeologists have thoughts that sometimes move in the opposite direction; maybe I too might be able to imagine it that way.

But the logical stream, from *Pa.* to *Pr.*, might be depicted by, say, a perspective series of prehistoric birdlike creatures in flight, diminishing toward the horizon, maintaining their correct shape (in their domain, *Pa.*) until they reach the frontier of *Pr.* The moment they cross this frontier they change, let us say, into jet airplanes belonging to the domain *Pr.*

Now there is a further advantage, in that two streams can be represented, i.e., the one to the left of the horizon emerging from the *Pa.* supply bulge, increasing in size in the direction of the edge where *Pr.* is to be found; and the one to the right of the *Pa.* edge, speeding away, and diminishing, toward the horizon of the *Pr.* swelling.

Suggestive though the telegraph wires in your drawing may be, they don't please me, because in an archaic, prehistoric world, the telegraph hadn't been invented.

You can see how this whole problem takes me! By writing about it I am hopeful that I shall achieve a greater clarity of thought and that I can stir up my inspiration (to use that great clumsy word again).

This whole problem persisted in Escher's mind as the problem of the magic gate he not only wanted to draw, but to which he so much wanted to give a form that would serve as a compelling evidence for the truth, the reality of what he had depicted.

It is a great pity that he was unable to achieve this *tour de force*. The thought of it nagged at him like a headache. And perhaps no other man but Escher could have depicted this for us, using methods he had adopted in his other prints in so masterly a way—that is, reflection, perspective, surface-division, metamorphoses, and the approach to infinity.

13 Worlds That Cannot Exist

Concave or Convex?

161.

What do you see when you look at the above print? Is it the outer edge of a convex, shell-shaped ceiling ornament? If so, then you are probably sitting with the main stream of light coming from the right. Contrariwise, if what you see is a shell-shaped basin set in the floor, then the light that aids your vision must be coming from the left, for the image projected on your retina allows of both of these interpretations. You can see it as either concave or convex. One minute your "cerebral calculating center" works it out that you are seeing something convex, and the next minute it tries to persuade you that you are seeing something concave.

Figure 161 is an enlarged detail from the print *Convex and Concave* (1955), which is constructed entirely with elements susceptible to two opposite interpretations. It is only the architectonic filling in, together with the human and animal figures and clearly recognizable objects, that restricts it to one single interpretation. The result of this is that now and again these find themselves in a totally incomprehensible world—that is, the moment we make a wrong interpretation of their environment.

Before we embark on a study of the picture it will be well to become conversant with the more elementary forms of this ambivalence within the one drawing. If we take a brief look at the weather vane (fig. 160) we shall observe that at a given moment it will suddenly change direction. For instance, if you start by seeing its right-hand side pointing more or less toward you, lo and behold, after a few moments the situation changes and the same section is now turned away from you. In the two drawings

below we have tried to emphasize each one of these interpretations equally, but it may be that you will still find the reversal taking place after you have stared at them for a while. Thus we meet the phenomenon here in a very simplified form.

We can take this further (figure 159a). Let us draw a line AB. Which do you conclude is nearer to you—A or B?

Now we draw two parallel lines. By presenting them as very thick bars we can imply that Q and R are closest to us. And what is more, we no longer see two parallel lines, but two lines crossing each other at right angles. And we can use other methods of imposing one of the possible alternatives on the viewer. This comes out very clearly in the construction with four parallel lines in figure 159b, transformed as they are into two dipole antennae in a totally different position.

We do the same thing with two diamond shapes (figure 159c). These are completely identical, yet a different interpretation is accentuated in each lozenge, with the result that we see the first as a plank at close quarters that we can look up to from below, and next as one we can look down on from above.

In the case of a diamond drawn next to a square, the number of possibilities becomes even greater; and the small illustrations show the four different interpretations (figure 162).

Thus even a single line drawn on a blank sheet of paper allows of two quite distinct interpretations, and obviously this twofold interpretation can also be a feature of the most complicated figures, indeed of every print, every photograph, and every picture. The fact that we usually do not notice this is due to the way in which numerous details of the picture represent things that clearly have only a single meaning in the tangible world of experience. Whenever this does not apply it will be found that one interpretation can be arrived at just as well as another, especially if we change the direction in which the light is shining on the paper. In figure 163 the same photograph of a dewdrop on the leaves of an *Alchemilla mollis* plant has been printed twice over, once in its normal position and once upside down. No doubt you will see the leaves in the one photograph as concave and those in the other as convex. The same thing applies to the lunar landscape which can be seen twice printed in figure 164.

Because the foremost architectural details in the print *Convex and Concave* are the three cubical temples with cross-vaulting, we hae drawn two identical cubes in figure 165 just as they appear in the print. But possible interpretations have been stressed, while their position vis-a-vis the observer is indicated by a number of angular points. F stands for in front and B stands for behind; u is under and a is above. These two cubes can easily be recognized in the furthest left and furthest right temples in the print.

The lithograph *Convex and Concave* is a visual shock. Apparently, or in any case at first sight, it is a symmetrical edifice;

159a.

159b.

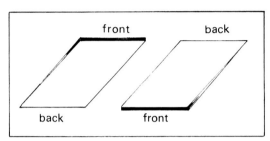

front back

back front

159c.

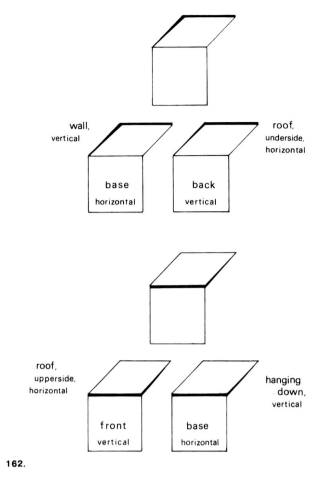

wall,
vertical

roof,
underside,
horizontal

base
horizontal

back
vertical

roof,
upperside,
horizontal

hanging
down,
vertical

front
vertical

base
horizontal

162.

160. The weather vane effect

163. Dewdrops can give a concave or convex effect

164. The same goes for the craters on the moon

85

thus the left-hand side is the mirror image of the right-hand side, the transition in the middle being not abrupt but gradual and entirely natural. However, when the center is crossed something takes place that is worse than falling into a bottomless abyss, for everything is turned literally inside out. Topside becomes underside, front becomes back. The people, the lizards, and the flower pots do resist this inversion, for they are easily identifiable with palpable reality and this, to our way of thinking, cannot have an inside-out form. Yet even they have to pay the price if they dare to cross the frontier: they end up in such an odd relationship with their surroundings that the mere sight of them is enough to make one dizzy. To take a few examples: at the bottom left there is a man climbing up a ladder to a landing. Ahead of him he sees a small temple. He can go and stand beside the sleeping man and wake him up to ask him why the shell-shaped basin in the middle is empty. Then he can have a try at mounting the stairs on the right. By then it is too late, for what looks like a stairway when viewed from the left turns out to be the underside of an arch. He suddenly finds that the landing, once firm ground beneath his feet, has now become a ceiling to which he is strangely fixed, just as if there were no such thing as a force of gravity.

The same thing will also happen to the woman with the basket if she walks down the stairs and then steps over the central line. However, if she stays on the left-hand side nothing untoward will happen to her.

Perhaps we experience our most marked visual shock when we look at the flute players on the opposite side of the vertical middle line. The one to the upper left is looking out of a window and down on the cross-vaulted roof of a small temple. He could, if he wished, climb out and go and stand on that vaulting, then jump down from there onto the landing. Now if we take a look at the flute player slightly lower down to the right, we observe that he can see an overhanging vault above him; he may as well put right out of his head any notion of jumping down onto the "landing," for he is looking down into an abyss. The "landing" is invisible to him because in his half of the print it extends backward. On the banner in the top right corner the

print has been provided with an emblem neatly summarizing the picture's content. If we let our eye travel slowly over from the left half of the print to the right, it is possible to see the right-hand archway as a stairway also—in which case the banner's appearance is totally unreal. We can leave further excursions into this print to the viewer.

Figure 166 gives a diagram of the contents, and here the print is divided into three vertical strips. The left-hand strip has a distinct "convex architecture" and it is as though, at every point, we are looking downward from above. If the print were drawn using normal perspective we should be bound to find a nadir below the bottom limit of the plate. Yet the vertical lines remain parallel, because in this instance what is called oblique or angular perspective is being used, so we must think rather in terms of a pseudo-nadir. In the section to the far right we see everything from below; the architecture is concave and the eye is drawn upward towards a pseudo-zenith. In the central section the interpretation is ambivalent. Only the lizards, the plant pots, and the little people are susceptible to just one single interpretation.

In figure 168 we are shown the plan on which the print has been drawn. It is of course somewhat more complicated than the symbol on the banner, but in any case it presented Escher with many more possibilities.

A fair number of preparatory sketches for the print *Convex and Concave* have been preserved, among which figures 169, 170, 171, and 172 are very intriguing. A year after *Convex and Concave* appeared, Escher wrote to me about it thus:

Just imagine, I spent more than a whole month, without a break, pondering over that print, because none of the attempts I made ever seemed to turn out simple enough. The prerequisite for a good print—and by "good" I mean a print that brings a response from a fairly wide public quite incapable of understanding mathematical inversion unless it is set out extremely simply and explicitly—is that no hocus-pocus must be perpetrated, nor must it lack a proper and effortless connection with reality. You can scarcely imagine how intellectually lazy the "great public" is. I am definitely out to give them a shock; but if I aim too high, it won't work.

apparent zenith ▲

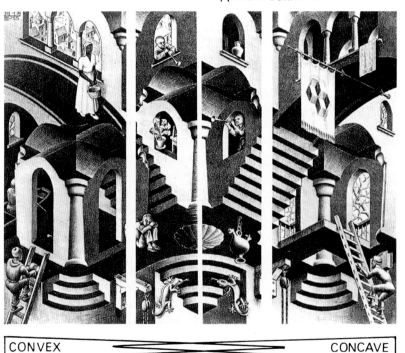

CONVEX ══════════════ CONCAVE

▼ apparent nadir

166. The structure of *Convex and Concave*

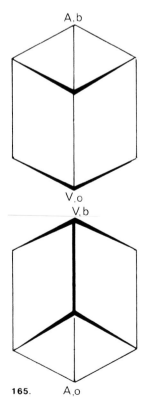

A,b

V,o
V,b

165. A,o

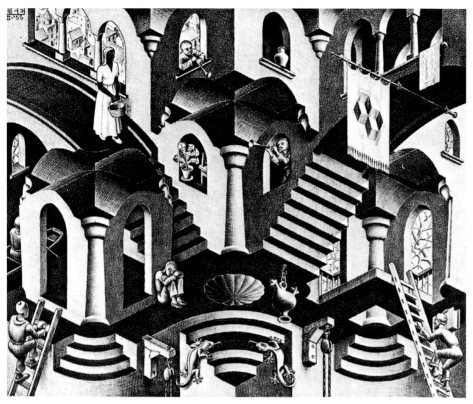

167. *Convex and Concave*, lithograph, 1955

170.

171.

168. Cube scheme for *Convex and Concave*

172.

169.

169-172. Studies for *Convex and Concave*

87

At this same period I introduced Escher to the phenomenon of pseudoscopy, whereby, with the use of two prisms, the retinal images of both eyes can be interchanged. He was most enthusiastic, and for a long while he took the prisms around with him, so as to try out the pseudoscopic effect on all sorts of spatial objects. Here is one of his many descriptions:

173. The "pseudoscope"

> Your prisms are basically a simple means of undergoing the same sort of inversion that I have tried to achieve in my print *Convex and Concave*. The tin staircase that the mathematician Professor Schouten gave me, which gave rise to the print *Convex and Concave*, will definitely invert if one looks at it through the prisms. I mounted them between two pieces of cardboard which were held together with elastic bands; this made a handy little viewing box. I took them with me on a walk in the woods and enjoyed myself looking at a pool with fallen leaves, the surface of which suddenly stood on its head; a watery mirror with the water on top and the sky beneath, and never a drop of water falling "down."
>
> And even the interchange of left and right is fascinating too. If you study your own feet, and try moving your right foot, it looks as though it is your left foot that moves.

If you wish to observe a pseudoscopic effect you should obtain two right-angle prisms (of the kind to be found in most binoculars). Mount these between two pieces of cardboard as shown in figure 173. You will have to be able to give a slight turn to at least one. of these prisms. As a first object for pseudoscopic observation it is best to select a somewhat exotic flower shape—for instance a double, large-leaved begonia. Hold the pseudoscope in front of your eyes and close your right eye. Make sure that you are looking at the begonia with your left eye. Now close the left eye and, without moving either the pseudoscope or your head, look through the right-hand prism with your right eye. If you cannot see the flower, or if it is not in the same place, turn the right-hand prism until you view the flower from the correct angle. Then open both eyes. As soon as you become accustomed to it, both parts will come together and you will see an inverted image. Indeed everything will seem to have turned back to front. You can see a box or a glass turned out; an orange turns into a paper-thin cavity; the moon advances right up to your window and hangs among the trees in the garden; if you look at a glass of beer while it is filled by somebody, you will have a well-nigh incomprehensible experience. The entire spatial world becomes for you an ever-changing *Convex and Concave* movie!

175.

Cube with Magic Ribbons

The subject embarked upon in the print *Convex and Concave* was too attractive a one not to be pursued further. While *Convex and Concave* was a whole story, the same thing comes to us as a pithy phrase in *Cube with Magic Ribbons*, which came into being a year later. For here too we have the possibility of ever-changing interpretation, in front and behind, concave or convex, while in this case there is also a contrast with an object that has been depicted in such a way as to allow of only one single interpretation. The main theme of the print consists of two ellipses intersecting each other at right angles and broadened out into bands. Each of the four half-ellipses is able to appear turned both toward and away from the viewer, and each point of intersection allows of four different interpretations. The ornaments on the ribbons can be seen as protruding half-spheres with holes in the middle or else as circular depressions with half-spheres in the middle. The reversal effect seen here very closely resembles what we have seen in the moon photograph in figure 164.

Escher's preparatory studies reproduced here show that the idea of a cube did not emerge at first, and that the ornamentation of the ribbons was originally attempted in other ways.

176.

177.

174. *Cube with Magic Ribbons*, lithograph, 1957

178.

179.

175-180. Studies for *Cube with Magic Ribbons*

89

Phantom House

In the trial studies for the lithograph *Belvedere* (1958) the edifice was repeatedly called *Phantom House*. But, because the atmosphere of the final print had nothing ghostly about it, the name was changed. Anyhow, ghostly or not, the architecture is quite impossible. Any representation of three-dimensional reality is reckoned to be the projection of that reality on a flat surface. On the other hand, every representation does not have to be a projection of three-dimensional reality. This is made abundantly clear in *Belvedere*, for although it certainly looks as though it is the projection of a building, yet no such building as is illustrated in *Belvedere* could possibly exist. We can see below the basic theme of the print—that is to say, the cubelike shape the pensive young man is holding in his hands (figure 181). In the middle we can see the extremely bizarre outcome of this construction—i.e., a straight ladder standing inside the building and yet at the same time leaning against the outside wall! (Figure 183.)

Belvedere is closely related to *Convex and Concave*, and this we can see by studying figures 182a, b, and c. Figure 182a represents the framework of a cube. We have already seen that the projection of two different realities can be observed within it. We arrive at one of these by assuming points 1 and 4 to be near at hand and 2 and 3 to be further away from us. For the other reality 2 and 3 are close to us and 1 and 4 further off. This play on both possibilities was the theme of *Convex and Concave*. But it is also possible to regard 2 and 4 as in front and 1 and 3 as behind. Now this goes entirely contrary to our concept of a cube, and so for that reason we do not naturally arrive at this interpretation. However, if we allow some volume to the ribs of the cube, we can force this interpretation on the viewer, making the rib *A*2 pass in front of the rib 1-4, and *C*4 in front of 3-2. At this juncture figure 182b emerges, and this is the basis of *Belvedere*. And even another cuboid shape is possible, as in figure 182c. Now let us study the print itself.

In *Belvedere* one could almost fancy one hears the playing of a spinet.

A Renaissance prince—let us call him Gian Galeazzo Visconti—has had this pavilion built, with its view over a valley in the Abruzzi. However, on closer examination it turns out to be a rather weird-looking place. This is due not so much to the presence of the raging prisoner, of whom nobody seems to take the slightest notice, but to the way the place is built. It would appear that the top floor of the belvedere lies at right angles to the one beneath it. The longitudinal axis of this top floor is in line with the direction in which the woman at the balustrade is gazing, while the axis of the floor below corresponds to the line of vision of the wealthy merchant as he stands looking out over the valley.

181. Detail from *Belvedere*

183. Detail from *Belvedere*—the ladder, starting on the inside and coming out on the outside...

182.

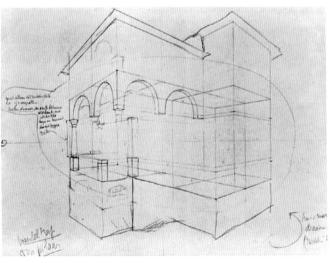

184-185. Studies for *Belvedere*

90

Then, too, there is something very unusual about the eight pillars that join the two storeys together. Only the extreme right and the extreme left pillars behave normally, just like the ribs *AD* and *BC* in figure 182a. The other six keep on joining front side to rear side, and so must somehow or other pass diagonally through the space in the middle; and this the merchant, who has already laid his right hand against the corner pillar, would quickly discover if he were to place his left hand on the next pillar along.

The sturdily constructed ladder is dead straight, and yet clearly its top end is leaning against the outer edge of the belvedere while its foot stands inside the building. Anyone standing halfway up the ladder is not going to be able to tell whether he is inside or outside the building. When viewed from below he is definitely inside, but from above he is quite as definitely outside.

If we cut the print through the center horizontally, then we shall find that both halves are perfectly normal. It is simply the combination of both parts that constitutes an impossibility. The young man sitting on the bench has worked this out from a much-simplified model which he is holding in his hands. It resembles the framework of a cube, but the top side is joined to the under-side in an impossible way. It is in fact, probably quite impossible to hold such a cuboid in one's hands, for the simple reason that such a thing could not exist in space. He might be able to solve this riddle if he were to make a careful study of the drawing which lies on the ground in front of him.

In the bottom left-hand corner of one of the preparatory studies (figure 185), there is an interesting note: "spiral staircase around pillar." The definitive version certainly includes a ladder, but one would love to know how on earth Escher could have managed to draw a spiral staircase running around one of the pillars joining the front and rear sides of the building.

There has been no lack of attempts to produce a spatial model of the cuboid form used by Escher in *Belvedere.* A very skillful achievement can be seen in figure 187, a photograph by Dr. Cochran of Chicago. But his model consists of two separate pieces that resemble this cuboid only when photographed from a certain angle of vision.

Wrong Connections

In the British *Journal of Psychology* (vol. 49, part 1, February, 1958), R. Penrose published the impossible "tribar" (figure 188). Penrose called it a three-dimensional rectangular structure. But it is certainly not the projection of an intact spatial structure. The "impossible tribar" holds together as a drawing purely and simply by means of incorrect connections between quite normal elements. The three right angles are completely normal, but they

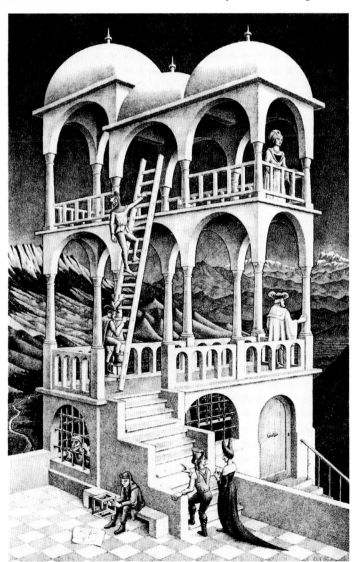

186. *Belvedere,* lithograph, 1958

187. "Crazy Crate," photographed by Dr. Cochran, Chicago

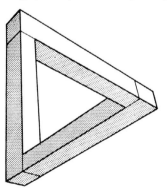

188. Tribar by R. Penrose

have been joined together in a false, spatially impossible way, so as to make a kind of triangle whose angles, incidentally, add up to 270 degrees!

Nowadays innumerable varieties of impossible figures are known, all of them being derived from false junctions. A very simple, although less well-known one, can be seen in the top row in figure 189. Below it sections of it are shown again; and these could very well exist in space, their false connections having been omitted.

It is perfectly feasible to take a photograph of the impossible tribar (figure 191). In this case, just as in the case of the crazy crate in figure 187, this photograph of the unconstructable object can be taken only from a single given point.

Escher came across Penrose's figure just at the time he was engrossed in the construction of impossible worlds, and the tribar gave rise to the lithograph *Waterfall* (1961). In this picture he linked together three such tribars (figure 190). The preparatory sketches show that his original intention was to draw three colossal building complexes. Then the idea suddenly came to him

that falling water could be used to illustrate the absurdity of the tribar in a most intriguing way.

If we start by looking at the upper left part of the print we see the water falling and thereby causing a wheel to turn. It then flows away through a brick outlet-channel. If we follow the course of the water we find that it unquestionably flows continually downward, and at the same time recedes from us. All of a sudden the furthest and lowest point turns out to be identical with the highest and nearest point; therefore the water is able to fall once again and keep the wheel turning; perpetual motion!

The surroundings of this impossible watercourse have the function both of strengthening the bizarre effect (the greatly enlarged mosses in the little garden, and the polyhedrons perched on top of the towers) and at the same time, of lessening it (the adjacent house and the terraced landscape in the background).

The relationship between *Belvedere* and *Waterfall* is obvious, for the cuboid that is basic to *Belvedere* also owes its existence to the intentionally false way in which the corner points of the cube are joined together.

189. Impossible connections

191. Photograph of impossible tribar

192.

193.

190. Three tribars linked together

192-193. Pencil studies for *Waterfall*, seen as a building

194. Another building-like sketch

195-199. Sketches in which the *Waterfall* idea was worked out

196.

195.

197.

198.

199.

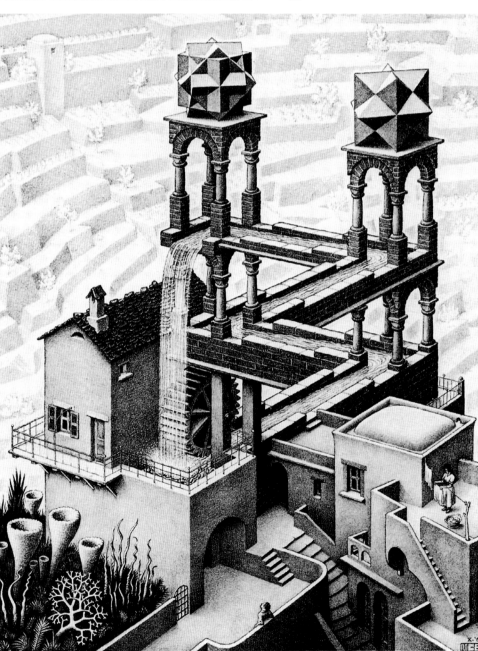

200. *Waterfall*, lithograph, 1961

93

The Quasi-Infinite

Escher has tried to represent the limitless and infinite in many of his prints. The spheres that he carved in ivory and wood, the surfaces he completely covered with one or more human or animal motifs, display both limitlessness and infinity.

In his limit prints, both the square and the circular ones, infinity is depicted by the continuous serial reduction of the figures' dimensions.

In the print *Ascending and Descending*, a lithograph made in 1960, we are confronted with a stairway that can be said to go upward—and downward—without getting any higher. Herein lies the connection between this print and *Waterfall*. If we study the print and follow the monks step by step we shall discover without the slightest doubt that each pace takes a monk a step higher. And yet on completion of one circuit we find ourselves back where we started; therefore in spite of all our ascent we are not a single inch higher. Escher also discovered this concept of quasi-endless ascent (or descent) in an article by L.S. Penrose (figure 203a). The deception is revealed, if we decide to cut the building into slices. Thus we find slice 1 (upper left) repeated at the bottom (right front), at a much lower level (figure 203b). So the sections do not lie in horizontal planes, but they go upward (or downward) spirally. The horizontal is seen to be in reality a spiral movement upward, and it is only the stairway itself that remains in a horizontal plane.

To demonstrate the possibility of drawing a continuous stairway in a horizontal plane, we have set out to construct one ourselves (figure 204a, b, c, and d). *ABCD* represents a quadrilateral lying horizontally. We have then drawn vertical lines from the central point of each side. It is easy to draw steps, which form a stairway rising from *A*, over *B*, to *C* (figure 204a). The trouble arises when we want to continue from *C*, over *D*, and back to *A*.

In figure 204b this is done in such a way that the steps take us downward, and so the whole beauty of the idea is lost. We take two steps up and two steps down, so it comes as no surprise when we find ourselves back at our starting point. However, if we alter the angles (figure 204c) then the stairway does in fact continue to go upward; so this diagram would serve our purpose. However, a building drawn according to this diagram would still have an unsatisfactory shortcoming. The dotted lines indicating the direction of the side walls slope toward each other at the upper right; there is nothing wrong with that, for they fit in (having vanishing point V_1) with the perspective representation of a building of this sort. But the other two dotted lines meet at the point V_2 at the lower right and this plays havoc with the notion of a print drawn with proper perspective.

We can, of course, get V_2 at the upper left if we make the sides *BA* and *DA* longer, as shown in figure 204d. In this way each of the two sides becomes one step longer. Escher's print demonstrates how this solution achieves a semblance of verisimilitude.

We have discovered where it is that this print fools us —i.e., the stairway lies in a completely horizontal plane, whereas the rest of the building, such as the plinths of the columns, the window frames, etc., which really ought to lie in horizontal planes, are in fact moving upward spirally. So the front of the building looks absolutely plausible, but if Escher had drawn the rear view in another print, we should then have discovered that the whole building had collapsed.

Now we can take a further look at the staircase from this point (figure 205). If we draw lines along each large strip we notice that this delineates a prismatic shape whose side surfaces have breadths in the ratio 6:6:3:4. Those parts of the print which appear at a similar height form a spiral (shown in dots). Figure 206 sums up this print once again. But the thin lines indicate horizontal planes (and therefore parallel to the stairway), while the thick-lined spiral shows the quasihorizontal lines of the building.

203a. Original drawing by Penrose **203b. The Penrose drawing sliced**

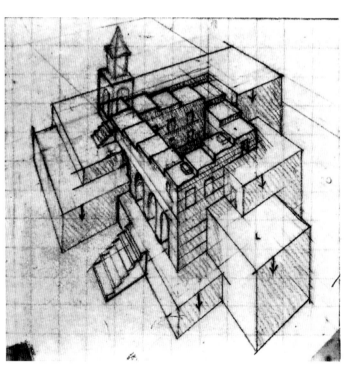

201. Preparatory sketch for *Ascending and Descending*

203c. Plaster of Paris mold of the impossible Penrose stairs

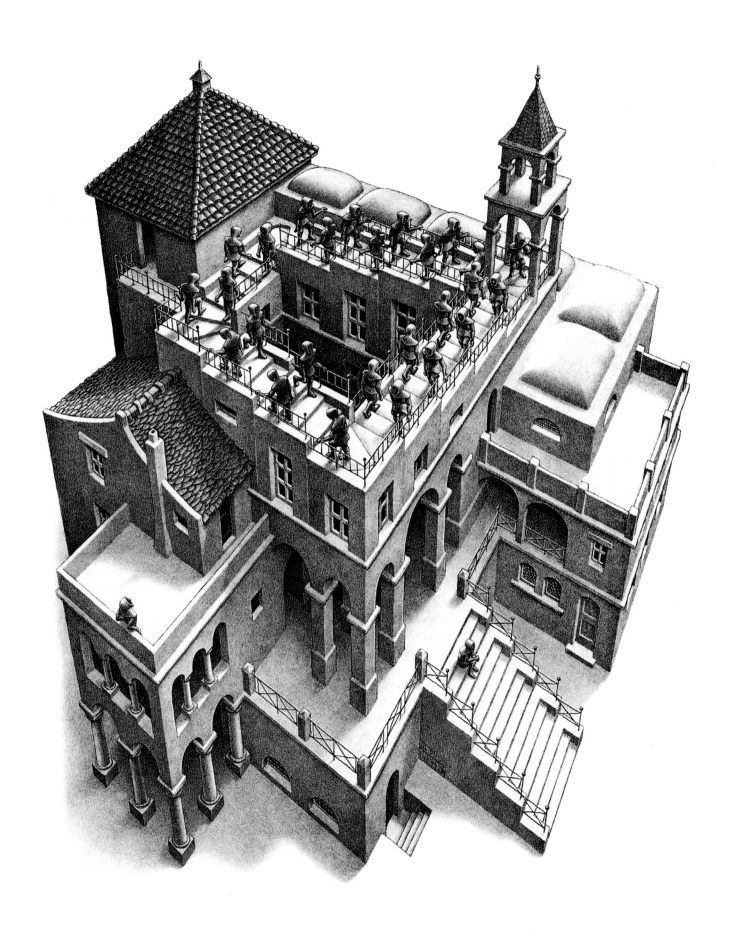

202. *Ascending and Descending*, lithograph, 1960

95

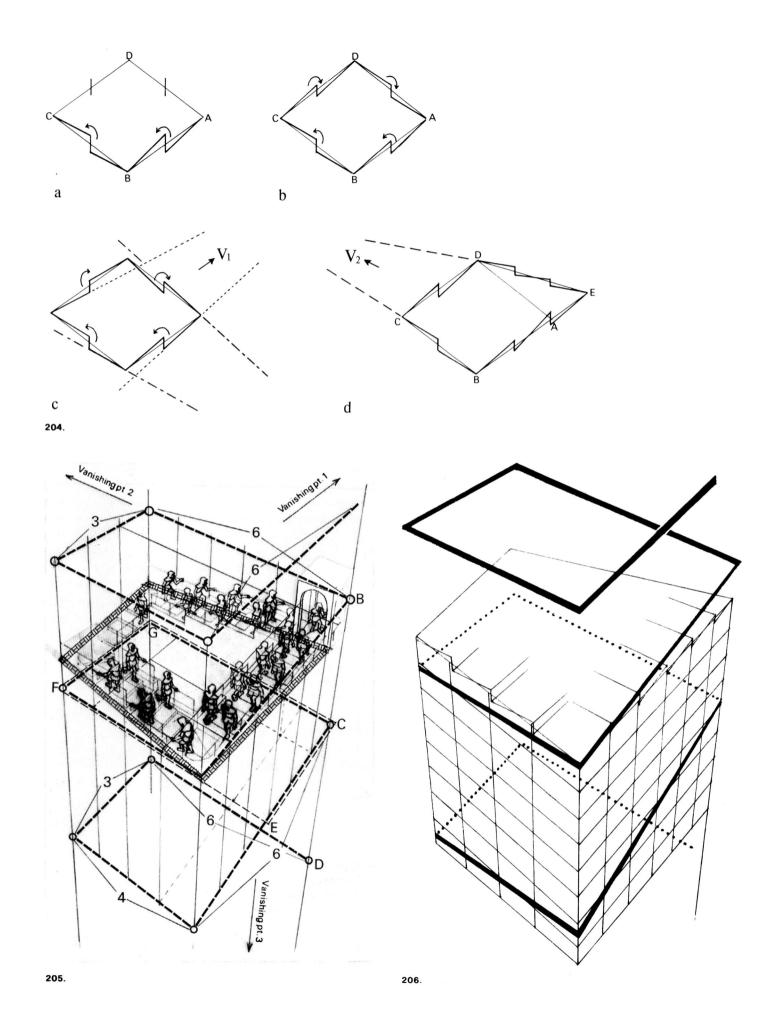

a

b

c

d

V₁

V₂

204.

Vanishing pt 2

Vanishing pt. 1

Vanishing pt. 3

205.

206.

14 Marvelous Designs of Nature and Mathematics

207. "Long before there were men on this globe, all the crystals grew within the earth's crust."

"Long before there were men on this globe, all the crystals grew within the earth's crust. Then came a day when, for the very first time, a human being perceived one of these glittering fragments of regularity; or maybe he struck against it with his stone ax; it broke away and fell at his feet; then he picked it up and gazed at it lying there in his open hand. And he marveled.

"There is something breathtaking about the basic laws of crystals. They are in no sense a discovery of the human mind; they just 'are'— they exist quite independently of us. The most that man can do is to become aware, in a moment of clarity, that they are there, and take cognizance of them."

M. C. Escher, 1959

Escher on the subject of crystals was lyrical. He would take out a minute sample from his collection, lay it in the palm of his hand, and gaze at it as though he had dug it up out of the earth that very minute and had never seen anything like it in his life before. "This marvelous little crystal is many millions of years old. It was there long before living creatures had appeared upon earth."

He was fascinated by the regularity and the inevitability of these shapes, which are to men at once secret and almost wholly unfathomable. And this is what they were to him also, as he modeled them in all sorts of materials and depicted them in many different positions on his paper.

On a flat surface he had to work out ways of producing periodic surface-division. In the spatial world of crystals various configurations had already been realized, and these cried out to be drawn and to be so manipulated that their characteristics could be displayed with greater clarity.

Then too, Escher shared this interest in regular polyhedra (produced in nature as crystal shapes) with his brother, the geologist Professor B. G. Escher. When, in 1924, the latter was appointed to a lectureship in the University of Leiden in general geology, mineralogy, crystallography, and petrography, he found himself held up for lack of a good textbook. So he wrote a standard work of more than five hundred pages on general mineralogy and crystallography, which appeared in 1935.

Tetrahedron
(4 planes)

Hexahedron
(6 planes)

Octahedron
(8 planes)

Dodecahedron
(12 planes)

Icosahedron
(20 planes)

208. Platonic solids

209. Stars, *wood-engraving, 1948*

210. Escher with a model of Platonic solids

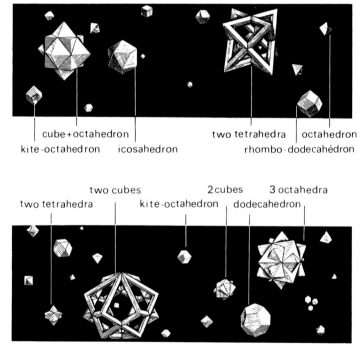

cube+octahedron
kite-octahedron icosahedron

two tetrahedra octahedron
rhombo-dodecahédron

two cubes
two tetrahedra kite-octahedron 2cubes 3 octahedra
dodecahedron

211.

98

The Greek mathematicians already knew that only five regular solids were possible. They can be bounded by (1) equilateral triangles, as in the cases of the tetrahedron (regular four-faced figure), the octahedron (regular eight-faced), and the icosahedron (regular twenty-faced); (2) by squares, such as the cube, or (3) by regular pentagons, as in the dodecahedron (regular twelve-faced figure) (figure 208).

In the wood engraving *Stars* (1948) (figure 209) we find these Platonic solids, as they are called, illustrated. *Tetrahedral Planetoid* (figure 212) is an inhabited tetrahedron. When, in 1963, the tin-container manufacturing firm Verblifa asked Escher for a design for a biscuit tin he harked back to the simplest polyhedra and gave it the form of an icosahedron, which he decorated with starfish and shells (figure 125).

In order to have before him a permanent reminder of how these five Platonic solids are put together, Escher made a model out of wire and thread (figure 210). When, in 1970, he moved from his own house in Baarn, where he had lived for 15 years, to the Rosa-Spier Home in Laren, he gave away most of his belongings and handed over a number of stereoscopic models, which he himself had made, to The Hague municipal museum; but that great brittle model made entirely from wire and thread he took along with him to hang up in his new studio.

The Platonic solids are all convex. Kepler and Poinsot discovered four more, concave, regular solids. If one accepts different (regular) polyhedra as the boundaries of a regular solid then there are twenty-six further possibilities (the Archimedean solids). Finally, we can take different interpenetrating solids as new regular solids; thereupon we can get an almost infinite series of composite regular solids. In these cases we are going far beyond what nature has contrived in the way of crystal shapes. Of the Platonic solids only the tetrahedron, the octahedron, and the cube appear as natural crystals, and no more than just a small number of the other possible polyhedra. So it looks as though, in this matter, human fantasy is richer than nature.

All these spatial figures fascinated Escher and kept him busy: we come across them in his prints, sometimes as the main subject, as in *Crystal* (1947), *Stars* (1948), *Double Planetoid* (1949). *Order and Chaos* (1950), *Gravity* (1952), and *Tetrahedral Planetoid* (1954), and sometimes as decorative features, as in

Waterfall (1961), in which regular solids crown the two towers. Escher also made a few regular solids in wood and in plexiglass, not as models to be copied but as *objets d'art* in their own right.

One of the finest of these pieces is *Polyhedron with Flowers* (figure 218), which he carved in maple in 1958. It is about thirteen centimeters high and is made up of interpenetrating tetrahedra. Before starting on this elegant freehand version, he had first carved an exact model. He also designed and carved himself the wooden puzzle which, when fitted together, makes an Archimedean solid called a stellated rhombic dodecahedron. A puzzle of this type has long been known, but it had never been so symmetrically constructed as this one of Escher's. Closely related to these spatially constructed regular solids are the various spheres that he covered completely with relief carvings of congruent figures. In *Sphere with Fish* (1940) (figure 217), made out of beechwood and with a diameter of fourteen centimeters, there are twelve identical fish entirely filling up the spherical surface. On other spheres, two or three different figures are used. Take, for instance, *Sphere with Angels and Devils* (1942), which has already been mentioned.

There are some copies of these spheres, carved in ivory by a Japanese at the request of a keen admirer of Escher, the engineer Cornelius Van S. Roosevelt, grandson of President Theodore Roosevelt, who recently donated his collection of about two hundred Escher prints to the National Gallery of Art, Washington, D. C.

Stars (1948)

This little universe is filled with regular solids. Close-up in the center of our field of vision, we see a framework composed of three octahedra. "This handsome cage is inhabited by a chameleon-type creature, and I shouldn't be surprised if it wobbles a bit. My first intention was to draw monkeys on it."

Tetrahedral Planetoid (1954)

This planetoid has the shape of a regular, four-faced solid (that is to say, a tetrahedron). We can see only two faces of it.

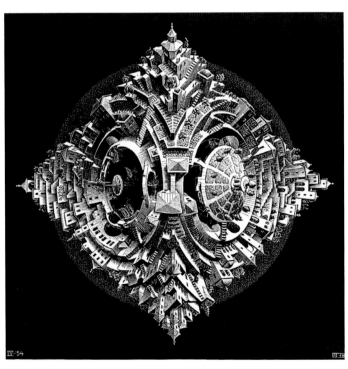

212. *Tetrahedral Planetoid,* **woodcut, 1954**

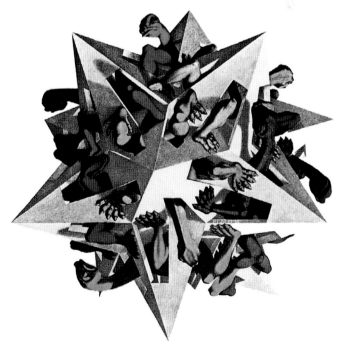

213. *Gravity,* **lithograph, 1952**

99

The inhabitants have made the greatest possible use of all the faces and have built terraces on them. This planetoid's atmosphere does not extend to the corner points, so the folk who live up there must have some method or other of taking a bit of atmosphere with them in order to keep alive. Escher constructed these terraces with great accuracy by imagining the planetoid to be carved out of a globe built up in concentric layers like an onion. After he had cut off the globe in order to get his tetrahedron, every ring was carefully carved at right angles.

Gravity, (1952)

This is a stellated dodecahedron, one of the regular solids discovered by Kepler. This interesting solid may be regarded as being constructed in various different ways. Inwardly it consists of a regular twelve-faced body (a dodecahedron), each face of which is a regular pentagon. And upon each of these faces there is superimposed a regular, five-sided pyramid.

A more satisfying way of looking at it is to regard the whole solid as consisting of five-pointed stars, but with each of the rising sides of every pyramid belonging to another five-pointed star.

Escher was very fond of this spatial figure, because it is at once so simple and so complex. He made use of it in a number of prints. Here we see each star-*cum*-pyramid as a little world inhabited by a monster with a long neck and four legs. A tail could not be coped with, because each pyramid has only five openings. For this reason Escher had first thought of having his solid peopled with tortoises (figure 214).

214. The rejected tortoise

Fold-out of tetrahedron

60°

60° 60°

Fold-out of octahedron

Tetrahedron bounded by

Octahedron bounded by 3 equilateral triangles

215a. Foldout of the tetrahedra and the octahedra

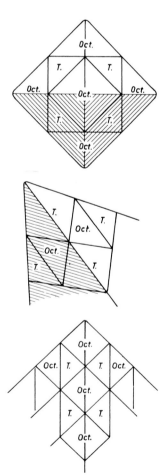

215b. Combinations

216. *Flatworms*, **lithograph, 1959**

The walls of each monster's tent-shaped house serve as floors on which five of the other monsters are standing. Thus every single surface we can point to is both floor and wall.

Escher called this hand-painted lithograph *Gravity*, because each of these heavily built monsters is so forcibly drawn toward the center of the stellated polyhedron.

There is a definite link between this print and various perspective prints in which the multiple function of surfaces, lines, and points is brought to the fore. Compare, for instance, the concept of this print with that of *Relativity*, which appeared a year later.

New Types of Building Blocks

It is possible to use random-shaped blocks in the building of walls, floors, and ceilings. In large constructions building blocks of similar shape would be preferable, whether they were fired bricks or quarried stone. And the shape of such block is almost without exception barlike—that is to say, a spatial figure bounded by right angles. We are so very accustomed to this shape in building blocks that we find it difficult to imagine any other.

And yet it is quite possible to fill up the whole of space (leaving no gaps) with blocks of a totally different shape from this. The queer-looking underwater building to be seen in the lithograph *Flatworms* (1959) is constructed entirely of two different types of blocks, the octahedron and the tetrahedron.

Now it would not be possible to fill the space completely with tetrahedra only, or with octahedra only, for there would always be gaps left between them. But it can be done if one effects a certain alternation of each type of block. And Escher has produced this print to demonstrate the fact. If you wish to make a further study of this strange edifice then there is nothing for it but to cut some octahedra and tetrahedra out of cardboard and stick them together yourself. A fold-out of each of these spatial figures can be seen in figure 215a. The dotted lines indicate where the folds should come. If you set about playing with these spatial figures you will find that you can make with them all the shapes that are to be seen in the print. To help you over this, figure 215b shows how, in a number of places on the print, the tetrahedra and octahedra lie in relationship to each other. To my way of thinking, it would be an incredibly difficult task to make a spatial copy of the whole print using both types of building block; but if any reader has got the courage and energy to tackle it, they are in for a good deal of enjoyment. Of course, there will not be any horizontal or vertical floors or walls to be found in this, and I believe that nobody is going to feel very much at ease in such a building. Indeed, this is why Escher allocated it to the flatworms for their dwelling.

On reading the foregoing description of his print *Flatworms*, Escher asked me to add the following remarks:

In spite of the lack of horizontal and vertical planes, it is possible to build columns and pillars by piling up tetrahedra and octahedra in such a way that, when viewed as a whole, they do in fact stand vertically. Five of these pillars are shown in the print. The two that stand in the right-hand half of the print are in a sense the reverse of each other. The further to the right of these shows only octahedra, but there must be invisible tetrahedra inside, whereas the pillar to the left of this appears to be built entirely of tetrahedra, yet there must be an internal vertical series of octahedra one on top of the other like beads strung on a necklace.

In addition to folding cardboard and sticking it, it is also possible, and less time-consuming, to make tetrahedra and octahedra by modeling them out of small lumps of plasticine, about the size of a large marble. To fill the space completely you will need twice as many tetrahedra as octahedra. The advantage of this method is that, at room temperature, the plasticine building blocks can easily be fitted together without adhesive and can also be pulled apart again. In this way it is possible to play about and experiment with them. The rules of the game can be made even clearer if different colors of plasticine are used for tetrahedra and for octahedra.

217. Sphere with Fish, stained beech, 1940 (diam. 14 cm.)

218. Polyhedron with Flowers, maple, 1958 (diam. 13 cm.)

Superspiral

Escher was not interested only in spatial figures that have a close relationship with crystal shapes. Any interesting regular spatial figure gave him the urge to depict it. Between 1953 and 1958 he made five prints in which the subject was *spatial spirals*. Let us discuss the first of these: *Spirals* (figure 220), a wood engraving in two colors. The origin of this print is worthy of note.

Now, an artistic effort may well be a response to a challenge. One child says to another, "Hey, you can't draw a horse!" And a horse is promptly drawn. The print *Spirals* itself was the outcome of a challenge. In the print room of the Rijksmuseum in Amsterdam Escher came across an early book of perspective, *La pratica della perspectiva* by Daniel Barbaro (Venice, 1569). The opening of one of the chapters was decorated with a torus, the surface of which consisted of spiral-shaped bands (figure 219). The engraving was not particularly good and the intended geometrical shapes were not very well drawn—two things about it which annoyed Escher and were not unconnected. Escher set himself the even more difficult problem of how to present not simply a

219. Frontispiece of *La pratica della perspectiva*, by Daniel Barbaro, Venice, 1569

220. *Spirals*, wood engraving, 1953

torus, but a body that would become thinner and thinner and would keep spiraling back into itself. "A self-centered sort of thing," as he later referred to it, ironically. The problems caused by this were very troublesome and necessitated months of planning and construction work. We have reproduced only a few of the trial sketches here (figure 221). The final outcome is a remarkably brilliant print in which the artist gets across to us something of his own wonderment at the pure laws of form. Four bands, getting progressively smaller, wind themselves as spatial spirals around an imaginary axis, and this axis itself has the shape of a flattened spiral.

Anyone who could see the many preparatory studies for this engraving would be impressed by the infinite trouble Escher had taken to produce an accurate presentation of the spatial figure he had visualized. Indeed, he would have found it easier to take a photograph of such an object.

However, this spatial object is by no means to be had for the asking. No doubt a worker in precious metals could make one, but it would call for a great deal of time and skillful craftsmanship. This presentation is truly unique; Escher is showing us something we have never seen before.

Moebius Strips

"In 1960 I was exhorted by an English mathematician (whose name I do not call to mind) to make a print of a Moebius strip. At that time I scarcely knew what this was."

In view of the fact that, even as early as 1946 (in his colored woodcut *Horseman*, figure 91), then again in 1956 (the wood engraving *Swans*), Escher had brought into play some figures of considerable topological interest and closely related to the Moebius strip, we do not need to take this statement of his too literally. The mathematician had pointed out to him that a Moebius strip with a half-turn has some remarkable characteristics from a mathematical point of view. For instance, it can be cut down the middle without falling apart as two rings, and it has only one side and one edge. Escher makes the first of these characteristics explicit in *Moebius Strip I* (1961) (figure 222) and the second—which is closely related to it—in *Moebius Strip II* (1963) (figure 226).

These strips are named after Augustus Ferdinand Moebius (1790–1868), who was the first to use them for the purpose of demonstrating certain important topological particularities. It

221.

222. *Moebius Strip I*, wood engraving, 1961

223. How to make a Moebius Strip

103

is a very simple matter to make a model of one (figure 223). First of all we make a band by pasting together a strip of paper. *AB* is the place at which it has been joined. This cylindrical strip has two edges (upper and lower) and both inner and outer surfaces. Next, we imitate Moebius, putting a twist in the strip so that *A* comes next to *B* and *B* next to *A*. And now it comes to light that the strip has only one edge and one side. For if you start to paint the "outside," it turns out that you can keep on doing so until the entire surface of the paper has been colored; and if you run your finger along the "upper" edge toward the right, without taking it off, you will make two circuits and arrive back at your starting point; nor will you have missed touching any single bit of the edge. Thus, the Moebius ring has only one edge and one side. To make this drawing Escher constructed large spatial models, both of the ants and of the strip itself.

Now, if we cut an ordinary cylindrical strip down the center we get two new cylindrical strips that can be taken apart completely. But if we try to do the same thing with a Moebius strip, we shall not end up with two loose parts—it remains intact. Escher demonstrated this in *Moebius Strip I* in which there are snakes biting each other's tails. The whole thing is a Moebius strip cut lengthwise. If we follow the snakes with our eye, they look as though they are fixed together all the way along; but if we pull the strip out a little we shall find we have got one strip with two half-turns in it.

In *Horseman,* a three-colored woodcut made in 1946, we see a Moebius strip with two half-turns. If you make one for yourself you will find that it automatically forms itself into a figure-eight. This strip definitely has two sides and two edges. Escher has colored one side red and the other blue. He conceives of it as a strip of material with a woven-in pattern of horsemen. The warp and woof are of red and blue thread, so that one horseman comes out blue and the other red. The front and the rear of a horseman are mirror images of each other, and there is nothing unusual in this, for it could be said of any figure one cares to choose. But now Escher starts manipulating the strip so that an entirely different topological figure is produced. In the center of the figure-eight he joins the two parts of the band together in such a way that the front and the rear sides become united. We can copy this in our paper model if we use Scotch tape to turn the middle of the figure-eight into a single plane surface. From a purely topological point of view, we ought at this point to drop one of the two colors,

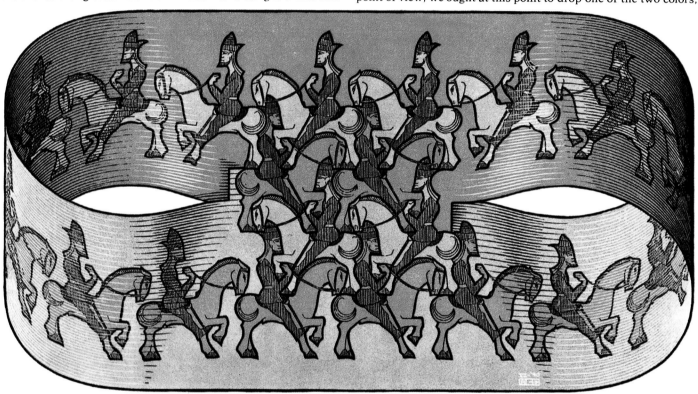

224. *Horseman*, woodcut, 1946

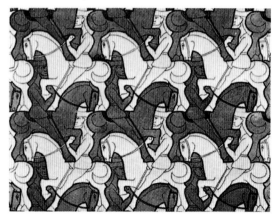

225. **Page from Escher's sketchbook**

Grid for the print *Swans*

104

but this is not really what Escher intended. He wishes to show how the little red horsemen on the underside of the print combine with the blue ones, which are their mirror image, to fill up the surface completely. This is achieved in the center of the print.

Of course, we can also find this in a very fine page from Escher's space-filling sketchbook (figure 225), but in this particular print it is presented in a most dramatic way, for here we can see the filling process actually taking place before our eyes.

Escher also deals with a topological subject in his woodcut *Knots* (1965) (figure 227). He came across the idea for this knot in a de luxe loose-leaf printed book by the graphic artist Albert Flocon. The latter is a keen admirer of Escher and has done a great deal to make Escher's work more widely known in France. In this book, consisting mainly of copperplate engravings, Flocon too was trying to explore the relationship between space and the depicting of it on a flat surface. In this he is, however, much more theoretical than Escher (witness, for example, his reflections on perspective), and on the other hand his engravings are much freer, less exact, less directed toward principles or essential requirements. It was in Flocon's book *Typographies* that Escher found the picture shown on the left in the print *Knots*. At all events

he considered this knot, consisting of two bands set at right angles to each other, so remarkable that he thought he would devote a separate print to it. A drawing made in 1966, when he was on a visit to his son in Canada, indicates that he was still working on it a year later. The large knot is square in section and appears to be made out of four different strips; however, if we follow one of these strips we find that we traverse the entire knot four times, without going over any bounds, finally arriving back at the place where we started. So there is only one strip after all! We can make a model of it ourselves by using a long piece of foam plastic, square in section. Having tied a knot in it we must then turn the ends toward each other and stick them together. There are several possibilities.

The open-work caterpillar-wheel style of the knot was the outcome of repeated attempts to find a form in which both the outside and the inside of the structure would be clearly visible. This is a problem Escher wrestled with many a time, and several prints have had to remain in the planning stage because he was unable to achieve a clear presentation of interior as well as exterior.

226. *Moebius Strip II*, **wood engraving, 1963** **227.** *Knots*, **woodcut, 1965**

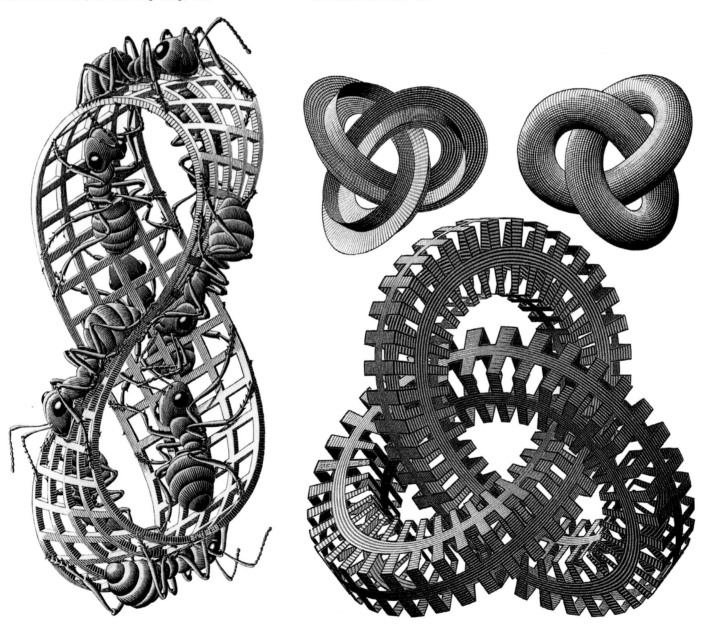

15 An Artist's Approach to Infinity

In an article published in 1959 Escher expressed in these words what it was that inspired him to depict infinity:

We find it impossible to imagine that somewhere beyond the furthest stars of the night sky there should come an end to space, a frontier beyond which there is nothing more. The notion of "emptiness" does, of course, have some meaning for us, because a space can be empty, at all events conceptually, but our powers of imagination are incapable of encompassing the notion of "nothing" in the sense of "spacelessness." For this reason, as long as there have been men to lie and sit and stand upon this globe, or to crawl and walk upon it, to sail and ride and fly across it (and fly off it), we have held firmly to the notion of a hereafter, purgatory, heaven, hell, rebirth, and nirvana, all of which must continue to be everlasting in time and infinite in space.

It is to be doubted whether there exist today many draftsmen, graphic artists, painters, sculptors, or indeed artists of any kind, to whom the desire has come to penetrate to the depths of infinity by using motionless, visually observable images on a simple piece of paper. For artists nowadays are motivated rather by impulses which they are unable or unwilling to define, or by some compulsion, incomprehensible, unconscious or subconscious, which cannot be expressed in words.

And yet it can happen, so it seems, that someone who has accumulated but little of exact knowledge or of the learning that previous generations achieved through study—that this individual, filling up his days, in the way that artists will, toying with more or less fantastic notions, feels one fine day ripening in him a definite and conscious desire to approach infinity through his art, as accurately and closely as he can.

What kind of shapes is he going to use? Exotic, formless blobs that can awake in us no associative thoughts? Or abstract, geometrical, rectilinear constructions, squares or hexagons which at most will bring to mind a chessboard or a honeycomb? No, we are not blind, deaf, or dumb; we consciously perceive the shapes that are all around us and that, in their rich variety, speak to us in a clear and fascinating language. And so the shapes we use to build up our surface-division are recognizable tokens and clear symbols of the animate or inanimate material all around us. If we are going to construct a universe then let it not be some vague abstraction but rather a concrete image of recognizable objects. Let us build up a two-dimensional universe out of an infinite number of similar-shaped, and at the same time clearly recognizable, building blocks.

228. *Development II*, woodcut, 1939

It can become a universe of stones and stars, of plants and beasts, or people.

What has been achieved in periodic surface-division . . . ? Not infinity, of course, but certainly a fragment of it, a part of the "reptilian universe." If this surface, on which forms fit into one another, were to be of infinite size, then an infinite number of them could be shown upon it. But we are not simply playing a mental game; we are conscious of living in a material, three-dimensional reality, and it is quite beyond the bounds of possibility to fabricate a flat surface stretching endlessly and in all directions.

However, there are other possible ways of presenting the infinite, many without bending our flat surface. Figure 228 shows a first attempt in this direction. The figures that were used to construct this picture are subjected to a constant radial reduction in size,

working from the edges toward the center, the point at which the limit is reached of the infinitely many and the infinitely small. And yet even this treatment remains no more than a fragment, for it could be extended outward just as far as we would like, by the addition of even larger figures.

There is only one possible way of overcoming this fragmentary characteristic and of obtaining an "infinity" entirely enclosed within a logical boundary line, and that is by going to work the other way round. Figure 243 shows an early, albeit clumsy, application of this method. The largest animal shapes are now found in the center and the limit of infinite number and infinite smallness is reached at the circumference.

The virtuosity in periodic surface-division that Escher had reached stood him in good stead with his approaches to infinity. However, an entirely new element is called for: networks to facilitate the representation of the infinite surface on a piece of flat material.

Prints with Similar-shaped Figures

When, after 1937, Escher first started flat surface-division, he used congruent figures only, and it was not until after 1955 that we find him using, to some degree, similar-shaped figures to approach infinity through serial formations. And this possibility was seen and used as early as 1939 in the print *Development*

229. The inner part of *Smaller and Smaller I*, wood engraving, 1956

II. But the figures' increase in size outward from the infinitely small at the center is still entirely subservient to the concept of metamorphosis.

The figures are not only small in the center but also unidentifiable; and it is not until they reach the outer rim that they appear as complete lizards. The very title of this print indicates its close connection with metamorphosis, for *Development I* (1937) is a metamorphosis print in which congruent rather than like-shaped figures are used.

We can distinguish three groups among the similar-shaped-figure prints if we take note of the patterns that serve as their underlying frameworks.

1. Square-Division Prints

These are the simplest in construction and yet the first of them did not appear until 1956 *(Smaller and Smaller I).* A year later Escher worked on a book for the bibliophile club De Roos(M. C. Escher, *Periodic Space-Filling*, Utrecht, 1958), and in it he showed the diagram on which this kind of print is based, also drawing a simple print of a reptile so as to demonstrate the fundamental principle involved. In 1964 he used this diagram once again for a more complicated print, *Square Limit* (figure 230), but this time with the quite clear intention of trying to represent infinity in a print.

The fact that this diagram was so simple was probably the reason why Escher gave up using it.

2. Spiral Prints

The plan of these prints—a circular surface divided up into spirals of like-shaped figures—had already been established with the appearance of *Development II*. The following prints are based on it: *Path of Life I* (1958), *Path of Life II* (1958), *Path of Life III* (1966), and *Butterflies* (1950).

We could probably add *Whirlpools* to this category. The aim of the *Path of Life* prints is not so much to represent infinite smallness as to depict an expansion from infinitely small to infinitely large and back to small again, a process analogous to the one of birth, growth, and decline.

3. The Coxeter Prints

In a book by Professor H. S. M. Coxeter, Escher discovered a diagram that struck him as being very suitable to the representation of an infinite series. This gave rise to *Circle Limit* prints numbers I to IV (1958, 1959, 1959, 1960). *Circle Limit* I, III and IV are reproduced in figures 243, 244 and 77.

Escher's last print, *Snakes* (1969) (figures 245 *et seq.*), also belongs to this group, although the network for this has been adapted to Escher's particular aim in a most ingenious way.

Square Limits

What have we got here (figure 230)? We might say it is an infinite number of flying fish. In figure 231 we see a simple solution to the problem of depicting infinity; the right-angled isosceles triangle *ABC* is the starting point. Two more right-angled isosceles triangles, *DBE* and *DCE*, are drawn on the side *BC*. We repeat this process and so get the triangles 3 and 4, 5 and 6 and so on.

We could continue the process to infinity and still end up very much where we started. If the square *EFCD* is one decimeter in length, then the squares below it must have sides measuring ½ decimeter, those below again ¼ decimeter and so forth (see figure 231, right). A simple calculation tells us that $\frac{1}{2} + \frac{1}{4} + \frac{1}{8} + \frac{1}{16} + \frac{1}{32} + \frac{1}{64}, = 1$. Therefore *CG* = 2 decimeters and nevertheless we find we have an infinite number of squares continually diminishing in size. Figure 231 may be fascinating for the mathematician but not for the average observer. Escher has brought this framework to life by filling each of the triangles with a lizard (figure 232). He made this print as an illustration for a book about periodic surface-division. The same plan is basic to *Smaller and Smaller*, a wood engraving made in 1956 (figure 229).

The woodcut *Square Limit* (1964) has a rather more complicated basic pattern. In figure 233 a quarter of it is shown, plus a

230. *Square Limit,* **woodcut, 1964**

little bit more around the central point of the print at *A.* We come across figure 231 again in several parts, and only along the diagonals of the square is a different solution to be found. Escher made the following marginal note on this print in a letter:

Square Limit (1964) was made *after* the series *Circle Limits I, II,* and *III.* This occurred because Professor Coxeter pointed out to me a method of "reduction from within outwards" which I had been looking for in vain for years. For a reduction from without inwards (as in *Smaller and Smaller*) does not bring with it a philosophical satisfaction because no logical, self-contained, or fully effective composition is to be found within it.

After this empty satisfaction of my longing for an intact and complete symbol of infinity (the best example was achieved in *Circle Limit III*), I tried to substitute a square form for the circular one — because the rectilinear nature of walls of our rooms calls for this. Rather proud of my own invention of *Square Limit,* I sent a copy of it to Coxeter. His comment was, "Very nice, but rather ordinary and Euclidean, and therefore not particularly interesting. The circle limits are much more interesting, being non-Euclidean." This was all Greek to me, being, as I am, a complete and utter layman in things mathematical. However, I will gladly confess that the intellectual purity of a print such as *Circle Limit III* far exceeds that of *Square Limit.*

108

231. Principle of the square division prints

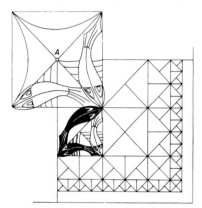

233. Part of *Square Limit*

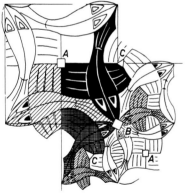

234. The three different meeting-points

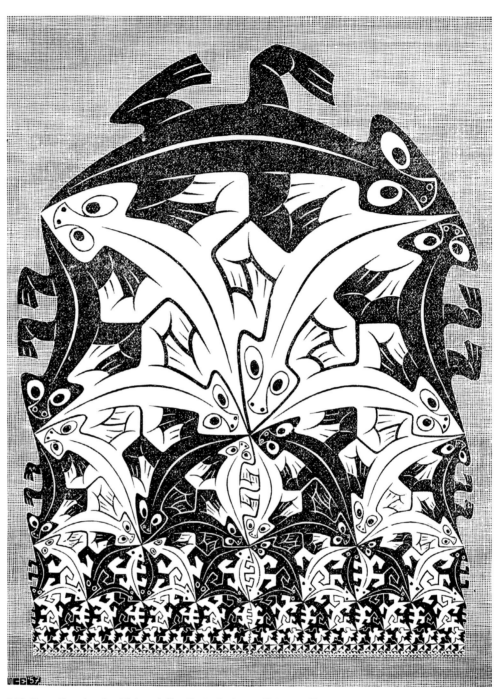

232. From *Regelmatige Vlakverdeling* (Periodic Space-Filling) by Escher. Published as a Bibliophile Publication by the De Roos Foundation, 1958.

If we think we have now completely understood this print, we are deceiving ourselves. The simple question, why does Escher have to use three tints for this print and why can he not make do with two, may well cause us confusion. Let us look at figure 234, in which the same part is illustrated as in figure 233. If we focus our attention on the points where the fish come together, then we shall see that there are three different kinds. At *A* four fins of four different fish come together, at *B* four heads and four tails touch, and at *C* three fins meet. At *A* only two colors are required, and at *B* also, if it is merely a question of keeping the creatures apart. But three tints are necessary for this at *C*.

If we look for several points of the *A* variety then the first thing we notice is that these points are to be found only on the diagonals of the print. In the center are the fins: gray/black/gray/black; on the diagonal from lower left to upper right we find repeated: white/gray/black/gray and on the diagonal from lower right to upper left we have: white/black/gray/black. No other combinations appear.

When it comes to the *B* points all we can expect is white/gray/black; but at the *C* points we start finding some surprising combinations again, if we look closely at the fish heads.

However often one looks at this print it continues to fascinate with its great wealth of variety.

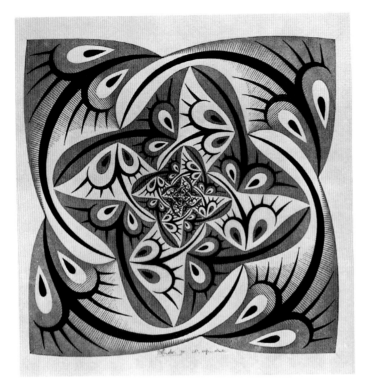

235. *Path of Life II*, woodcut, 1958

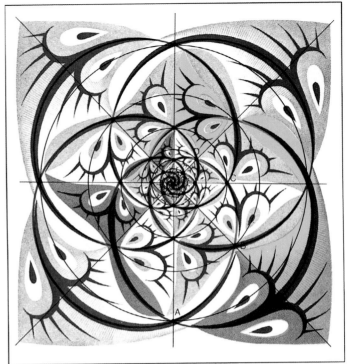

236. The construction of *Path of Life*

Birth, Life, and Death

The network giving the basic pattern of the *spiral prints* is a series of logarithmic spirals. Escher was not acquainted with that mathematical concept but constructed it as follows: First a number of concentric circles are drawn and the distance between them becomes smaller toward the center. Then he drew a number of radii dividing the circles into equal sectors.

Starting at a point on the circumference of the outermost circle, he marked the points of intersection both of consecutive radii and of consecutive circles, moving inward. He then joined up the resultant points with a flowing line. We can also do this moving in the opposite direction. Figure 239 shows such a construction.

The entire structure of circles, radii and spirals forms a grid pattern of similar-shaped figures continuously diminishing in size toward the center. In *Path of Life I* Escher has used double spirals starting at eight points on the circumference. In *Path of Life II*, which to my mind is the finest of them all, there are four starting points, and in *Path of Life III* the twelve spirals set out from six points.

This basic pattern was already drawn up in 1939, when Escher used it for *Development II* (figure 228), but in this instance it serves only to produce steadily diminishing figures. In the *Path of Life* prints this network is used in a more sophisticated way, for here we have two spirals starting out from different points on the circumference, and joined together round the outside. Thus we can reach the center via a spiral from the outer edge and return from thence spiraling to the circumference until we meet up with our first spiral once again. We now shall use *Path of Life II* in order to make a closer study of this.

The large fish at the lower left (figure 235) has a white tail and a gray head. This head is contiguous with the tail of a smaller though similarly shaped fish. And so we proceed via three further and smaller fish in our spiral course toward the center. Close to the center the fish get so small that it is no longer possible to draw them—yet there is an infinite number of them!

In figure 236 the spiral we have just been following is drawn in red; along this path we find only gray fish. From the point of infinite smallness white fish grow out of the gray ones and swim away from the center along the blue spiral. On reaching the edge this merges into the red spiral along which we set out. At this point the fish change color again; white becomes gray and a new cycle begins. Of course, the whole idea of this is that a white fish, coming to life at the center, grows up to its maximum size, only to grow old and to sink back, as a gray fish, whence it came.

I regard this print as a maximum achievement both for the succinct way in which the concept is presented and for its great simplicity and elegance. I rate this print very high indeed and regard it as the best of all Escher's approaches to infinity.

We reproduce only a working drawing of *Butterflies* (1950) (figure 237) and this does not show the basic network very clearly. If one were to attempt an analysis of the final print without realizing that the framework for it was derived from that of the spiral prints, one would be totally misled by the great number of shapes. In this case the strict regularity of them would be almost entirely hidden.

The impressive woodcut *Whirlpools* (1957) (figure 238) came into being prior to the *Path of Life* prints. The same construction is used here as was used for the spirals, while a number of possibilities inherent in this framework were not utilized. Only two spirals are drawn simultaneously in the upper and lower constructions and they both move in the same direction. These spirals are in line with the backbones of two opposing series of fish, and at the center one construction merges with the other.

The gray fish are born in the upper pool and, growing larger, keep swimming further outward. Then they start on their journey (already diminishing in size) toward the lower pool, where after an endless series of reductions, they disappear at the central point. The red fish swim in a contrary direction, from the lower pool to the upper.

The whole picture is printed from two blocks only. The one from which the gray fish of the lower part are printed is used over again to print the red fish of the upper part. This is why we see Escher's signature and the date twice on the same print.

Toward the end of the year in which *Whirlpools* appeared,

110

237. Sketch for the wood engraving *Butterflies*

239. Logarithmic spirals as a network for
the spiral prints

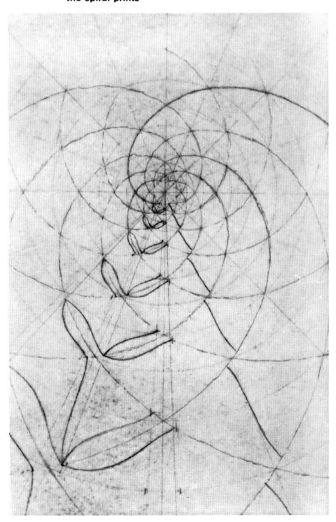

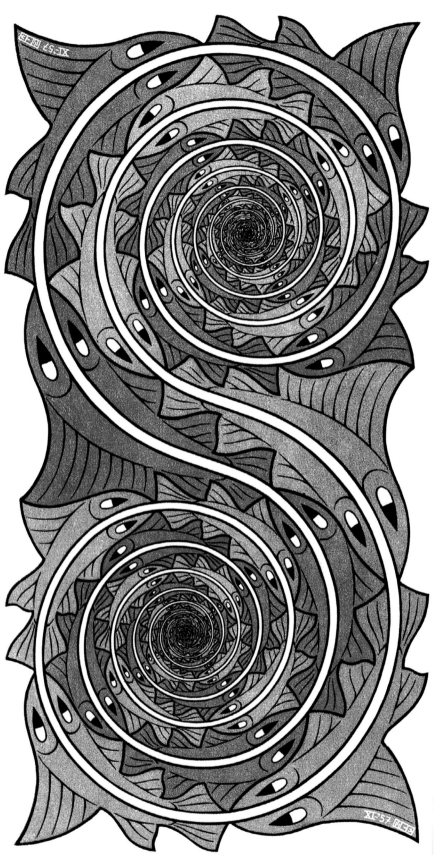

238. *Whirlpools*, woodcut, 1957

111

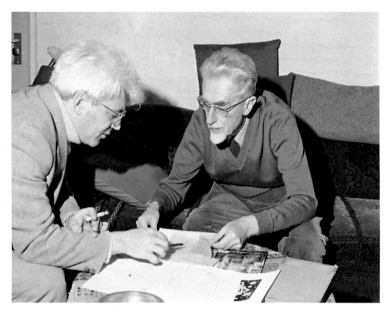

240. The author and M. C. Escher a few weeks before his death. "I consider my work the most beautiful and also the ugliest."

242. The Coxeter illustration

241. Sketch for cemetery mural

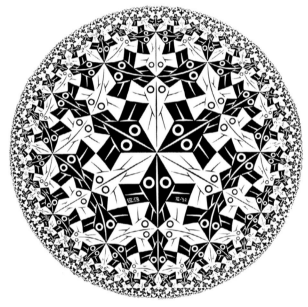

243. *Circle Limit I*, woodcut, 1958

Escher received a commission from the city of Utrecht for a mural in the main hall of the third municipal cemetery. This is done as a circular painting with a diameter of 3.70 meters. Not only did Escher produce the design but he carried out the actual painting himself (page 59). This wall-painting is almost an exact replica of one half of *Whirlpools*.

The Coxeter Prints

In order to demonstrate hyperbolic geometry* the French mathematician Jules Henri Poincaré used a model in which the whole of an infinite flat plane was shown as being within a large finite circle.

From the hyperbolic point of view no points exist on or outside the circle. All the characteristics of this type of geometry can be deduced from this model. Escher discovered it illustrated in a book by Professor H. S. M. Coxeter (figure 242) and he immediately recognized in it new possibilities for his approaches to infinity. On the basis of this figure he arrived at his own constructional plan.

This was how *Circle Limit I* came into being in 1958; it was described by Escher himself as a not entirely successful effort:

> This woodcut *Circle Limit I*, being a first attempt, displays all sorts of shortcomings. Not only the shape of the fish, still developed from rectilinear abstractions into rudimentary creatures, but also their arrangement and their position vis-à-vis one another

* In contradiction to the long-known principles of Euclidean geometry, through any given point outside a line there pass precisely two lines parallel to that line.

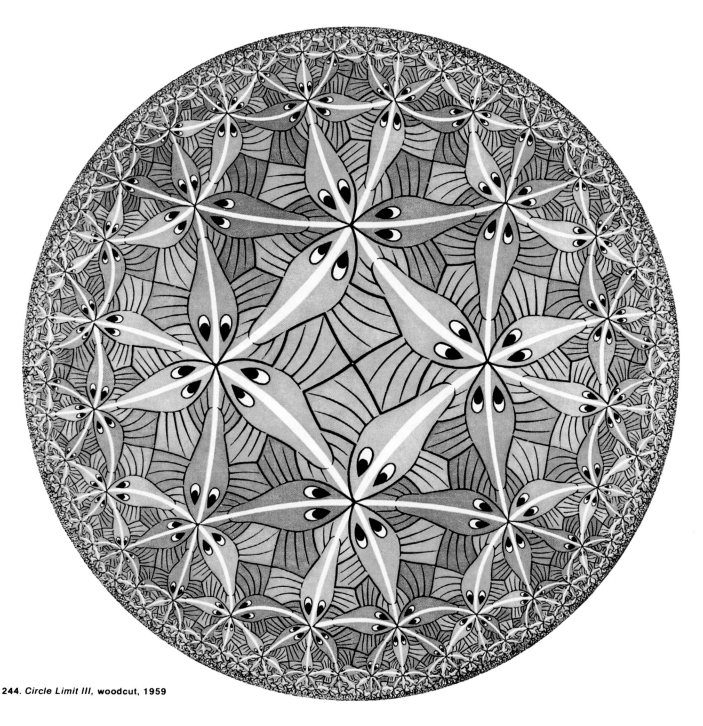

244. *Circle Limit III*, woodcut, 1959

leave much to be desired. It is true that three different series can be discerned, accentuated by the way in which the axes of their bodies run on from one to the other, but these consist of alternating pairs of white fish with their heads together and black ones with their tails touching. Thus there is no continuity, no "traffic flow," nor unity of color in each row.

Circle Limit II is not a very well-known print. It much resembles *Circle Limit I*, but in place of fish it has crosses. Once in a conversation Escher joked about it, saying, "Really, this version ought to be painted on the inside surface of a half-sphere. I offered it to Pope Paul, so that he could decorate the inside of the cupola of St. Peter's with it. Just imagine an infinite number of crosses hanging above your head! But Paul didn't want it."

Circle Limit IV (and here the figures are angels and devils) also closely follows the Coxeter scheme. The best of the four is *Circle Limit III*, dated 1959 (figure 244), a woodcut in five colors. The network for this is a slight variation on the original one. In addi-

tion to arcs placed at right angles to the circumference (as they ought to be), there are also some arcs that are not so placed. Here is how Escher himself describes this print:

In the colored woodcut *Circle Limit III* the shortcomings of *Circle Limit I* are largely eliminated. We now have none but "through traffic" series, and all the fish belonging to one series have the same color and swim after each other head to tail along a circular route from edge to edge. The nearer they get to the center the larger they become. Four colors are needed so that each row can be in complete contrast to its surroundings. As all these strings of fish shoot up like rockets from the infinite distance at right angles from the boundary and fall back again whence they came, not one single component ever reaches the edge. For beyond that there is "absolute nothingness." And yet this round world cannot exist without the emptiness around it, not simply because "within" presupposes "without," but also because it is out there in the "nothingness" that the center points of the arcs that go to build up the framework are fixed with such geometric exactitude.

113

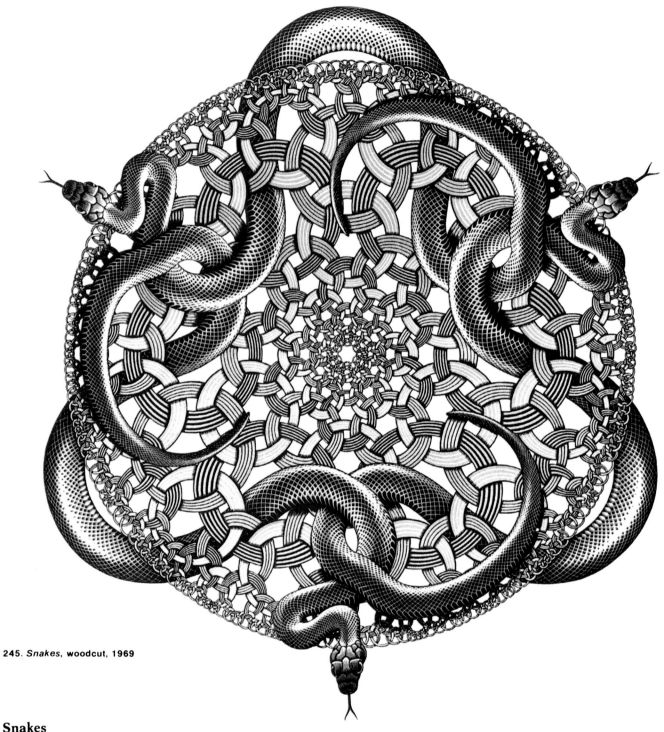

245. *Snakes*, woodcut, 1969

Snakes

In 1969, when Escher was already aware that he would once again have to undergo a serious operation, he used every possible moment in which he felt sufficiently fit to work on his last print: *Snakes*. He gave me a vague description of it at the time—a chain mail, edged with small rings and having large rings at the center. Snakes would be made to twist in and out of the larger gaps. This was a new invention; infinitely small rings would grow out of the center of the circle, reach their maximum size, and then diminish again as they approached the edge. But he wasn't going to divulge any more about it. I was not even allowed to see the preparatory studies. He was staking everything on getting the print finished and he could not put up with any criticism at all, for he was afraid that this might take away his keenness to pursue it.

There is no sign whatsoever, either in the print itself or in the preliminary studies, that Escher was calling upon his last reserves of strength. The drawings are powerful and firm and the final woodcut is particularly brilliant. It does not bear any marks at all of exhaustion or old age.

It is true that the presentation of infinity is considerably less obtrusive. In earlier prints Escher took things to fanatical lengths and, using a magnifying glass, cut out little figures of less than half a millimeter. For the center of the wood engraving *Smaller and Smaller I* he purposely used an extra block of end-grain wood so that he could work in finer detail. In *Snakes* he makes no attempt whatever to keep on with the small rings until they fade away into the thick mist of infinitely small figures. As soon as the

114

idea of constant diminution has been suggested, he takes it no further.

In the sketch of the rings (figure 246), drawn almost entirely freehand, we can see the sophisticated structure of the network. From the center of the biggest ring toward the outer rim of the circle, we come across the Coxeter network once again; but toward the center the arcs curve in opposite directions. By introducing these curved lines Escher achieved a diminution toward the center also. This is a case of Escher's playing the part not merely of a mathematician but of a carpenter using his tools with extraordinary skill, thereby setting the mathematician himself a puzzle as to how this new network can be interpreted.

One can search the biological textbooks in vain for the three snakes that serve to raise the print above mere abstraction. This type of snake is what Escher himself regarded as beautiful and the most "snakish" of all, after studying a large number of snake photographs.

Five of the many preparatory sketches show again how carefully Escher worked and how well considered every detail had to be before he began to cut his wood.

And this meticulous attention to detail was characteristic of the artist. Escher's art is the expression of a lifelong celebration of reality, interpreted in his visualizations, unique to his talent, of the mathematical wonder of a grand design that he intuitively recognized in the patterns and rhythms of natural forms, and in the intrinsic possibilities hidden in the structure of space itself. Over and over again, his work shows the inspired effort to open the eyes of less talented men to the wonders that gave him so much joy. Although he himself has said he spent many nights wretched with his failure to achieve his visions, yet he never gave up the sense of wonder at the infinite ability of life to create beauty.

246. Sketches for *Snakes*

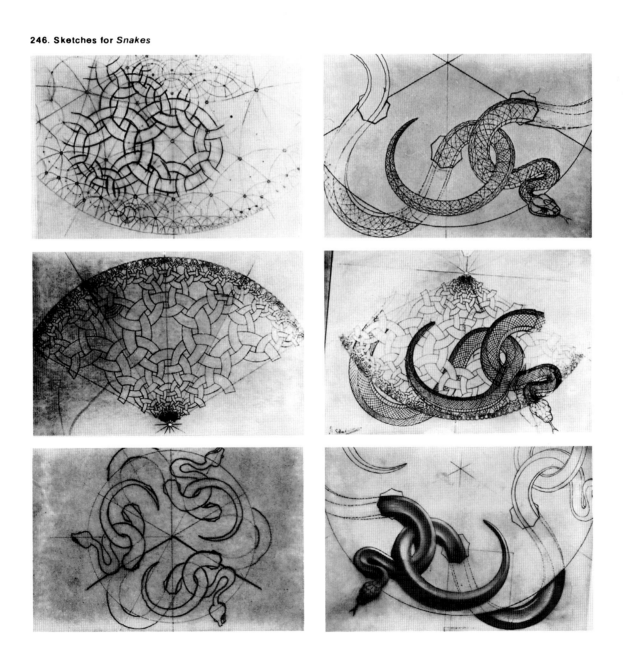

Index to Escher's Work Used for this Book

(Italic numbers denote pages with illustration)